The Web Writer's Guide

The Web Writer's Guide

Darlene Maciuba-Koppel

Focal
Press
An imprint of Elsevier Science

AMSTERDAM LONDON NEW YORK OXFORD PARIS TOKYO
BOSTON SAN DIEGO SAN FRANCISCO SINGAPORE SYDNEY

Library of Congress Cataloging-in-Publication Data
Maciuba-Koppel, Darlene.
 Web writer's guide / Darlene Maciuba-Koppel.
 p.cm.
 Includes bibliographical references and index.
 ISBN 0-240-80481-3 (alk. paper)
 1. Web sites—Design. 2. Technical writing. 3. Authorship—Style manuals. 4. English language—Rhetoric. I. Title.

 TK5105.888 .M32 2002
 808'.006025—dc21

 2002018882

British Library Cataloguing-in-Publication Data
A catalogue record for this book is available from the British Library.

The publisher offers special discounts on bulk orders of this book.
For information, please contact:

Manager of Special Sales
Elsevier Science
225 Wildwood Avenue
Woburn, MA 01801-2041
Tel: 781-904-2500
Fax: 781-904-2620

For information on all Focal Press publications available, contact our World Wide Web home page at: http://www.focalpress.com

10 9 8 7 6 5 4 3 2 1

Printed in the United States of America

This book is dedicated in memory of my father, Leon Maciuba, who encouraged me in all my endeavors.

Contents

Chapter Checklists

Acknowledgments

I would like to thank the entire editorial team at Focal Press, who first saw the spark of potential in my book. I would also like to thank my editor at Focal Press, Amy Jollymore, who was such a pleasure to work with. I want to recognize Wendy Lyons, my tireless and determined agent at Waterside Productions, Inc., who believed in my book from the beginning. I also appreciate the valuable input and the generosity of time from the online writers, Web experts, and entrepreneurs whose names you will see sprinkled throughout this book. On a personal level, I thank my husband, Ron, for his continued support and patience during my writing of the manuscript. I also thank my children—Melissa, Tasha, and Craig—who were patient during my relentless dedication to "the book," and my faithful Shih Tzu, Teddi, who spent countless hours at my side. Finally, I acknowledge my fellow writers. We all share a magical bond as we sit at our desks and play with words. The seduction of writing beckons to us daily. Why do we write? We write because we have to write—to feed our creative spirits.

Welcome

The World Wide Web continues to evolve. The UCLA Internet Report[1] indicates that the Internet's capacity to carry information doubles every 100 days. New advances in technology are making the news online, and in print, on a daily basis. Researchers tell us that future technological breakthroughs will soon bring us three-dimensional audio and visual experiences on the Web. Marketing experts continue to tinker with business models that will work on the Web and bring in financial gain.

We are all still trying to understand how to harness the power of this new phenomenon that has changed our lives in so short a time. In the interval, it's a challenge for anyone to try to make predictions for the Web's future for even the next few months. The most dependable Web trend we can rely on today is constant change. As writers, we need to embrace change on the Web because it can be our ally as long as we follow its lead.

We have all learned a lot from the first dot.com splash to the dot.com crash. Now we—business people, technology experts, and content providers—are all a lot smarter as we ride the waves of the next revolution of the Web. To successfully navigate the waves of change, writers have to stay on top of the latest research on the Web. We have to be willing to learn new skills and then to relearn again as technology continues its march of change. When the use of audio and video increases on the Web, writers will still be needed to produce the words that form the foundation of these technologies.

Luckily, writers have many traits that will give us a leading edge on the Web. We are adaptable. Most of us have learned to write under many challenging conditions, whether in our work or personal environment. With some additional training and determination, we can easily switch our writing focus if we need to. We can learn to write electronic white papers, do copywriting for e-commerce sites, or get involved

with online learning. We're naturally curious, digging into the nooks and crannies of the Web to capture those important facts that make our stories sing. Although the technology and business models may change, the Web will still need idea people. Ideas are our greatest asset. Writers are born idea generators. We take our ideas and transform them into words and text that pulls readers into our stories. We can use words to entice and grab readers' attention. Reading on screens is hard, but we can learn how to blast through those barriers for readers by spinning magic with our words.

Goals

My goals in writing this book are to offer you the tips and tools that you will need to succeed in writing for the Web. I hope that the research and facts that I have presented will give you some new ideas. I believe that the experts who you will meet in this book will offer you solid information. Most of all, I hope that I have inspired and motivated you in your pursuit of writing for the Web.

Target Audiences

Another of this book's purposes is to offer ideas to the many different types of writers who create content for the Web. These people include freelance online writers, staff writers and marketing managers at corporations, trainers who develop online documentation, and the instructors who teach online writing at schools and universities. I also offer information to help new online writers build a career. Finally, I have tried to provide ideas that will stir up the creative juices of the more experienced online writers.

Organization

Think of this book as your toolkit—a book to pick up when you need an idea, a tip or a tool, guidance, or inspiration. The organization of the book makes information easy to find and use. Depending on your specific daily needs, you can easily dip into the sections that will give you the most help. Because we all seem to be slipping in and out of different career costumes on a regular basis, I attempted to cover the main areas of the Web that are important today.

Part One offers an orientation to online writing. The Quick-Start Section (Chapter 1) is aimed at those of you who are beginning to

explore online writing as a career. In this chapter, you can get a quick glimpse into what the Web has to offer writers. I have also included a brief guide to the online writing process that includes research, identifying your target audience, determining your document's purpose, writing the first draft, and editing.

The Online Writing Process Roadmap directly refers you to those pages that provide more in-depth information on the specific tasks of online writing. The remainder of the chapters in Part One give you a good grounding in the differences in online writing, Web site guidelines, and navigational cues.

Part Two offers information on search engines and research on the Web. Chapter 6, "Getting Ready to Write," helps you to get your online writing tools in place. This chapter is an informal tutorial that provides a good grounding for new online writers. Chapter 7 "Writing Content for the Web," provides the essential guidelines for online writing. Chapter 8, "Editing Web Writing," will help you produce clean, crisp copy.

Part Three explores the different venues where writers can find online opportunities. These venues include corporations, e-commerce, online news, e-mail newsletters, and e-zines.

Part Four suggests strategies to help writers promote their online writing career. These strategies include chapters on how to find writing jobs and how to market writing services. The chapters on copyright and contracts give information to help writers protect their rights. The final chapter is a quick guide to e-books and the job possibilities and future of that industry; and the writing opportunities in online learning.

Chapter Checklists

To enhance the focus of this book as a tool-oriented textbook, I have developed 24 customized checklists, worksheets, and forms that are listed on the Chapter Checklists page. I hope these checklists will be a handy tool that will aid in your development of online content and save you time.

Dig into this idea grab bag now and get ready to write powerful online copy. I'll be looking for your content on the Web.

ENDNOTE

1. The UCLA Internet Report, "Surveying the Digital Future." (Los Angeles: UCLA Center for Communication Policy, November, 2000), www.ccp.ucla. edu. Accessed November 30, 2000.

PART ONE

Orientation

Chapter 1
Quick-Start Section and Online Writing Process Roadmap

The purpose of the Quick-Start Section and Online Writing Process Roadmap in this chapter is to give you a brief overview of online writing. If you're crunched for time, you can read this chapter and get right to work on your writing project.

The section on Study the Web will help those readers who are new to online writing to create a self-study course for themselves. The section on Analyzing Your Existing Web Site will help readers who have experience in online writing and are ready to improve their current site. The Preparing to Write section will lead both new and experienced writers through the steps they need to take to develop a well-written document. These steps include research, identifying your target audience, determining your document's purpose, writing the first draft, and editing.

When you need more detailed information, the Online Writing Process Roadmap will help you to jumpstart your online writing learning by listing the pages to go to for more information.

QUICK-START SECTION: A BRIEF GUIDE TO THE ONLINE WRITING PROCESS

William Zinsser, author of the classic book *On Writing Well*, once said, "You learn to write by writing." I believe that the same maxim holds

true for writing for the Web, but with an additional twist. You learn online writing by both studying and doing online writing. You must become an active participant: studying and researching the web; organizing, writing, rewriting, and editing your draft until you produce a document that satisfies both you and your editor (or client) and, most important, your readers.

Doing all these tasks repeatedly helps you to polish your craft. At the same time, you gain a greater understanding of what online writing is all about. Becoming an expert in online writing will enable you to expand into other online venues, such as copywriting, e-mail newsletters, or corporate intranets. But how do you become an online writing expert?

Basic Fundamentals: Study the Web First

If you are new to the Web, you need to spend some time studying the medium itself before you begin to do online writing. Look at various Web sites and documents. You'll notice that the Web's unique characteristics require a new approach to writing.

When readers land on a Web page, they are like foreigners exploring new territory. Online readers do not have the benefit of context that a print publication provides to them. Readers don't know if your document is 15 or 150 pages long. Print publications offer us context. We can hold a magazine in our hands, scan the table of contents, and flip through its pages to get an idea of its contents. As an online writer, you must provide readers with a roadmap to find their way through a Web site or document. You're performing more than the role of a writer now. You'll have to become a guide who can make information easy to find and easy to read.

If you write print articles, you quickly learned how to focus your articles by exploring the who, what, when, and where of your story. Now you can use those same techniques on Web pages to orient readers and communicate your message more clearly.

Plan Your Own Self-Study Course

You can't help online readers unless you travel the virtual roadways yourself. Plan your own self-study course by visiting a variety of Web sites. Look at the sites of your competitors. Study their home pages, interior pages, site design, typeface, graphics, navigational cues, and internal/external links. What makes their sites user-friendly? What do you find frustrating about their sites?

You should even look at sites that are outside your own line of business or interests. Visit corporate sites, news sites, nonprofit sites, government sites, and educational sites. Even some personal home pages offer a high degree of sophistication that you can learn from. You might be amazed at the ideas you pick up by viewing other sites. Visiting a variety of sites gives you a fresh outlook and energizes you.

Analyze how the written content on a site works with the design. Try to figure out what makes an online experience pleasant for you. Notice how good online writing features:

- Short chunks of text
- Meaningful headings and subheadings

Learn from those writers who write compelling headlines and catchy copy. Ask yourself what draws you into their stories. Take notes when you find writers who know how to tell a good story. For example, many of the writers at ClickZ.com and Poynter.org know how to write compelling articles.

Pay attention to those sites that frustrate you. Did you encounter broken links; complex, convoluted sentences; or dense blocks of text? Determine how you can avoid making those same mistakes in your own online writing. Your analysis of other sites will help you learn what works and doesn't work on the Web.

Make sure that you don't focus your efforts too narrowly. You need to be an expert in online writing, but you will improve your online writing skills even more if you better understand the skills of the other members on the Web team. You should also visit those technology sites that focus on design and usability issues. Learn the basics of hypertext markup language (HTML), if only to give yourself a better understanding of how sites are structured. Keep up with the latest research on Web technology by subscribing to technology-focused e-mail newsletters.

Analyzing Your Existing Web Site

If you have been writing content for a Web site for awhile and are part of a team, step back and take a critical look at your site as if you were a first-time visitor. Study your home page. Try out your internal search engine. Follow the links on your site. Examine how the table of contents and index make information easy to find. Or are your navigational aids confusing? Dig deep into your site and look at the arrangement of your archives. Ask yourself if the site is truly interactive.

Look for possible barriers that you may have put in front of your users. For example, do your pages take too long to download? Do you

make readers click through too many layers of links before they find the information they need? These barriers may cause you to lose repeat visitors. If you think you can't be objective, ask a group of first-time users to evaluate your site. Observe them and take notes as they navigate through your site. You might want to develop a list of questions to ask them after they have viewed your site.

After you have completed your analysis of your Web site, gathered user feedback, and studied other sites, you're ready to hold a brainstorming session with your team. Now is the time to freely generate new ideas for your site.

Later, after you have come up with some solid ideas through your brainstorming session, you need to develop a well-thought-out and long-range plan for your site. Better yet, in this world of constant change, you should probably think in terms of short-range *and* long-range plans. In this way, you can quickly adjust your plans if the economic climate changes. Your plan should address your site's:

- Purpose
- Objectives
- Target audience
- Content that your site will feature

Make sure that you develop a unique selling proposition (USP) for your site. Developing a unique creative concept could make the difference between a site that receives a great deal of traffic and press coverage and a site that draws little attention. During the planning phase, focus on your target audience. Every step of your plan should relate back to your target audience. This is a good time to anticipate the weekly time and funds that will be needed to maintain the site.

Preparing to Write

Before you approach a corporation or an online publication for a free-lance assignment, do some initial exploration on the Web. Try to get a feel for your potential client and target audience. This tactic will make you appear more knowledgeable when you attempt to make the sale. If you're approaching a corporation, visit their Web site and navigate their pages. Look at the company's recent press releases, "Press Room" section, product and service offerings, annual report, list of office locations, and white papers. If the company offers an e-mail newsletter, subscribe to it. The time you spend on information gathering will help you write a more targeted and intelligent query.

If you are querying an online publication, visit its Web site. Look at the advertisements on the publication's site. This will give you an idea of the target audience. Read the message boards, archived articles, and writers' guidelines. Subscribe to the publication's e-mail newsletters. All of this preparation will help you develop a profile of the publication and its audience.

Before you even write the query (or proposal), determine your goals. In the case of a corporation, are you pitching a series of brief electronic articles on "Increasing Sales with E-Mail News Alerts" that will be targeted to sales managers? If you are querying an online consumer publication, are you proposing an article on "Avoiding Common Diet Traps"? Determining your goals will help you focus your research.

Once you've settled on your potential client and goals, it's time to do additional study on the Web on your chosen topic. This will sharpen your query and help you develop a lead that will catch your potential client's attention. Look at both primary and secondary sources on the Web. You can locate primary sources in online research journals and secondary sources in online articles. During your research, you'll probably come across experts who are knowledgeable about your specialty. Develop a contact list of these experts so that you can call on them for current and future projects.

Along with your query, you should include an ASCII resume and clips pasted into the body of your e-mail message. Many people do not like to receive attachments because of possible viruses. They may also have software that is different from yours. Instead of e-mailing your resume and clips, you can refer potential clients to your Web site via your site's URL.

Doing Research

Explore the Web and learn about the many research tools at your disposal. Search engine sites may be the first tools that come to mind. Although the great variety of search engines enable you to explore many different areas of the Web, search engines don't cover the entire Web and are usually behind in indexing Web pages; however, there are other tools you can use. Seek out tutorials that teach you how to make the best use of the Web and improve your online writing. These tutorials can be found on university sites (e.g., Purdue University's Online Writing Lab [OWL]), online library sites, and educational sites.

If you are writing an online training tutorial for pharmaceutical sales representatives, different associations offer information on a variety of disease conditions. Nonprofit organizations, such as the American Institute for Cancer Research, can offer writers important background information.

Some corporations provide online research reports and white papers that are made available to the public. E-mail newsletters on specialty subjects, such as online writing, e-commerce, and copywriting, can teach you a lot. Subscribe to writers' mailing lists to keep up with the news in your discipline.

Use your bookmark list as a research tool and a way to keep up with the latest trends. As you come across reputable sites that relate to your writing specialty, bookmark them. Sign up for the site's e-mail announcements so that you will be notified when the site is updated. Divide your bookmark list into natural categories (e.g., search engines, writers' reference sites, health sites) to save time when you're working on an assignment.

Because the Web is composed of niches, you'll increase your success rate by specializing in one or two areas. What niche should you choose? You could base your niche on your educational background, hobby, or previous job experience. Whatever niche you choose, follow the latest research and trends in your specialty. Seek out the specialized e-journals and Web sites, and subscribe to their e-mail newsletters. Subscribe to one of the major news sites to keep up with the changes in your industry. As you do more research and writing on the Web on your specialties, you may find new outlets for online work. Your first job may be writing articles for an online science site. As you gain experience, you could become a content producer for that site.

In preparing for an online writing career, you should also investigate other resources that will help you develop online documents. One example of a resource for journalists is the Profnet database of experts. More information on this database can be found in Chapter 6, "Getting Ready to Write."

Identifying Your Target Audience

Before you can write a document for the Web, you need to take the time to identify your target audience and its interests. By determining your target audience's interests and needs, you will be able to craft a more focused article. Get to know your audience by studying the reader demographics. You can usually get these demographics from the site's editor. Read the in-house Web site style guide. Look at readers' e-mail messages and read bulletin boards. If the site has done surveys in the past, find out what's on the readers' minds.

Sometimes organizations hold focus groups to better understand the needs of their users. See if you can sit in on the sessions. If not, maybe you can get a transcript of the sessions. Although you have to be careful not to depend too heavily on the small sampling of focus

group results, at least you can get some additional information to add to your arsenal of data gathering.

Determining the Purpose of Your Document

Once you have identified your target audience and their interests, it's time to determine the purpose of your document. To guide your writing efforts, develop a targeted one-sentence statement that sums up your document's purpose. You need to ask yourself what you want your readers to know after they read your online document.

Writing the Draft

Online writing requires a new way of thinking for print authors. As you begin your first draft, start training yourself to write in short chunks of information. (You can storyboard your draft on index cards or use your word processing software to create an outline.) Begin to develop subheadings and topic sentences for each information chunk. This step will help you organize your information and create a natural flow throughout your document.

During your writing, think about internal links that you might add within your site that offer readers more detailed information. Decide on external links to other sites that can enhance your document's value (e.g., a link to a reputable reference site listed at the end of your article).

While writing your first draft, remember that your text should be easy to scan. Reading text on screens is more difficult than reading print copy. Make it easy for your online readers by writing meaningful headings and subheadings so they will be prepared for the copy that follows. Creatively written headings and subheadings can also grab readers' attention and cause them to keep reading copy they might otherwise pass over. Tight writing is even more important on the Web. Shorter sentences and simple words make your copy reader-friendly. Strip your copy of unnecessary words and phrases.

After you have developed a rough first draft, work on creating a compelling lead (introduction) that draws readers into your copy. It's usually easier to write the lead after you have written the first draft of your document. At that point, you know the main ideas your story will cover. Good leads can ask readers a question, cite a quote or statistic, or directly address the reader with the "You" factor. Focus your efforts on creating a strong lead that will pull readers through your story and keep them reading.

To help you develop catchy titles, headings, subheadings, and leads for your documents, visit different Web sites. The greater variety of sites you visit, the more ideas you will come up with. Notice the titles that make you want to read a specific article. What techniques

did the authors use that you might adapt when you write your own titles? Try different approaches. Fire up your titles with action verbs. Arouse curiosity with an unusual fact.

Remember that the chunks of information you write must be self-contained and provide context because readers may come upon a portion of your text through a search engine or index.

Editing

After you have written your first draft, it's time to let your copy cool down. Only then should you begin to edit your document. You'll come back to your copy with a fresh perspective and more easily spot errors and clumsy prose. To make sure you produce a high-quality and error-free document, you should follow a specific set of procedures during the editing process. If you are responsible for all of the content on a site, you can do this by developing an in-house style guide and a customized Editorial Checklist that meets the needs of your particular Web site. If you have a complex Web site, you may have to develop an Editorial Checklist for each category of your Web site. More information on in-house style guides and Editorial Checklists can be found in Chapter 8, "Editing Web Writing."

Now get ready for editing. Print out a copy of your document and proofread the hard copy. You will more easily catch errors this way. Follow a systematic approach when you proofread. Read your copy aloud. Check all the headings and subheadings first. Do they communicate your message? Look at your lead. Does it invite readers to continue reading?

The editing process offers you the final opportunity to make your copy Web ready. Increase the credibility of your document by making sure all of your content is accurate. If you have any doubts, go back to your reference sources, including the experts you interviewed and the reference style books you used.

Here's your chance to lighten up your copy and cut down those words that detract from the main purpose of your story. Make sure you are writing in your users' language. If you need to use acronyms, make sure you spell the word out on the first occurrence. If you are creating documents for a corporate site, make sure your copy is focused externally on potential customers, not internally on the corporation. Look for a natural flow to your content.

After you self-edit your work, it's important that a copyeditor review the document. The document should then go through a final edit after it is coded and before it is loaded onto the site and goes live.

After your edited copy has been posted to the Web, your work isn't over. Let's say your feature article appears on the home page of your Web site. One week from now, it may be time to move that article into

your archives section and post a new feature article. Basically, you need to develop a regular schedule for updating the copy on your site. You also need to let readers know that you updated the site, either through an e-mail newsletter or an e-mail announcement.

ONLINE WRITING PROCESS ROADMAP

Chapter 2
Web World Statistics and Web World Differences

The statistics on the Web are staggering. Research reports, from both public and private sectors, tell us that the Internet is growing at an astonishing speed. There are a lot of differences on the Web compared to print or broadcast communication but most of us seem to agree on one thing. We like the new kid on the block—the World Wide Web.

WEB WORLD STATISTICS

Research from the UCLA Internet Report claims that the "Internet represents the most important technological development of our generation."[1] The report suggests that the effects of the Internet may surpass the effects of television and could, over the coming decades, be similar to the influence of the printing press. To compile the report, researchers surveyed 2,096 households across America, comparing Internet users with nonusers.

How fast is the Internet growing? According to the UCLA Internet Report, the "Internet's capacity to carry information doubles every 100 days." In early 2000, the number of online, "indexable" documents passed the one billion mark. The report further states: "Every 24 hours, the content of the World Wide Web increases by more than 3.2 million new pages and more than 715,000 images."[2]

13

After existing a little more than five years as a widespread communication tool, the Internet is viewed as an important source of information, according to the UCLA Internet Report results. According to the study, the most popular Internet activities are Web surfing (81.7%), sending and receiving e-mail (81.6%), finding hobby information (57.2%), reading news (56.6%), and finding entertainment information (54.3%). The study shows that, "In less than a decade, e-mail has become a fundamental communication tool in America." The study reports that 42% of Americans use e-mail every day.[3]

What do all these statistics mean to online writers? Savvy online writers who follow consumers' usage of the Web will be in a better position to propose and obtain online writing jobs from Web development firms, advertising agencies, public relations firms, e-commerce sites, corporations, and other smaller companies.

WORLD OF PRINT PUBLICATIONS

If your writing experiences have been primarily in print, you're familiar with the rewards of seeing your work published in magazines and books. Your article may be on the cover of a magazine and catch the attention of thousands of readers. You can pick up a magazine, scan the table of contents, and pick out your byline. You have the satisfaction of knowing that some readers might clip that article and file it away for future reference.

If you write books, you have the satisfaction of seeing your name printed on the spine of a book, standing there on the shelf of your favorite bookstore waiting for readers. Magazines and books exist in three-dimensional space—you can pick them up and hold them in your hands. You and your readers can flip through the pages to get an idea of the kind and amount of information contained within.

THE ONLINE READER'S EXPERIENCE

On the Web, online readers see only the information that is on their screen. They don't know how long a document is unless they scroll down to the end. Without good navigational cues, they do not know whether they are reading a 10-page document or a 100-page book. They can't anticipate how you will address the remainder of the topic under discussion. Print documents are linear; information is laid out in a logical sequence. In the online world, there is no specific beginning, middle, and end. Through the power of hypertext links, readers can access your documents at any point to find information

that meets their needs. Once they are on your site, they can choose to follow the linear path that you carefully created or they can leave your document and follow a random or intuitive path of their own.

The online world is an active medium. Readers have to constantly make decisions about which links to follow and which to ignore. They are actively engaged, filling out subscription forms, sending e-mails, and participating in discussion boards. Readers demand interactivity and, to be a successful online writer, you have to include elements of interaction.

In the online world, there is no controlled circulation or press run. Readers may find your articles by accident while searching for other information. They may come upon your article by doing a keyword search or by reading a list of hypertext links. Once they land on one of your pages, your goal should be to get readers to use your site and find out more about you. Encourage them to click through your site to find what they want. Set up a response system using e-mails or discussion boards to determine their needs.

If your writing strikes a nerve within a certain niche community, readers may e-mail your site's URL to their friends around the world. If your content is really good, it may live on for years. Conversely, if your writing is bland and boring, or if you lack credibility, you won't get a chance to hook your readers' attention. They won't take the time to read your article, and they may never seek out your site again.

Grabbing Online Readers' Attention

To grab your readers' attention, you can't merely rely on the marketing efforts of online publishers. The World Wide Web is too big. Each of your words has to work doubly hard to pull readers in. Your article may be one in a list of 20 articles that comes up in a search engine list. You need to develop attention-getting headlines that will cause readers to stop surfing and click on the link. Headlines and subheads should communicate your intentions as clearly as possible, but that's only part of the story. Once you get readers to visit your site, you have to create navigational cues that tell readers where they are on your site and what to expect if they click on any additional hypertext links.

MAKING YOUR TEXT WEB-FRIENDLY

If you're used to writing long paragraphs for print articles, begin to cut your paragraphs into shorter blocks of text. Smaller chunks of paragraphs and sentences work better on the Web because they are easier to

read. Make every page independent, and explain its topic without assuming that users have read the previous page.

Provide links to background information to help users understand the page they are reading or to provide them with further details. Orient your readers by putting navigational cues on each page and the ability to link back to the home page. Be ruthless and choose your words wisely; every word has to help communicate your intent. If your words don't serve a purpose, cut them out.

In print, you are restricted to the linear and logical presentation of an article. In the online world, readers can access your article non-sequentially. If readers suddenly land on your site in the middle of an article, they need to know who is sponsoring the site, the contents that the page contains, and if they are the target audience for this information. If your article is long, you can guide readers by clearly labeling each section, such as "Section Two: Developing Web Headlines."

You can also take advantage of the opportunities of hypertext links by offering busy readers a brief summary of your story presented in concise chunks of text. Readers who want more depth can be offered links to background details on the subject and reference material, both within the site and to external Web sites. Linking to external sites does have its drawbacks. External links can quickly change. Readers will become frustrated if the links you point them to don't contain the information you said they would. Broken links also cause readers to question your credibility.

COMMUNICATING YOUR MESSAGE ON EACH PAGE

Because Web pages can be accessed independently, the headers and footers of each page have to give more information than a printed page in a book. A single Web page may be the only part of your site that users visit. To orient readers and help Web pages communicate your message, you need to borrow the four W's from the newspaper trade. On each page, tell readers the who, what, when, and where of your site.[4]

Who

Tell readers whose site this is. Are you a nonprofit organization, corporation, or individual? Put your logo in the upper left-hand corner of the screen to further identify your site.

What

Let readers know what kind of information the page contains by providing clear titles at the top of the page. The title gives readers an idea of the contents that follow. The page title also shows up as text if the user decides to bookmark your page title. A vague title will not help readers remember why they bookmarked the page. For example, the title "Skin Cancer FAQs" is more informative than the vague title "Cancer FAQs."

When

Telling readers when the information on a page was originally created helps readers assess and determine the credibility of the material. It's also important to provide the date when the document was last revised. This gives readers an idea of the material's timeliness. Large documents call for a date on each page (or screen) because readers may have to scroll or click on links to read the entire document.

Document review and date maintenance are especially important for complex documents. If you develop manuals, training materials, and product information, schedule regular reviews of all online documents. Check to see if the material is still current. If not, change the documents and add the revision date.

Where

Tell readers where you are from by providing your corporation or organization's name on each page. On the main pages of your site, include your home URL. Tell readers how they can find additional information about your organization.

ADAPTING YOUR WRITING TO ONLINE READERS

To successfully write for the Web, you need to understand online users' expectations. People come online more to find specific information than to be entertained. They are looking for answers to questions. They are impatient and have short attention spans. The Web is a personal medium; people make choices according to their interests and take action by clicking on links. They expect to receive immediate feedback.

To provide a satisfactory user experience, you must continually orient your readers. They need to know what site they are on and where they are on that site. For example, has the user landed on an e-commerce site that sells promotional products, such as shirts and coffee mugs, to companies? Is the user in the section of the site that offers customized products where companies can get their logos printed on the shirts?

Print Brochures versus Online Brochures

A print brochure immediately tells potential customers a lot of information. Customers can get a quick idea about a company and its products and services by briefly reading the brochure and looking at its physical appearance. The size, quality of paper, type of photographs, and foldout tell them a lot about the company's credibility.

While online, readers may come upon an online brochure right in the middle of its presentation. They may not even know that they have landed on a specific company site. Therefore, you have a lot more upfront work to do online.

Whether you are writing a sales document for a business-to-business site or an article for consumers, take the time to visit the current site to see how similar documents have been handled. Look at competitor sites as well to gain additional ideas. Are the pages well identified? For example, readers should immediately know that they have entered a consumers' health site through branding such as a logo that communicates its intent and good navigational cues in the form of headings and subheadings.

You can also use your writing to orient your readers by speaking directly to them in your lead. Use the lead, too, to give readers an idea of the material that will follow. If you are writing content for business-to-consumer or business-to-business sites, provide unbiased information about products and services and then offer readers a one-click purchase option.

TAKING ADVANTAGE OF THE INTERACTIVE MEDIUM

The Web is an interactive medium. When you write for a print publication, you seldom receive letters from readers. On the Web, users can immediately react to your articles by sending you e-mails or by participating in article-related online discussion boards on your site.

You often have to develop a tough skin when reader response comes in the form of criticism; however, readers' compliments can let you know that you are on target on a certain subject. Readers can also supply you with ideas for future articles. Encourage e-mail responses from readers and participate in chat sessions and discussion boards. These efforts result in user-generated content and more reader involvement, which add value and vitality to your site. It's a good idea to moderate user-generated content to help grow the communities and control flames.

SHORTER ONLINE DEADLINES

Compared to print publications, deadlines are much shorter for online publications. It can take from three to six months before you see your article published in a magazine, whereas online your article can be published within weeks or less, depending on the site.

Online rates vary; online e-zines usually pay low rates because they have a small amount of capital with which to work. Specialized industry sites, larger online publications, and e-commerce sites can pay reasonably well. Writing for a corporation's intranet and Internet can be lucrative. If you specialize in a specific area or field, such as technical or medical writing, you can increase your chances of finding higher-paying work.

ARE YOU MAKING THE WEB WORK FOR YOU?

- Does your e-mail address appear at the end of your articles?____
- Do the links at the end of your articles add value?____
- Are you asking readers for feedback on your articles?____
- Do you encourage user-generated content? Do you participate in discussion boards and chat groups?____
- Are you "listening" to your readers comments and responding with articles that meet their needs?____
- If readers tell you something is wrong, do you quickly fix it? And thank your readers?____
- Do you regularly survey your readers to determine their interests?____

ENDNOTES

1. The UCLA Internet Report, "Surveying the Digital Future." (Los Angeles: UCLA Center for Communication Policy, November 2000), www.ccp.ucla. edu. Accessed November 30, 2000.
2. Ibid.
3. Ibid.
4. Lynch, Patrick J., and Sarah Horton. "Interface Design." In *Web Style Guide, Yale Style Manual* (http://info.med.yale.edu/caim/manual/interface/interface.html). Accessed February 15, 1999.

Chapter 3
Web Site Guidelines

A well-designed Web site gives your target audience a good reason to explore your site and to make return visits. What are the key characteristics of great Web sites?

First, the site should revolve around original and credible content that is well organized and timely. When you regularly update your content, you send a positive message to your readers. The content should also be professionally edited. The information should be focused to meet your users' needs.

Second, in addition to quality content, the users' experience should be pleasant. Picture your users sitting in front of their screens. Do you want them to sit by idly while they wait for the graphics on your site to download? No?—then use graphics sparingly. Likewise, eliminate splash screens that merely display your logo. Make it easy for users to navigate through your site and find the information they need.

When users land on one of your pages, it only takes them a few seconds to form an opinion of your site and what it offers. If they are not interested in your product or offering that day, you won't sell them; however, if your site makes a good impression, visitors will bookmark it and return when they are ready to buy.

BUILDING YOUR WEB SITE

Whether you're part of a team building a business site or an individual creating your own personal home page, a Web site requires commitment because your goal is to produce a quality end product.

Brainstorming Stage

Before your first brainstorming meeting, take the time to research what the competition is doing on their Web sites. Look at your competitors' home page, site design, typeface, graphics, navigational cues, and internal links. Is the information easy to find? Study their content. Is it timely and well written? Take note of what features draw you into your competitors' sites, and note down what features you don't like. Figure out ways that your competitors could have improved the site.

Look at their sites through the eyes of typical users. Can users easily contact someone on the site? Compare the design of simple sites to the design of sites that are overloaded with graphics and text. This total analysis of sites will help you determine what works and doesn't work on the Web.

If you are redesigning your site, step back and take a critical look at your overall site. Look back through your archives. Analyze your audience demographics. Ask a group of new users to navigate through your site. Make note of any problems they encounter.

After your analysis is done, it's time for a brainstorming session. Gather a small group of people (six to eight) to brainstorm ideas for your Web site. The team could include Web site developers, designers, writers, researchers, and editors. Invite a new employee to the session. That person can bring fresh ideas to the process.

To get your creative juices flowing, prop the room by posting blow-ups of the pages of your Web site (if you have one) and your competitor's Web sites on the walls. Post samples of graphics, designs, pictures, slogans, typefaces, color schemes, and any ideas that will encourage your team to limber up their creative muscles. If you don't have actual samples, write these ideas down on a white board. Sketch your ideas out on posters.

To jumpstart the creative process, use mindmapping, which is a whole-brain thinking technique that was originally developed by Tony Buzan. Mindmapping will help your team generate new ideas and make new connections. Tape a large piece of paper on the wall. In the center of the paper, draw a simple image of a Web site. If you're just developing your site, draw a square to symbolize the site. Now ask the people on your team for ideas about how you can create an innovative site. Encourage your team to offer any ideas, even if they sound outlandish. Now isn't the time for judgment. Write down keywords to represent the team's ideas.

If team members offer ideas in the form of images, draw simple pictures on the paper. Use different colored markers to highlight the keywords and pictures. Connect the keywords and pictures to your central image with lines. After the mindmapping session is finished,

work with your team to decide what new ideas you can apply to the Web site.[1]

Planning Your Web Site

Take the time to develop solid short-term and long-term plans for your Web site.

Purpose

Use the planning stage to determine the purpose of your Web site. For example, will you be selling laptops to consumers or offering online writing courses to fiction writers? The purpose of your site determines how you will present your content to users. Having a well-defined purpose in mind will also keep you on track as you create your site.

SMART Objectives

After you develop your purpose, you need to set specific objectives for your site. It helps to write a concise, clear statement describing your site's objectives. Use the SMART formula of Specific, Measurable, Achievable, Results-oriented, and Time-based. For example: "Our site will offer three online fiction writing courses during the first six months of the year." Your objectives also need to address how content creation and updating, as well as technical maintenance, will be handled over the long run. It's human nature to underestimate the time it takes to complete a project.

Target Audience

Spend some time thinking about your online target audience. Your audience determines how you will present your content. Maybe your site will cater to more than one target audience. It's important to look at your potential site design from your readers' viewpoint. Determine who your readers will be and what they will expect from your site. Are your readers engineers in high-tech companies who want fast and accurate information? Or are your readers retirees who are new Internet users? They'll need a clearly structured site and easy-to-use navigational aids. Gathering information about your audience's needs, interests, and background will help you design an effective site that meets the requirements of both novice and expert users. On a technology-oriented site, new users will benefit from hierarchical maps, frequently asked questions (FAQs), and a glossary. Experienced users

will want to obtain their facts fast; they know what they're looking for. They prefer detailed text menus over graphic menus.

Content

Define the types of content that your site will feature. The Internet is a world of niche audiences. Your content should focus on the niche that you are trying to attract. Your site could include "how-to" advice, news briefs, product information, or interactive services. The key is to offer content that will both attract your target audience and meet your own objectives without sounding like a straight sales pitch. A gourmet-cooking site could feature ongoing articles by well-known chefs, recipe archives, a food glossary, and an online store where readers can purchase gourmet food items and equipment.

To enhance usability, divide the content on your site into categories and subcategories. For example, the category of recipe archives may be broken down by appetizers, soups, salads, main entrees, bread, and desserts. Appetizers could further be broken down into subcategories of hot appetizers, cold appetizers, and quick-fix appetizers. The names of your categories and subcategories should be clear and provide readers with an accurate idea of the contents within. The phrase "just rewards" might mean dessert to you, whereas it may puzzle other readers. This is particularly true for people who use English as their second language.

Be careful not to present too many layers of categories and subcategories for your readers to click through. Each of the layers adds an extra barrier between your readers and your content. The additional layers also use up more of your readers' time, which may cause them to get frustrated and move on to the next site.

Time Constraints

After you come up with a list of great ideas for your site, determine how much time you will need to create new content and update older content. Creating content includes doing the research, writing, editing, and proofreading. If you're a one-person operation, you're also responsible for the design of your site, production process, and publication schedule. You'll need to determine if you have the available time, budget, and resources to turn out a quality site.

Plan for Growth

Look ahead and try to anticipate how your site will evolve over time. Make sure that your category and subcategory names can grow with your Web site. Will you be able to easily add new content categories? If you add too many categories, you risk confusing your readers. How

often will you update documents? How will you archive your material so that it's meaningful to your readers when they are doing a search? For example, if a reader is looking for a specific article in one of your past newsletters, the link "December 15, 2000 newsletter" is meaningless to them; however, the link "December 15, 2000 newsletter—How to Write for Intranets" becomes more meaningful to readers.

What Makes Your Site Unique?

Besides quality content, you also need to identify the valuable offering that distinguishes your site from others. In business terms, it's called the unique selling proposition (USP). Try to identify the USP that will make visitors remember and return to your site—and tell their friends to visit, too. To ensure that you continue to meet your audience's needs after your site is created, build in a feedback system. The system could include a short survey that tracks readers' satisfaction.

Storyboarding Your Site

After you have made decisions about the content of your site, use paper and pencil to storyboard each page of your site. This exercise helps you create simple and logical pages. Storyboarding will also help you define your site's navigation and links. List all the elements, such as navigational buttons, or types of documents that will be contained on each page. Begin to create headings with obvious names, such as "News Briefs," so users will know what to expect when they follow a link. Now is a good time to finalize your choice of typeface, site colors, icons, headers, and footers so your site will have a consistent look. After the storyboarding phase is complete, it's time for the designers and writers to collaborate to create the site. Writers should have at least a basic understanding of Web design principles, usability factors, and HTML coding.

WHAT'S YOUR CREDIBILITY QUOTA?

Every time users visit your site, they're putting you through a quick credibility test. Because anyone can be a publisher on the Internet and make claims, users rightfully have come to be skeptical. They want to know who you are and what you're all about. You will gain users' trust by identifying yourself, your business or organization, and your beliefs upfront.

Let users know that there are real people and an organization behind the site. On the home page, provide links to contact information so that users can ask questions, report problems, or request additional product information. Depending on the size of your organization, clearly labelled buttons could be linked to separate pages that offer users e-mail addresses for customer service, sales, editorial, job information, or other departments.

Make Readers Comfortable

Use your "About Us" page to tell users about your company's philosophy and background. Whether you're a large or a small company, steer clear of stodgy mission statements. Instead, tell users what you can do for them. Make users glad that they clicked on your site to visit. Briefly talk about the products and services that you offer. If you're a non-profit organization, you might want to list your board of directors and bylaws.

Make Communication Easy

On the Internet, users expect and want to interact and communicate with you. Encourage communication with a "Contact Us" button on your home page. This button enhances your reputation when you offer users complete contact information for your organization. You will also be showing users that you are interested in their needs. Users should be able to easily contact you if they have any questions or comments. If users can't do this, your site is defeating the interactive nature of the Web—instant communication. Don't make the blunder of hiding your contact information. This will frustrate users and possibly cause them to leave your site and never return. They'll wonder what you're trying to hide.

What Contact Information to Include?

Contact information should include your complete address (company name, street, city, state, zip code). If your company has many locations and business units, list the locations, business units, and addresses on separate pages. If you have a personal site and do not want to list your home address, include a post office box address instead.

Include any related URLs that would be helpful to users. List toll-free numbers, telephone and fax numbers, and names and e-mail addresses

of the key staff in your company with live "mailto" links. When users click on the "mailto" links, they are automatically taken to a blank e-mail message that contains the e-mail address of the designated person. Users can then type in their message or specific request.

If you merely include your Webmaster's e-mail address on your site, you risk losing valuable user feedback or business. A Webmaster's specialty is making sure that your site functions properly; he or she does not have to know the details of your products and services. Your Webmaster's e-mail box may also become overloaded, and your users then won't receive a timely response. Or your users may prefer a more personal contact from a person with a real name other than Webmaster.

To obtain feedback, you could also offer users Web-based forms. The form should be simply designed. The forms can allow users to fill in fields, such as name and address, and to choose from various options in a checklist, such as subscribe or unsubscribe. The form can also include a free-form text area where users can type in a small amount of information. Help users to fill out the form by clearly explaining what information is needed in brief sentences. For example, "Explain the error message you see on your screen." Give clear names to each of the fields, such as invoice number or bar code. Finally, test the form on users before you post it on your site. Privacy issues are still a big concern on the Web among consumers. If you require users to register their personal information before they can even explore your site, you risk losing visitors. Let users get to know your site and learn that you follow ethical business practices before you ask them to provide you with personal information.

Creating a Privacy Policy

One important way to show users that you value their privacy is to create a privacy policy and place it in a prominent place on your site. The Direct Marketing Association (DMA) offers these suggestions for privacy policies:[2]

- Keep the policy simple.
- Make the policy easy to read, easy to understand, and easy to find on your Web site.
- Promote your policy internally in employee communications. This effort will help employees answer any questions that they receive from consumers with confidence and correct information.
- Promote your policy with key stakeholders (e.g., investors, customers, contributors, and policy makers).

On their Web site, the DMA offers Webmasters an interactive privacy policy generator. The DMA developed the tool to help marketers create policies that are consistent with the DMA's Privacy Principles for online marketing. Webmasters can complete a questionnaire and create a privacy policy statement that can be posted on their own Web site. After the Webmasters fill in the questionnaire, the DMA e-mails the privacy policy statement to them for final editing and posting to their sites. To access the DMA interactive privacy policy generator, go to www.the-dma.org/library/privacy/creating.shtml.

The Organization for Economic Cooperation and Development (OECD) has developed privacy guidelines that "represent an international consensus on how best to balance effective privacy protection with the free flow of personal data." To help implement the guidelines in the electronic world, the OECD has created the OECD Privacy Policy Statement Generator in cooperation with industry, privacy experts, and consumer organizations. You can learn more about the organization and the generator at http://cs3-hq.oecd.org/scripts/pwv3/pw home.htm.[3]

Good Content Creates Credibility

Good writing that is concise and clear increases credibility. The tone of your content and the language that you use depends on your audience. If you are writing content for an e-commerce site, you would use marketing language to help sell your products; however, it's important to use informative marketing language to communicate your message instead of mere marketing fluff. The latter can weaken your credibility. Prospective buyers are looking for the facts. If you are writing content for a telecommunications site that sells equipment to large corporations, you would use the industry jargon that they understand. These corporations want to feel comfortable that you know your business and can meet their needs.

Provide Writers' Biographies

Another way to increase credibility on your site is to provide brief biographies of the writers who created the articles or reference materials. Do this by linking the writers' bylines to their brief biographies. The biographies can also contain the authors' e-mail addresses in case readers want to contact them.

Provide Reputable External Links

Providing links to other reputable sites enhances your credibility because this shows readers that you have done your research and that

you have well-rounded knowledge of your topic. You'll be saving readers time and increasing the value of your site. These efforts could result in increased traffic to your site.

Copyright Notice

Provide a copyright notice on your site and keep it updated. You will lose credibility if the copyright notice on your site states "©1998, XXX Inc" and the year is 2002.

USABILITY

To enhance usability, Web sites should be designed around the needs of the user. On the Internet, it takes only a few minutes for users to determine whether a Web site is usable. If users can't figure out how to find the information they need, they will leave and search for a new site. Web sites that are easy to navigate generate customer satisfaction and return visits. Complex navigation schemes and long download time drive users away. When users first find your site, they should immediately understand your intent. Users should be able to quickly find the information they need. Visual consistency throughout the site and good navigational aids help users intuitively learn how to use your site.

Content also contributes to enhanced usability. Make sure that you produce content that is well written, concise, and edited. Show consistency through meaningful wording of headings, subheadings, and links. Your content should also be easy to scan.

DESIGN CONSIDERATIONS

Good design means more than flashy multimedia magic. Good design enables users to interact with your site in a natural way; good design keeps readers involved and helps them reach their goals. Similar to usability, good design is based on user needs. Likewise, a simply designed site is more appealing than a complex site. The design of your site should be determined by the type of service or information that you offer. Jakob Nielsen, author of the book *Designing Web Usability: The Practice of Simplicity*, believes that sites should be structured around what the user wants to do instead of merely mirroring the company's organization chart. Your layout, graphics, and multimedia should enhance the content on a site. Use graphics, photographs, and

charts to help you tell the story. Make your pages easy to read by providing enough contrast between the text and background page. Studies show that black text on a white background is the easiest to read.

Consistency Is Key in Design

When designing your site, it's important to develop a consistent set of standards. Be consistent in the presentation of your pages. On every page, use the same layout, color scheme, and font scheme. Use the same navigation system throughout your site, and put the navigational cues in the same spot on every page.

Design for Different Users

Different users have different needs; make sure that the structure of your site satisfies the various levels of users. Some readers want to dive in, get their information, and leave. Other users, such as researchers, come to your site to feast at the buffet table.

To find out if your site is meeting users' needs, you need to watch real users while they navigate through your site. Make note of how different types of users solve problems. Watch for areas of your site that frustrate them. Identify the factors that make your site work and incorporate those changes.

WEB CONTENT ACCESSIBILITY GUIDELINES

In October 1994, Tim Berners-Lee, inventor of the Web, founded the World Wide Web Consortium (W3C) at the Massachusetts Institute of Technology, Laboratory for Computer Science (MIT/LCS), in collaboration with CERN. The Web Content Accessibility Guidelines and checkpoints were developed by the W3C as standards for Web design. The organization's goal is to make Web content accessible to people with disabilities (e.g., those who are blind or deaf); however, the organization suggests that following the guidelines will also make Web content more available to all users no matter what device (e.g., personal computer browsers, handheld wireless devices, mobile phones) they are using to access information or restrictions (e.g., poorly lit rooms, hands-free environment) they face in their environment. Adherence to the guidelines can also help users find information faster on the Web.

The guidelines were specifically written for Web content developers, which includes page authors and site designers, and for developers of authoring tools; however, the guidelines offer writers practical suggestions that can help them create clear and reader-friendly documentation.[4] For example, one of the Priority 1 checkpoints states that authors should "Use the clearest and simplest language appropriate for a site's content." Another checkpoint suggests that developers "Provide a text equivalent for every non-text element." Some examples of the latter include images, image map regions, graphics, and animations.[5] More detailed information and regular updates of the W3C guidelines and checkpoints are available at www.w3.org.

HOME PAGE

The home page is where readers get their first impression of your organization. Here is your chance to pull readers in and invite them to stay awhile. A simple home page with a limited amount of content and good navigational cues is more enticing than an overloaded home page crowded with links to internal pages. The successful search engine "Google" is a good example of clean design. Stay away from creating a home page that displays a huge graphic and an "enter" button. The large graphic only increases your users' download time, and the "enter" button requires the users to click on an extra link. There is a fine balance to creating a successful home page. Maintain a consistent style and tone by developing a home page template. Vincent Flanders, author of *Web Pages that Suck*, says that your home page should tell visitors three things:[6]

1. Site's purpose—who, what, when, where, and why
2. Type of content contained in the site
3. How to find the content

Site's Purpose

Flanders suggests that—just like a story tells the who, what, when, where, and why of its contents—your home page should tell readers what to expect when they first arrive. He compares the home page to a roadmap that tells visitors where to find important information.[7] Your home page should give visitors the answers they need in plain words, not in the language of corporate-speak or a mission statement. Tell visitors how your site can help them fulfill their information needs. Remember that people come to your site for a specific purpose.

To help visitors remember your site, you might want to create a catchy slogan that ties in with your brand name and offerings. For example, if your site is called "Gourmet-on-Wheels," your site slogan may be "Wheeling Gourmet Food to Your Front Door."

Type of Content Contained in Your Site

Your home page should also give readers an idea of the content that is contained within the interior pages of the site. Borrow an idea from the magazine world and create a simple annotated table of contents on the home page. Let readers know about articles, columns, advice, and tips within your site. Entice readers to explore your interior pages by providing clear paths of exploration. Put a "What's New" section on the home page to tell users about Web site updates, sales, new products, and breaking news. Alternately, you could set up your site like a museum exhibit, telling your story with text and images, interactive experiences, and in-depth background information.

Make Archives Work for You

Get more mileage from your older but still valuable content. Add punch to your home page by featuring a "weekly tip" taken from one of the archived documents on your site. For example, you might have a selling skills primer archived on your intranet. By featuring a weekly selling skills tip that links to the primer, you will encourage your salespeople to review their skills.

Time Short? Write Short

If time constraints prevent you from writing and posting feature articles on a weekly basis, write short articles instead. A well-written 200-word article can freshen up your site and attract readers who may be just as time-crunched as you. Use an opt-in e-mail reminder to tell readers of the article update.

How to Find the Content

Your site's structure should be easy-to-use, obvious, and logical to the user. On the home page, navigational cues should answer the question of how to find information—either through a menu of links, table of contents, or navigational buttons. Supply both graphics and text for navigational buttons to meet the needs of people with disabilities. Provide a simple search box because many users are search dominant.

Users should be able to type in a simple query in the search box. Make the search function available on every page of your site. If your users have to struggle with your navigational structure, they'll abandon your site.

STRUCTURING YOUR WEB PAGES

Certain structural elements should be built into every Web page. These three elements bring organization and consistency to your pages:

- Header
- Body text
- Footer

Header

As your page loads, the first thing visitors see is the header. The header also becomes the text for any bookmarks the reader makes to your pages, and the header appears in search engine lists. The header has to hook readers and tell them what the page is about. The header should be a concise, simply worded reminder of the page contents. Once your header hooks users, your content then has to lure them into your site.

Body of Text

The body of your text has to sparkle. Content brings new readers to your site, and fresh content makes them return. Here's where you begin to establish the look for your site in terms of your use of titles, font size, color, and formatting. Design your text so that each page can stand on its own. Do this by covering only one topic on each page. Set the page up for easy scanning. Allow for a good balance of text and white space. The use of white space can give emphasis to your content, create visual order on a page, and make pages easier to navigate. Use white space in margins, in paragraph breaks, and between titles and paragraphs.

Footers

The use of consistent navigational cues, such as footers, helps establish a specific look for your individual pages. Their use can also help

establish your site's identity. Offer a limited number of hypertext-linked features within the footer section of each page. These features could include a search function, home button, and structural links to help users understand the context of their current location on a page. Footers can also include copyright notices, disclaimers, and revision dates of documents. Strive for a good balance of information in your footers, avoiding a cluttered look.

Depending on your type of site, you may want to offer the same navigational cues at the tops and bottoms of each page to make navigation easier for your users.

KEYS TO GOOD DOMAIN NAMES

Your domain name is your Internet address, which enables users to easily access your Web site. Whether people find your domain name (URL) through a search engine or an index, your domain name may be the first impression that people have about your online presence. Try to acquire a simple domain name that is easy to remember and easy to spell. An ambiguous domain name will make it difficult to attract users.

You will get more value and recognition from your domain name if you tie it in with the name of your company. Other ways to enhance the value of your domain name are to link it with your brand name, identity, or online personality. For example, Perception® Kayaks (a division of Watermark Paddling Sports, Inc.) uses the domain name www.kayaker.com to promote its popular brand of kayaks.

Because people may see your domain name offline, make your domain name memorable so that they will visit your site the next time they are online. Make URLs short, and use simple common language. Use lowercase characters and avoid special characters.

The Internet Corporation for Assigned Names and Numbers (ICANN) is a nonprofit corporation that coordinates certain Internet technical functions, which includes managing the Internet domain name system. The latest news from ICANN can be found at www. icann.org. Obtain a domain name by visiting the InterNIC site at http://internic.net, where you can find a list of registrars.

CATERING TO YOUR USERS

To develop a successful site, you have to meet the needs of your visitors, but first you have to identify your potential visitors. You have

to determine how visitors will be using your site. Is your audience primarily teens who purchase CDs on your music site? Or programmers who visit your site for the latest news for nerds (e.g., www.slashdot. org). You also need to determine why users are visiting your site. Do they visit for the discount prices you offer? It also helps to understand user motivation and what attracts their interest. Besides selling CDs, a music site might also offer a daily gossip section on pop singers and a chance for teens to communicate with each other through a discussion board. Find out what other sites your users visit and visit these sites to get additional ideas on how to meet users' needs.

Surveys can help you better understand your users. Use surveys to find out about your audience's demographics, professional interests, leisure interests, and Internet usage. Keep the surveys short and offer an incentive such as a prize for participating in the survey. To continue meeting your users' needs, ask them what they want to see on your site through these short surveys.

Meeting International Users' Needs

As the use of the Internet grows, the number of non-English users will grow, too. By the year 2002, most Internet users will speak a language other then English. According to the independent research firm Computer Economics, by 2005, non-English speakers will account for 6 of 10 Internet users.[8] This means that Web sites will have to offer visitors the choice of viewing pages in multiple languages. Many sites do this now.

AUDIENCE RULES

On the Web, the audience is the ultimate judge of your content. If your content is or isn't working, you'll get immediate feedback from your readers—and it pays to listen.

The best way to determine if your site works is to ask a group of users, who match your audience demographics, to sit down and navigate through your site. You may not have the money to perform expensive usability tests; however, watching how people use your site—and taking notes during the process—will help you build simpler and more successful sites. In the process, you'll learn about user skills, motivations, interests, and biases. Create opt-in e-mail surveys and conduct polls on your site to measure user satisfaction. You can create

an opt-in e-mail list by asking users who visit your site if they agree to receiving e-mails from you.

FREQUENTLY ASKED QUESTIONS (FAQ): BASIC GUIDELINES

Add value to your Web site by developing a list of frequently asked questions (FAQs) on a separate page on your site. The purpose of an FAQ page is to answer common questions that users may have about your business, organization, products, services, or site. An FAQ page may also appear on customer support sites, training sites, discussion lists, and newsgroups sites.

Think of the page as a quick-reference guide for your users. The page can also summarize important information for new visitors, as well as help inexperienced users who are new to the Internet. By proactively providing answers to common questions, you will also save yourself and your staff the time of individually responding to e-mails from visitors.

Developing FAQs

Here are some basic tips to consider when creating an FAQ page:

- *Title your FAQ page.* At the top of the page, create a title for the FAQ page that describes the contents that will follow. For example, "XYZ Cell Phone FAQ."
- *Introduce your FAQ page.* Give a brief introduction of the overall subject of the FAQ page before you list the individual questions and answers. This gives readers an idea of the scope of your list.
- *Keep it simple.* The FAQ list should be a simple, brief resource for your users. Limit your list to one to two pages in length. Make your list easy to scan.
- *Limit your questions and answers.* Limit your list to 5 to 10 questions and answers. This tactic will make your list easier to read.
- *Develop a logical order.* Arrange the questions in a logical order for the user. You might list the simplest questions first, followed by the most complex questions. Alternately, you could list the most frequently asked questions first and then the less frequently asked questions.
- *Create grammatical questions.* Create grammatical questions (e.g., Who do I contact for service on my wireless phone?).
- *Make your questions stand out.* Differentiate your questions from your answers by using a bold or larger font for your questions.

- *Make your list easy to read.* Add a space between each question and between each answer to enhance readability.
- *Be concise and clear.* Write concise and clear questions and answers. Attempt to keep questions to one line of text. Answers should be written as brief paragraphs. Your answers should provide readers with concrete information.
- *Edit for clarity.* Edit your page, eliminating wordiness and unimport-ant FAQs.
- *Accuracy is important.* Double-check your facts and figures. If you present incorrect information, you'll lose credibility in your customers' eyes. Revise any FAQ information when facts change on your site, or within your company or organization.
- *Eliminate industry lingo.* Avoid abbreviations and industry jargon, which your users may not understand unless your target audience belongs to a specific industry.
- *Meet the users' needs.* Develop the FAQs from a user's viewpoint. Analyze the e-mails and phone calls that you get from users. What are the users' most common questions? What information do they need? If you are introducing a new service, determine the facts that users will need to know about the new service.
- *Provide reader-friendly formatting.* Place your questions at the top of the page in a menu format and hypertext link the questions to the corresponding answers. Avoid presenting the entire question as a link; this makes the questions more difficult to read on the screen. Instead, create a link from a keyword or phrase within each ques-tion. Provide links from each answer back to the top of the page. To provide context as users scroll up and down the page, put the same number for each question and answer pair (e.g., question, 1. Who do I contact for service on my wireless phone?; answer, 1. Contact 1-800-555-1234).
- *Make it easy for readers to contact you.* On the FAQ page, encourage readers to contact you with any additional questions by providing a live link to an e-mail address. If suitable, include links to outside companies or sites that you named and to the support group within your company.
- *Keep it timely.* Put a date (month, day, year) on the FAQ page. When you update the page, add the date of the last revision. It's important to regularly update the list to reflect changes that have been made in your organization, company, products, or services. With the ongoing demands to provide fresh content on a site, it's easy to neglect or forget the seemingly smaller issues like FAQs; however, keeping your FAQs updated will enhance the value of your information in your customers' mind. Therefore, put a regular schedule in place to keep your FAQ page updated.

FAQs for Large Corporate Sites

FAQs on a corporate site are usually more involved than the short list of questions and answers found on smaller company sites. Because a corporation serves many audiences and can offer many products and services, the list may need to be divided into natural categories of questions. Categories might include different business units, product groups, or product applications. Each category should have a descriptive title and an overview that links to the appropriate, numbered questions and answers. On more complex FAQ pages, the answers may then even link to additional information. These types of FAQ pages require careful maintenance because all details and links need to be checked on a regular basis, and the content has to be updated often to reflect changes.

Use Your FAQ Page as a Marketing Tool

Use your FAQ page as a marketing tool to encourage potential customers to contact you with further questions about your products and services by including your sales department's e-mail addresses and toll-free number. Offering this option may result in new sales.

LINKS POWER THE INTERNET

The Internet is essentially a world of links. The Internet's basic design enables any document to link to and be linked from any other document. Links are the power behind the Internet, whether they appear in articles, navigational buttons, banner ads, or a search engine listing. Clicking on links easily shuttles users from one place to the other on the Internet; however, links are only as good as the content they link to. The internal and external links in your site have to lead to content that is useful, relevant, and current if you want users to visit and return to your site.

Writing Links to Inform Readers

Links on sites should be written so that they describe the content of the page they lead to. Unless you provide the proper context, users don't know ahead of time if they are going to a personal Web page or

a business site. If it isn't possible to adequately describe the page within the confines of the link, then a short descriptive blurb should appear below the link. Users choose links based on their expectations of what the page will reveal to them. If the link is not descriptive or is vague, users will make an incorrect choice and lose confidence in your content. When developing terms for your links, test the terms on users. This effort will help you determine if the terms mean the same to users as they do to you. Ask your users how they would label your links.

Avoid Link Rot

Once you put a page on the Web that regularly attracts users, you must keep it there indefinitely; removing the page will cause "link rot." Try not to move popular pages in your site. These pages could still be showing up in search engines, or other sites may still link to these pages. Your users may have bookmarked these pages as their favorite section on your site (e.g., a list of annotated links). If you move pages, users will then encounter broken links, which will make your site appear less credible. If you are a business, you could also lose potential revenue. If you have to move links, create a redirect page that will automatically send users to the new location of the document.

CONTENT GARDENING

Old content can still be valuable to users as an historical reference or for background information. Jakob Nielsen suggests that because old content can continue to get hits over a long period, it behooves a company to employ a "content gardener" to maintain the content. This person's job is to edit, update, and remove outdated content so the older material still offers valuable information to users.

You can enhance old content by freshening up the links with more current background information. Alternately, you may want to revise your old content based on reader feedback that you received after the original publication of the content. Not only will you be adding value to your content, but you will also be showing readers that you're interested in and listening to their opinions.

The bottom line is that content gardening adds value. Compared to creating new content, doing content gardening also saves you time and money. After you have updated old content, put the revision date (month, day, year) on the document.

ONLINE GLOSSARY

An online glossary can help Internet novices and new users understand the terms you use on your Web site. Depending on your type of organization, a glossary can include technical terms, medical terms, unfamiliar definitions, abbreviations, acronyms, and jargon.

By providing a glossary, you only need to define an unfamiliar term once on your glossary page. You should link any unfamiliar terms within a document directly to the definitions in the glossary page. You should also provide an easy way for users to return to the document they were reading. Avoid putting too many glossary links in your document or your users will be distracted. You might want to add a glossary button at the bottom of each page so users have easy access to the glossary page. Within your glossary, you can cross-reference links to other terms.

KEEPING CONTENT CURRENT

Keep content current. In an issue of *CIO Web Business* magazine, Scott Kirsner says that on the Web today, "Stale equals fail."[9] What does old content say? Stale content tells readers that your site isn't important to you or to them. Stale content says that you put up a Web site and then walked out the back door to pursue other more interesting endeavors. Updated sites send a positive message to readers: These sites tell readers they care about them and they are actively engaged in the Internet. Keeping updated isn't easy, but it helps retain readers.

Refresh Strategy

Web sites should put a "refresh strategy" schedule into place. You should decide how often your Web site needs to be updated. The answer depends on the type of site you maintain (e.g., a business site, nonprofit association, or personal site). Figure out the costs and advantages of updating your site, too. Then decide how often you can reasonably make updates.

Determine the resources that will be responsible for regularly updating your site. Will you update the site? Or will another department in your company or an outside agency do the updating? Set up a regular schedule to determine when the updates should take place and in what sections of your Web site. Let users know of updates through an opt-in e-mail newsletter, "What's New" page, and by putting a notation on each updated page, such as "revised on March 3, 2001."

MAKING YOUR SITE MEMORABLE

Debbie Macinnis, Associate Professor of Marketing at the University of Southern California, says that customers remember your site in two different ways—through recall and recognition.

She suggests that you use specific tools to strengthen customers' memory of your site. Academic research indicates that people tend to remember the first and last items they see in a sequence better than the content they see in the middle. She suggests that online consumers will more likely remember the first and last pages they visit on your site compared to any of the other interior pages. This is why the first page of your Web site is so crucial.

Because people also tend to remember information better in short chunks, Macinnis says Web addresses are more memorable if the name itself creates a chunk that tells what the site is about. She gives the example of www.cdnow.com.

Macinnis suggests that information is recirculated through your short-term memory when you see it repeatedly. She says that if you want people to remember your Web address, use the process of recirculation by repeating your Web address many times on your site.

Macinnis claims that psychological research shows that people remember things better when they are represented as pictures. To ensure that people remember your message, use both pictures and words to get important points across to readers. This "dual coding" in the visual and verbal mode provides people with two ways of remembering your message.

Macinnis suggests that mood can also affect people's memory. Being in a good mood can help us remember things. By making your site interesting and fun, there's a good possibility you will affect people's mood and cause them to come back for repeat visits.[10]

Create a Web Site Personality

Charles Sayers believes that behind every great Web site, there's a great personality. Inject more fun and interest into your Web site by pumping your pages with positive personality. The personality could be a real person or a fictional character. On the Ragu Web site (www.ragu.com), visitors meet Mama Cucina and are invited into her kitchen, where they can look into her cookbook and find Italian recipes. They can also learn about Mama's secrets and visit a dining room and family room. Contests, video games, and a newsletter complete the fun.[11]

INCREASING SITE VISIBILITY WITH AN OPT-IN E-MAIL NEWSLETTER

New visitors may find your site through search engines or through links on other sites, but what can you do to turn these new users into repeat visitors? You can attract repeat visitors to your site by offering them opt-in e-mail newsletters.

Benefits

E-mail newsletters give you an opportunity to remind readers of your site. E-mail newsletters are also an inexpensive and effective way to tell visitors about new content on your site, new products or services, policy changes, or special offers. With e-mail newsletters, you can show readers that you are interested in building a relationship. An e-mail newsletter delivers a service to readers that is based on their interests because they opted to subscribe in the first place.

Creating E-Mail Newsletters to Complement Your Site

To succeed, e-mail newsletters have to offer value to readers. Tailor the material in each issue to your readers' interests. Think about the content that first brought readers to your site. Build and expand on this content in both your site and your newsletter. If your content contains primarily disguised sales messages, you'll turn readers off—readers don't like spam. Likewise, overloading people's e-mail boxes with multiple issues will cause readers to click on the unsubscribe link. Set up a regular publication schedule such as a weekly or monthly release.

Writing the E-Mail Newsletter

Take care in writing your content. Avoid sloppy writing and editing, poor grammar, and typos. Devote the same energy and attention to developing your e-mail newsletter that you give to writing the content for your site. Writing an e-mail newsletter is a lot different than typing up a quick e-mail to your friends. Think of your e-mail newsletter as an invitation to readers to learn more about your site and you'll attract a lot more visitors. Take the time to print out a hard copy of your e-mail newsletter and proof it thoroughly before sending it out.

Entice users into reading your e-mail newsletter by writing an appealing but informative subject line. The subject line should sum

up the main topic of the current issue (e.g., "Create Gourmet Lunches to Go").

Your e-mail newsletter should be brief and concise. Present just a few articles and keep each article to about a short paragraph in length. Give readers the option of reading the complete article by providing a link to each article in the appropriate section on your site. You should also provide a link from the e-mail newsletter itself to your Web site.

Provide Structure

Enhance the readability of your e-mail newsletter by putting a table of contents at the top of the newsletter. Readers can then see at a glance what information will be covered. Adding a space between paragraphs also makes reading easier.

Develop a standard header and footer to begin and end each newsletter issue. Your newsletter header should contain your affiliation and Web site URL. In the header, remind readers that they chose to subscribe to the e-mail newsletter. In the footer, include instructions so that readers can easily subscribe and unsubscribe from the newsletter. Add copyright information in the footer. Because readers have different e-mail software and capabilities, offer readers the choice of receiving a plain text or HTML e-mail version of your newsletter. More detailed information can be found in Chapter 12, "E-Mail Newsletters and E-Mail–Based Discussion Groups."

BUILDING ON THE INTERACTIVE NATURE OF THE WEB

The Web is a dynamic medium. Take advantage of its interactive nature by providing easy ways for users to provide you with feedback. Give users incentives to visit and to get involved on your site.

Feedback

Because the Internet is an interactive medium, it's important to provide different ways for your readers to respond to your article or Web site. Readers can provide you with new ideas, suggest areas on your site that need improvement, and tell you what works and what doesn't work. Listen to readers when they let you know of dead links or typos, or when they suggest new features. Quickly correct any

problems and thank readers for their time. Encourage reader questions and respond with thoughtful answers. Your responses will help you gain repeat visitors. Make feedback easy by providing a live e-mail link and a simple form for users to fill out.

Interactivity

Involve users on your site and you'll get more hits. User response offers readers the chance to participate in the creation of a Web site and to help shape the site to better suit their needs and interests. Invite conversation by seeding your discussion forums with questions and challenging debates. Tap into readers' interests by listening to their online conversations and take part in their communities—they will then become even more involved.

Live chats can increase your traffic in many ways, through prechat promotion efforts, the chat itself, the posting of the chat transcript on your site, and postchat discussions on bulletin boards.

Include interactive databases, online polls, and quizzes. Allow visitors to share information with each other through electronic "post-cards." Encourage user communication through community group pages, sharing of user success stories, Weblogs, contests, and online surveys. Provide authors' e-mail addresses and article feedback mechanisms so users can comment on articles. Offer e-mail mini-lessons on specific topics (e.g., crafts or writing).

Stickiness

Build a sticky Web site. Your users might linger a bit longer on your pages and return more often for visits. Sticky Web sites attract new and repeat visitors. Repeat visitors save you time and money because you don't have to spend additional efforts or revenue to attract new and replacement visitors. Sticky sites can also attract potential advertisers. So how do you get sticky?

Sticky Content

High-quality, unique content that changes often can increase your sticky factor. A substantial amount of content on a site also creates stickiness. Providing an easy-to-navigate site will also increase your sticky quota because users will be able to easily find your content. Enhance the value of your content by first determining your users' interests and needs—then tailor your content to meet those needs and interests.

To produce great content, you also need to develop a strategic plan and provide adequate resources to carry out that plan. Track the number of hits that your different forms of content are getting. If a certain document is receiving a high number of hits, regularly update that document and use it as a template to spin off other variations. Through opt-in e-mail alerts, let readers know when these documents are updated or new ones appear.

Sticky Community

By creating community on your site, you will increase traffic. Create community among people with similar interests by encouraging them to connect through bulletin boards—and they'll come back for more. In addition, these active communities will draw even more visitors. To increase visits to your site, send automated e-mail alerts to people who have posted messages on bulletin boards whenever someone posts a note in response to them. To increase repeat traffic, you can also ask users to sign up to receive e-mail updates whenever the content of your site is changed. Listen to what your users say on the boards, and adapt your site to meet your users' needs. Let your users drive the development of your site. Allowing users to respond to specific articles with their own opinions also encourages community. Offer personalization so that users can customize the site to meet their needs and interests.

Become User-Centered

Become user-centered by analyzing your audience demographics, user surveys, e-mail feedback, and users' writing and language style in discussion groups. Regularly ask users what information they need and how you can improve your content. Respond to user feedback to show you're listening, and make the changes that are requested.

Measure the stickiness of your site through cookie-based Web traffic software and log file analysis. Prudently gather information on customers' interests, demographic profiles, and geographical locations to help you plan a more targeted site.

QUALITY COUNTS

The goal of your Web site should be continuous improvement. Regularly test internal and external links on your site to make sure they are in working order. Increase the value of your content in your readers' mind by providing the date of a page's last revision. Readers will know that you care enough to regularly revise your content and to offer them the most current information. Make it easy for readers to

respond to you if they have questions or need additional information on your site or offerings. Print your documents out and proofread them for accuracy; better yet, have your documents professionally edited. Run your documents against the Editorial Checklist that is provided in Chapter 8, "Editing Web Writing."

WEB SITE CHECKLIST

Use the Web Site Checklist to ensure that you have created a reader-friendly site.

- Have you analyzed your competition?____
- Development of a solid Web site plan (includes purpose, objectives, target audience, content, time constraints, plan for growth, unique selling proposition)____
- Storyboard your site____
- What's your credibility quota?____
- Usability factors____
- Design considerations____
- Web content accessibility guidelines____
- Rate your home page____
- Good structure of Web pages____
- Does you domain name communicate?____
- Are you meeting users needs?____
- Assess your Frequently Asked Questions (FAQ) page____
- Do your links add value?____
- Content gardening schedule____
- Glossary____
- Is content current?____
- Is your site memorable?____
- Does your site have personality?____
- Are you taking advantage of opt-in e-mail newsletters?____
- Is your site interactive?____
- Quality assessment____

ENDNOTES

1. Wycoff, Joyce. *Mindmapping: Your Personal Guide to Exploring Creativity and Problem-Solving* (New York: Berkley Books, 1991), p. 43.

2. "How to Construct Your Privacy Policy," The Direct Marketing Association (DMA), www.the-dma.org/library/privacy/creating.shtml. Accessed June 23, 2001.

3. "What is the OECD Privacy Statement Generator?" The Organization for Economic Cooperation and Development (OECD), http://cs3-q.oecd.org/scripts/pwv3/pwh ome.htm. Accessed June 24, 2001.

4. "Web Content Accessibility Guidelines 1.0," W3C Recommendation 5-May-1999, www.w3.org/TR/1999/WAI-WEBCONTENT-19990505. Accessed February 25, 2001.

5. "Checklist of Checkpoints for Web Content Accessibility Guidelines 1.0," www.w3.org/TR/WAI-WEBCONTENT/full-checklist.html. Accessed February 25, 2001.

6. Flanders, Vincent, and Michael Willis. *Web Pages that Suck: Learn Good Design by Looking at Bad Design* (Alameda, CA: Sybex, 1998), pp. 22–23.

7. Ibid.

8. Get Ready for Non-English-Speaking Web Users, Global Update—Internet, Computer Economics Independent Research Firm, Target Marketing, September 1999, p. 30.

9. Kirsner, Scott. "Stale Equals Fail," *CIO Web Business Magazine*, March 1998, www.cio.com/archive/webbusiness/030198_main_content.html. Accessed October 26, 2000.

10. Macinnis, Debbie. "How to Make Your Web Site More Memorable," internet.com, December 7, 2000, www.internetday.com/archives/120700.html. Accessed January 10, 2001. Reprinted with permission from www.internet.com. Copyright 2001 internet.com Corporation. All rights reserved. internet.com is the exclusive Trademark of internet.com Corporation.

11. Sayers, Charles. "Personality," ClickZ.com. Reprinted with permission from www.internet.com. Copyright 2001 internet.com Corporation. All rights reserved. internet.com is the exclusive Trademark of internet.com Corporation.

Chapter 4

Navigation Cues

We have come to expect a certain degree of order when we read print documents. The layout and pages of a book provide us with a set of context, and the table of contents provide us with organization. As you read a book, you turn the page to continue reading. You fold down the corners of pages or insert paper bookmarks to mark your place in the book. In the print world, you can easily turn back to a page or section of special interest.

On the Web, however, readers do not have any of the physical cues that a book conveniently provides to help them assess information. Navigation is difficult. When users click on hypertext links and graphics, the link may take them to a site that is halfway around the world or to documents that are buried deep within your own site. Before readers make that click, they don't know how much information to expect from the resulting link or how relevant this information will be to their needs. They don't know ahead of time if they are going to a personal Web page or a business site.

Users can easily lose sense of where they are on the Web and where they've been. That's why it's important to provide them with consistent, clear navigation cues to keep them on track and help them recover their orientation if they become lost on your site.

SITE NAVIGATION

The main purpose of good navigation cues is to provide readers with the most user-friendly path that will give them the information they need. This means that both your site design and document design

should be based on your users' needs. Jakob Nielsen's research suggests that people are not searching on the Web—they are problem solving. People have specific information needs and they are looking for answers. To provide users with a reader-friendly Web environment, Nielsen believes your site should immediately answer these three navigation questions:[1]

- Where am I?
- Where have I been?
- Where can I go?

Where Am I?

Nielsen believes that the most important navigation question for users is "Where am I?" Users will not be able to understand the structure of your site unless they understand where they are. Readers need to know how their current location fits into the site's structure and to the Web itself.[2] Navigation cues, such as identifying your site with your logo on every page, brings a continuity and theme to your pages.

Take time to develop a distinctive and consistent look for your home page and for the interior pages of your site. There should be a meaningful title at the top of each interior page so readers know what to expect from the content. For example, the title "How to Write Humorous Greeting Cards" tells readers that the article is a how-to piece on a specific type of writing genre. Visitors may enter your site at one of your interior pages; therefore, you must include links to your home page on every page of your site.

Where Have I Been?

Because of the virtual nature of the Web, it becomes more of a challenge for users to track their history trail. The usual navigation buttons such as the "Back" button takes users back to the previous page. The "History List" provides users with a list of recently visited pages or sites. In the past, hypertext links to pages that had not been visited by users were usually blue; links to previously visited pages showed up in purple or red. This consistent change in colors helped users track their steps on the Web; however, as the Web continues to evolve, the colors of visited and unvisited links differs depending on the Web site you are viewing. Therefore, it's important to use standard link colors on your site. Users depend on link colors to remember what sections of the site they have or have not visited.

Where Can I Go?

Users naturally look for structure and pattern on the Web. "A consistent approach to the titles, headlines, and subheadings in your documents will aid your readers in navigating through a complex set of Web pages." For example, you could provide consistency through font size, style, or color.[3] Users should be able to intuitively follow the scent and learn the flow of your site. Provide a consistent format and predictable navigation cues throughout your Web pages. Include keywords and links that let users know they are on the right track. Navigation cues should answer the question of how to find more information.

NAVIGATION GUIDELINES

Every navigation cue you use should have a consistent look and location. For example, readers are used to seeing a logo in the upper left-hand corner of a screen. If you place a menu down the left-hand side of your home page, consistently place this menu in the same spot on each of your interior pages. These practices help readers orient themselves. Make navigation painless; users should be able to get their information in as few clicks as possible. Global navigation cues should be placed at the top and bottom of each page.

Table of Contents

A clear, well-organized table of contents, index, or menu can effectively display your site's content and organization. This hypertext-linked table, index, or menu can also serve as a navigation tool for users. A text-based table of contents for a complex site is more efficient than a graphical search map because these maps provide only a limited representation of the contents of the site.

Hypertext Links

On a Web site, navigation cues in the form of hypertext links point users to places to go within your site as well as outside your site. Hypertext links allow users to determine their own paths through your Web site. Therefore, it's important that you offer:

- Strong navigation support for both novice and expert users
- Shortcuts to popular information
- Links back to your home page

The links should clearly communicate what content they link to.

Grouping Hypertext Link Choices into Categories

Grouping hypertext link choices into categories will help users better understand the nature of the links and aid in scanning (e.g., appetizers, entrees, desserts). Make sure that the link communicates its message so that readers will know what to expect when they go to the resulting page. Avoid terms such as "Section Two," "Next," "Forward," or "More." Keep users informed with navigation feedback such as page headings, which help users know where they are in your document. Do not overload your pages with navigation choices. Users will stop reading after they see four to five choices.

Search Engine

Provide a search engine on your site so users can control their own exploration. A search engine can also help users locate specific information they are looking for and enhance navigation support. Because you cannot predict when a user will get lost on your site, it makes sense to provide a search capability on every page or to at least offer easy access to the search function.

New Updates

Let readers know when you have updated sections of your site by placing a "New" icon next to each new item. If you have a complex site, you may want to place a "What's New" link on your home page. The link can take readers to a page that tells them about all the newest changes on your site.

Archives

Provide archives, such as past issues of your newsletter, for readers who might want to research information or get more detailed facts on a subject. Provide a link from your home page or site map to the

archives. Provide descriptive information for each linked item; otherwise, the link becomes meaningless. For example, a reader would have to click on "Issue # 1—January 1, 2001" to find out what that issue covers. By providing brief descriptive information, "Issue # 1—January 1, 2001—How to Tighten Up Your Writing," you'll save readers time and frustration. Arrange the list of archives in descending order, with the most recent entries at the top of the list.

Navigation Icons

If you use navigation icons (symbols) on your site, use the same consistent icons throughout your pages. These icons should be universally recognizable. Most likely, not all of your readers are from the United States. Make sure these icons communicate your message clearly; it helps to add text underneath the icons.

Create a Reader-Friendly Site

Your readers should have a pleasant experience when they visit your site. Use dark type on a light background; this technique makes it easier for users to read. Eliminate excess or large graphics, confusing navigation bars, garish colors, and busy backgrounds that may muddy your message. To get an idea of what doesn't work on the Web, visit a wide variety of sites and study their pages. A visit to Vincent Flanders' "Web Pages That Suck," www.websitesthatsuck.com, can also provide you with excellent tips.

DESIGNING FOR DIFFERENT USERS

Design your site keeping in mind the needs of both novice and frequent users. For example, make the site easy to navigate so novices don't get lost. Provide new users with overviews, hierarchical maps, tutorials, and clear and consistent navigation aids. A glossary, acronym definitions, and a list of FAQs can also help first-time visitors. Users will give up if they encounter delays or difficulties. Users may not have the fastest connection or state-of-the-art browsers, so large graphics, for instance, can increase download time. Design your site so that expert users can easily move through your site and find the specific information that suits their needs. Use surveys or focus groups to ask both new and experienced users for feedback.

STORYBOARDING THE NAVIGATION PATHS ON YOUR SITE

After you gather and define all of the content for your site, storyboard all of the site pages. This tactic allows you to think through the navigation cues that will be needed on your site, such as headings, navigation buttons, menus, links, and specific functions like search engines. For every page, define the content and navigation cues. Your goal should be clear and concise navigation.

NAVIGATING WITHIN A DOCUMENT

Because readers can access any part of your document directly from a search engine or some other site, your online writing does not always have a definite beginning, middle, and end. Online media is nonlinear. This requires that you develop documents by looking at your writing from the readers' point of view. You will need to write in small chunks of content. Each chunk of writing has to stand on its own, and each chunk should cover a specific idea or topic. More information on how to write content can be found in Chapter 7, "Writing Content for the Web."

NAVIGATION CHECKLIST

- Do your pages have a consistent and distinctive appearance?____
- Look individually at your site pages. Does your content still make sense if users see each page out of sequence? Out of context?____
- Does each chunk of content cover a specific topic?____
- Have you used a logo to identify the name of your site on each page?____
- Does the user know where they are within your site?____
- Is each page dated?____
- Did you choose universally recognizable icons?____
- Whether symbolic or realistic, are your icons, buttons, and graphics clear in meaning, and consistent, and do they reinforce the theme that you selected?____
- Did you put a meaningful title at the top of each interior page?____
- Are your titles, headings, and subheadings consistent?____

- Did you place global navigation cues at the top and bottom of each page?____
- Does every page have a link back to your home page?____
- Do your links clearly communicate their messages so readers will know what to expect?____
- Have you provided a search function on every page?____
- How will you let readers know of updates to your site?____
- If you provide archives, are they easily found?____
- Did you design your site to benefit both novice and expert users?____

ENDNOTES

1. Nielsen, Jakob. *Designing Web Usability: The Practice of Simplicity* (Indianapolis, IN: New Riders Publishing, 2000), pp. 188–189.
2. Ibid.
3. Lynch, Patrick, and Sarah Horton. "Page Design," *Web Style Guide, Yale Style Manual*, Editorial Style, http://info.med.yale.edu/caim/manual/pages/editorial_ style.htm. Accessed May 3, 1999.

PART TWO

Turn Your Writing into Online Success

Chapter 5
A Primer on Search Engines and Research

The Internet has changed the way that writers research and write. Today, writers only need to tap in a few keywords in a search engine box and the convenience of a global digital library appears on their screen. Writers can access government sites, universities, associations, and experts in other countries, and do extensive research. Even the Library of Congress offers online research via e-mail. To benefit from Internet technology, writers need to stay current and seek out and experiment with new search engines. They need to learn the details of how each search engine works. Writers should use the many free search engine tutorials available on the Web. Writers should also subscribe to mailing lists that focus on search engine technology.

SEARCHING SMARTER: THE BASICS

In a few seconds—and with a few keystrokes—search engines can help you locate reference information for those articles or documents you are working on. You save the time of trekking down to the library or bookstore and coming back loaded down with books. But if you're new to the intricacies of specific search engines, they can cause you frustration when that same speed brings up thousands of irrelevant results. Although it may seem more convenient to use the search engine that automatically appears on the home page of your Internet service provider (ISP), it might not fit your specific needs.

No one search engine can provide you with all the answers because each search engine covers only part of the Internet. Because each search engine will most likely yield different results, it's in your best interests to use several search engines to do your research. Through experimentation, experience, and time, you'll find out which search engines yield the best results for your work.

Read the Search Engine Instructions

You'll save time by first reading the instructions that accompany most of the search engines online. That step will help you learn about what each service offers. Although the basic instructions are similar, the subtle variations can affect your query results. Every search engine has a specific set of instructions for advance searching and different tools for word and phrase searches. These optional tools often give you more control when you conduct a search. You'll find the information posted as "live links," "buttons," or "tabs" on the front page of the search engine site. Look for words like "advanced search," "FAQs," "help," or "custom search." Depending on the type of search engine, the site might also prompt you to look for "all the words," "any of the words," "exact phrase," or "page title." By getting to know each search engine, you'll find one or two search engines that best meet your needs.

Check the Search Engine's Default Settings

Many search engines appear with automatic default settings such as "all the words." Before you perform a query, check the advanced page section on the search engine site and look at the automatic default settings. Determine if the automatic defaults meet your research needs. If they don't, change the defaults or try a different search engine.

Determine Your Search Objective

Let's say you need to write an article on a specific topic. Before you begin your search, think about your objectives. What do you want to accomplish? Locate the latest research findings on Alzheimer's disease so you can develop a distance learning course for pharmaceutical sales representatives? Retrieve an extensive amount of information on online marketing for a series of articles for sales managers? Write down your objectives on paper. What keywords can you identify in your

notes? Use these keywords and any applicable synonyms to begin your search query. To help you begin the process, use the "Topic Worksheet" at the end of this chapter to guide your presearch analysis.

Expand Your Thinking

Think about the possibilities of your topic when you're performing your online search. What different ideas can you come up with when you apply the "who, what, where, why, and how" to your search efforts? For example:

- Who are the well-known experts I can interview?
- What is different about my topic?
- Where can I find the most cutting-edge research on this topic?
- Why would people be interested in this story?
- How can I bring a new angle to this story?

Add Keywords

If your first search turns up 10,340 hits on a topic, refine your search by adding additional keywords or phrases to your query. Put your most important keyword first (e.g., "laptop wireless" if you're searching on a set of two or three keywords).

Search for Specifics

Doing a search on general terms will result in thousands of sites being retrieved. For example, if you ran a search on the phrase "eating disorder," you would receive an overwhelming number and assortment of responses. Instead, use more specific terms. If you narrowed your search down to "anorexia eating disorder," you would receive more targeted results. Adding another word to the phrase will target your search even further (e.g., "teenager anorexia eating disorder"). Experts suggest using nouns and objects as search terms. You'll get better results.

Check Your Spelling

Overwhelming workloads and tight timelines can cause us to misspell even simple words. If you start coming up with irrelevant results, check the spelling of your words. Think about alternate spellings for

words. For example, the word "color" can also be spelled "colour" depending on your country of origin (the former is American, whereas the latter is British). There can also be various names for the same item, such as "purse," "pocketbook," or "handbag."

Addition and Subtraction Simplicity

Use simple addition (+) and subtraction (–) symbols to refine your search results. Either add the (+) or (–) symbols in front of keywords to tell the search engine which words must or must not appear in the final pages. Do not add a space between the symbol and the keyword. These tips will work with most search engines using their basic search options. For example, you might want to find pages that have references to both Victorian and novels on the same page. Type in the words "+victorian +novels." When you want a search engine to find pages that contain one word but not another (e.g., information on coins, but not from the Roman era), type "coins – Roman."

Boolean Searching

Boolean search commands are similar to search engine math commands. The major search engines can accommodate both types of commands. Danny Sullivan, of *Search Engine Watch*, suggests that both new and professional searchers benefit from using primarily search engine math instead of Boolean commands.[1]

If you decide to use Boolean operators, learn how to use them to increase your search success. The inclusion and exclusion of search terms are as important as knowing what you are looking for. If you add or eliminate keywords, you will decrease your search time and the amount of irrelevant data you receive. All Boolean commands should be typed in caps (e.g., OR, NOT, NEAR, AND).

The Boolean "OR" command tells the search engine to find one term or the other on a Web page. The "OR" command is most useful when the same term appears in two different ways on a page. For example, enter "NHL OR national hockey league." The Boolean operator "NOT" tells the search engine to find the first word but not the second word on a page. For example, enter "Clinton NOT Hilary." The Boolean "NEAR" command specifies how close words should appear to each other. The command "NEAR" appears only in some search engines. For example, enter "Monet NEAR Impressionism."

When you add the Boolean "AND" to your query of keywords, it instructs the search engine to find these exact terms on the same page.

For example, let's say you enter "marketing AND selling." Many search engines automatically "AND" all of the words in your query together. The result is that only pages that contain all of your query words will show up as potentially relevant. You may be missing pages that could help you in your research.[2] Check your search engine to determine if it does automatic "ANDing." As an additional research step, try substituting other synonyms for your keywords and search on different search engines to find the information you need.

Wrap Your Phrase in Quotes

Use double quotation marks (" ") around phrases if you want the words to appear in exactly the order that you requested. If you want to run a search on an exact phrase, such as a song, enclose the phrase in quotation marks. One example is the song "St. Louis Blues." Otherwise, some search engines will bring up pages that don't include all the words in your phrase.

Wildcards

Use the wildcard character "*" to search for plurals or variations of words. This technique is also good if you don't know the spelling of a word. For example, type in "dance*" and you will find words like "dancing" and "dances."

"Stop Words" List

Determine if the search engine maintains a "stop words" list. Stop words, such as "and," "in," "the," "a," "or," and "of" are often ignored by search engines. If the search engine maintains such a list, don't put known stop words in the search box. Some search engines allow you to search "stop words" if you surround them with "quotes" or enter a "+" sign immediately in front of the word. You could also do your search on another engine that does recognize "stop words."

Type in Lowercase

Type phrases and keywords in lowercase when seeking both lower and uppercase versions of words. Sometimes, typing capital letters will return only an exact match.

Researching the Results Page

Typically, you might do a search on a keyword or phrase, check out the titles on the "results page" of the search engine, and then move on to the next search engine. Next time, try a different approach. Study the information that accompanies each of the titles on the "results page." Does the information provide you with any clues that can help you in your research? Scroll up and down the results page. Are there other sections that offer additional information? Check the following areas: "definitions," "more results" section, "category," or "related categories" section, "second opinion," "cached" links, and "similar pages" section. A little investigative work on your part may yield more gems. You'll also be learning more about the ins and outs of search engines.

Seek Out Similar Successful Sites

Let's say you get another assignment in your niche and you want to find new sources of information. To increase your search success and find additional Web sites, analyze those sites that have helped you in the past when you worked on other similar writing projects. For example, when you wrote an article on interior decorating, maybe you found a site that contained articles and columns written by well-known experts. Go back to that site. Check out the site's annotated links or "What's New" section to locate more resources for your article. Read the site's updated articles. Check the biographies of new authors; they might lead you to new reference sources. Look at the words used on the site. Can you identify certain words cropping up repeatedly? Are there any new trends? Do a search on these words in your favorite search engines. All of this work may help you find new sites for your current assignment.

SEARCH SERVICES

Each search service catalogues its data differently. Search services either automatically crawl the Web looking for pages (i.e., they look through a database of Web pages that has been cataloged by robot programs that follow links) or they are directories that use human editors to collect their listings. Many of the search services use a combination of crawler-based and directory information.[3] To gain the most benefit from online research, writers should seek out and experiment with a variety of search services.

Working with Search Engines

With search engines, you type in keywords and phrases to find information on the Internet. Some search engines also allow you to type in questions. The search engine then queries full text pages that are stored in a database. Search engines are more helpful if you are seeking comprehensive information on a subject.

One of the best search engines is Google (www.google.com), which is clean and fast and delivers relevant results. Other good search engines include Alta Vista (www.altavista.com); HotBot (http://hotbot. com); Web Crawler (www.webcrawler.com); Fast (www.alltheweb.com); Hotrate (www.hotrate.com); and Northern Light (www.northernlight. com). You can search the "special collection" documents in Northern Light for free, but you have to pay to view the entire document. An arts-and-technology search engine is Pilot-Search (www.pilot-search. com). Good news portals include Headline Spot (www.headlinespot. com) and Yahoo! News Full Coverage (http://fullcoverage.yahoo. com). Crayon (http://www.crayon.net) allows you to create your own newspaper.

Working with Meta Search Engines

Meta search engines query several search engines at once (e.g., Dogpile, www.dogpile.com). Dogpile searches more than a dozen different search engines and provides results from each of the search engines that it queries individually rather than combining them all into one list. Other meta search engines include Mamma.com (www.mamma. com); Ixquick (www.ixquick.com/); Ask Jeeves (www.askjeeves.com/); and MetaCrawler (www.metacrawler.com/index.html).

Working with Directories

Directories often contain annotated links describing the site or page they point to. Every site has been viewed and categorized by human editors. These efforts result in more useful and reliable listings. Examples of directories include Yahoo (www.yahoo.com); LookSmart (www.looks-mart.com/); and Open Directory (http://dmoz.org). The Open Directory Project's goal is to produce the most comprehensive directory of the Web by relying on a vast army of volunteer editors. SearchPower (www.searchpower.com) promotes itself as the world's largest search engine directory.

As the Web continues to develop, new search engines will emerge and other search engines will disappear or be bought out by more powerful companies. That's why it's important to keep up with the latest trends in search engines.

URL SLEUTHING

Sometimes you don't even have to use a directory or search engine to locate a specific organization's Web site. Try determining the organization's main URL by typing in the following common prefix—www. Next, type the company's name, acronym, or product name. End the address with the appropriate top-level domain, usually ".com" for commercial. (".edu" for educational, ".org" for organizations, ".gov" for U.S. federal government, ".mil" for military, and ".net" for Internet service providers and networks).

This technique can also help you find pages for URLs that no longer work or for links that lead to dead ends. If a link isn't working, you can also try deleting parts of the URL by beginning on the right-hand side of the URL and stopping at every forward slash, "/".

UNCOVERING THE INVISIBLE WEB

Chris Sherman, author of the book *The Invisible Web: Uncovering Information Sources Search Engines Can't See*, says that the Invisible Web is made up of information that search engines can't or won't add to their indexes. Sherman says that search engines aren't capable of vacuuming up everything on the Web, partly because of financial costs. Other barriers include Flash or audio, which prevents pages from being searchable.[4]

Sherman claims that the biggest part of the Web is made up of databases; however, the crawlers in search engines can't type, so it's as if search engines come up to the front door of the library (database) and can't get in. That means users are missing out on a lot of valuable information. The Invisible Web primarily consists of content-rich databases from libraries, universities, businesses, associations, and government agencies around the world. The Invisible Web is 2 to 50 times larger than the visible, known Web.

Sherman suggests that there are about 1.5 to 3 billion pages on the Web. A lot of the pages on the Web are customized to customers and therefore count as individual pages (e.g., My Excite). Therefore, the concept of a Web is fluid, so measurements can be tricky.

The Invisible Web offers higher-quality information that is free. Obtaining superior and dependable information is important for online writers. Search engines look at pages and may tell you what the database is about, but they do not tell you what is in the database. Sherman indicates that search engines are getting interested in tapping into the Invisible Web. Two examples are Google and Inktomi. Quigo Technologies, Inc., an Israel-based company, will be offering "Deep Web Solutions" to companies.

Take Time to Learn How to Use the Invisible Web

Because the Invisible Web offers researchers and writers a higher caliber of information, I asked Sherman if seekers of specific information should bypass search engines and go straight to the Invisible Web. Sherman compares the Invisible Web to the reference section in a traditional library. It takes awhile for users to learn where the good sources are in the Invisible Web, just like it takes users time to find the best reference sources in a traditional library.[5] Therefore, Sherman suggests that you start your research with search engines first. Browse and use the advanced features in search engines. Then, as you build on your experience, use search engines and the Invisible Web or go directly to the Invisible Web.

Try These Sources and Tips

Chris Sherman suggests two good places to look for databases:

- InvisibleWeb.com (www.invisibleweb.com) from IntelliSeek, Inc.
- The *Librarians' Index to the Internet* (http://lii.org)

Although the *Librarians' Index to the Internet* is not a pure Invisible Web, if you go into the advanced search section, you can sort by the following categories:

- Best of
- Directories
- Databases
- Specific resources

Sherman explains that another way to tap into databases is to type in a keyword in the search box of a search engine followed by the words "AND database."[6]

Your Best Source—The Invisible Web

According to Sherman, "The key point is that even if search engines allow you to get information from the Invisible Web, it's a better idea to go to a database once you have gained some experience. Databases are equipped with query tools that will help you obtain more finely tuned information. For example, each database is structured around a specific set of data. A database on weather images will be different from a database based on the census."[7] For more detailed information on how to search the Invisible Web, get a copy of Chris Sherman's book, *The Invisible Web: Uncovering Information Sources Search Engines Can't See*. Sherman also has a companion Web page for his book called Invisible-Web.net (www.invisible-web.net). The page will include 1,300 to 1,400 sources with a selective filter.

BUILDING YOUR BOOKMARKS (FAVORITES) LIST

Use your Bookmark list as a research tool and an easy way to keep up-to-date with the latest news. Bookmark reputable sites that relate to your specialty or niche. Sign up for e-mail announcements or news-letters so you will be notified when the sites are updated. Work smart by actively managing your bookmark list. Develop a logical filing system. Regularly organize your favorite sites or reference resources into meaningful categories. For example, if you specialize in writing articles on various disease states, you might categorize reference sites as follows: diabetes, cancer, arthritis, and cardiovascular disease. Update your bookmark list when you find new sites. Delete sites that are no longer useful to your needs, that are no longer updated by the owners, or that have disappeared.

If you are beginning a new writing project, create a new folder in your bookmark list for those sites that you will be regularly referencing during the project.

Online Bookmark Accounts

Online bookmark accounts can offer you more organizational tools than those provided with the standard browsers. This is a big help if you use a large number of favorite sites in your research. These accounts allow you to log onto your bookmark list from anywhere, whether from your home or office. Before you sign up for one of these

services, read the privacy policies. (In fact, the latter is a good practice whenever you sign up for any service or newsletter.) Three examples of online bookmark accounts are Backflip (www.backflip.com), Click-marks (www.clickmarks.com), and HotLinks (www.hotlinks.com).

SUBSCRIBE TO E-MAIL NEWSLETTER LISTS ON SEARCH ENGINES

When you subscribe to e-mail newsletters that focus on search engines, you will become more adept at research and keep your competitive edge as a writer. You'll also stay current on the latest research tools. Keep up with search engine changes by subscribing to the following lists:

Search Engine Watch

Danny Sullivan, an Internet consultant and journalist, created the *Search Engine Watch* (www.searchenginewatch.com) Web site. Sullivan continues to maintain the site for Internet.com. The site contains an extensive amount of information on the newest search engines as well as search engine tutorials.

Readers can subscribe to the free monthly *Search Engine Report* e-mail newsletter, which covers the world of search engines with news, reports, and in-depth features. There is also the premium (paid) *Search Engine Update*, a twice-monthly newsletter that offers longer and more in-depth articles on search engine optimization and promotion.

Chris Sherman is Associate Editor of *SearchDay*, which is part of *Search Engine Watch*. This free daily newsletter contains original content that covers breaking search engine news, tips for easier searching, and search features.

ResearchBuzz

Tara Calishain maintains the innovative *ResearchBuzz* Web site (www.researchbuzz.com). This site covers the world of Internet research with nearly daily updates on search engines, browser technology, and Web directories. Calishain sends out both a free and premium (paid) weekly e-mail newsletter with updates on Internet research. *Research-Buzz* is the free newsletter. *ResearchBuzz Extra* costs $20 per year ($15 if you are a student, librarian, or educator).

Librarians Index to the Internet (LII) by Librarians for Everyone

The *Librarians' Index to the Internet* (http://lii.org) is a searchable, annotated subject directory of more than 8,000 Internet resources—and this number is growing daily. These resources are selected and evaluated by librarians for their usefulness to users of public libraries. The index is meant to be used by both librarians and nonlibrarians as a reliable, efficient guide to described and evaluated Internet resources.

Carole Leita also manages a free, weekly e-mail announcement list. The list contains the top 10 to 20 resources added to the *Librarians' Index to the Internet* each week. There are currently more than 10,000 subscribers in 85 countries. Writers can use this excellent, current awareness list to keep track of great new Web sites. To subscribe, send the message (substituting your own name): "subscribe liiweek YourFirstname YourLastname" to listproc@sunsite.berkeley.edu.

SUBSCRIBE TO SPECIALTY E-MAIL NEWSLETTERS

Let the news on your specialty come to you. To keep informed of the latest research and information on your writing niche, subscribe to specialty newsletters. Not only will you learn about the latest innovations, but you'll also get new ideas for writing projects.

These e-mail newsletters will also be helpful when you get your next assignment if you've organized contact information and specific facts, either in files on your PC or in paper files. This information could include names and e-mail addresses of experts, reputable Web sites, statistics, or trends in the field.

On the Web, there is a newsletter on any subject from health to fine art to marketing. Profnet is one service that permits you to subscribe to e-mail newsletters by specific categories. InteliHealth, Inc. (http://ipn.intelihealth.com), which is a subsidiary of Aetna U.S. Healthcare, offers free e-mails to health professionals, the press, and consumers.

EDUCATIONAL ORGANIZATIONS

There is a wealth of educational material on the Web. There are the university-sponsored Online Writing Labs (OWLs) that offer helpful handouts and lesson plans for teachers. You can also find free educational materials from training companies and other reference information offered by companies. You can use these Web sites as

informational resources for your writing; however, as with any site that you visit, consider the source and content on the pages—and double-check your facts.

PRIVATE AND PUBLIC ORGANIZATIONS

Many organizations that used to offer information through the mail now post this information online. These organizations include non-profits, associations, agencies, medical institutions, and research centers. Writers can easily obtain background information and the latest research, statistics, and tips by simply visiting the appropriate site and printing out the data they need. One example is The Food and Nutrition Information Center (FNIC) (www.nal.usda.gov/fnic/), which is part of the U.S. Department of Agriculture (USDA). A powerful site that writers will find useful is the FirstGov.gov (www.firstgov.gov) site. This site is the only official U.S. Government portal to 30 million pages of government information, services, and online transactions.

TOPIC WORKSHEET

Jot down a topic or subject you'd like to explore on the Web:

BEGIN THE PRESEARCHING ANALYSIS

1. What UNIQUE WORDS, DISTINCTIVE NAMES, ABBREVIATIONS, or ACRONYMS are associated with your topic?
These words may be the place to begin because their specificity will help zero in on relevant pages.

2. Can you think of societies, organizations, or groups that might have information on your subject via their pages?
Search these as a "phrase in quotes," looking for a home page that might contain links to other pages, journals, discussion groups, or databases on your subject. You may require the "phrase in quotes" to be in the documents' titles by preceding it by title: [no space].

3. What other words are likely to be in ANY Web documents on your topic?
You may want to require these by joining them with AND or preceding each by + [nospace].

4. Do any of the words in questions 1, 2, or 3 belong in phrases or strings—together in a certain order, like a cliché?
Search these as a "phrase in quotes" (e.g., "affirmative action" or "communicable diseases").

5. For any of the terms in question 4, can you think of synonyms, variant spellings, or equivalent terms you would also accept in relevant documents?
You may want to allow these terms by joining them by "OR" and including each set of equivalent terms in []. In Infoseek, allow any of them by omitting + [no space] and − [no space] before them.

6. Can you think of any extraneous or irrelevant documents these words might pick up?
You may want to exclude terms or phrases with − [nospace] before each term, or AND NOT.

7. What BROADER terms could your topic be covered by?
When browsing subject categories or searching sites of webliographies or databases on your topic, try broader categories.

Copyright © 1998–2002 by the Library, University of California, Berkeley. All rights reserved. Document created and maintained on server http://www.lib.berkeley.edu/ by Joe Barker.

ENDNOTES

1. Sullivan, Danny. "Boolean Searching," Search Engine Watch, p. 1, www.searchenginewatch.com/facts/boolean.html. Accessed May 18, 2001.
2. Sherman, Chris. "The Hidden Power of AND," Search Day, May 8, 2001, Number 2, p. 1, www.searchenginewatch.com/searchday/01/sd0508-and.html. Accessed May 8, 2001.
3. Sullivan, Danny; "Major Search Engines . . . The Major Search Engines," Search Engine Watch, p. 1, www.searchenginewatch.com/links/Major_Search_Engines/The_Major_Searc . . . /index.htm. Accessed May 18, 2001.
4. Sherman, Chris. (Author of *The Invisible Web: Uncovering Information Sources Search Engines Can't See*). Telephone interview, August 8, 2001.
5. Ibid.
6. Ibid.
7. Ibid.

Chapter 6
Getting Ready to Write

MAKING THE MOVE TO ONLINE WRITING

Whether you have a stack of clips from print magazines or you're a novice writer who is eager to break into online writing, you need to develop a strategy for success and work that strategy on a daily basis. Online writing demands a new approach compared to traditional print medium. The Internet is a global library of niches. You have to be fast on your feet, focus your efforts, and nurture your writing niches. Technology and content needs change quickly, and you need to keep up with the changes. Yet these changes, with their accompanying growing pains, will eventually bring more opportunities for online writers. You'll enjoy freedom, challenges, and growth opportunities, and the ride of your writing life.

Dive In and Explore

In the beginning, set aside a few hours each day to explore the existing writing on the Web and your online writing potential will improve. Plan your own self-study tutorial by visiting a wide variety of sites. Analyze how the written content works with the site design. Look at corporate sites, news sites, nonprofit sites, educational sites, and personal sites. The Internet is a global source of "samples."

By studying various types of sites, you'll soon get a feel for what does and doesn't work on the Internet. Be on the lookout for new ways of presenting content information. Keep up with new developments in technology. Analyze the different theories of experts in the online

content field. Study how other online writers handle the topics you specialize in. Let's say that you specialize in health writing. Study what the competition is doing on this subject. First, look at the big, "brand-name" sites like the Mayo Clinic. How did the author's headline or first paragraph pull you into reading the article? What facts did the writer use to make you believe that the article was credible? What new article ideas can you get from reading this article? How can you do it one better? Look at the layout of the article. Did the author use sidebars? Quizzes? Discussion boards? How did the graphics support the article?

Use a search engine to perform a search on the keywords in your niche. Naturally, if you want to write articles that pertain to health, you would type in the words "health articles" in the search box. You might also search on other related words such as "fitness" or "nutrition." Look at the articles that come up in the search results. What can you learn from the writing styles of the authors? Analyze the articles that seem to miss the mark with poor leads and dull prose. Did the lack of facts in a particular article make you question the author's hypothesis? You can often learn a lot from poor articles, too. Look outside your particular niche and study how writers handle subjects that are different from yours.

Analyze the writing styles of various online content providers in different venues such as online news or copywriting. Do specific writers compel you to read on? What techniques do these writers use? Good hooks? Clear and concise writing? Remember that content is more than just the text in the body of a document. Headings and subheadings need to pull their weight, too. Subscribe to e-mail newsletters that focus on different subjects. Compare the e-mail newsletters that you look forward to week after week to the e-mail newsletters that cause you to click on the "unsubscribe" button after the second or third issue. In the first case, you may have felt you were receiving value through quality content. In the second case, the hard sell of the e-mail newsletter could have turned you off.

Multimedia is another form of content that you should study. Someone had to write the script for that video or audiotape. Your analysis will teach you to "see" and "hear" content in a whole different way.

To widen your education, look at different types of sites. If you have access to a company intranet, check out the content. Is the content regularly refreshed or do you see the same documents day after day? The article on the company's quarterly meeting quickly becomes stale if it is posted on the home page of the intranet for more than a month.

Check out distance learning sites and their offerings. Take an online course to help you get a feel for how the information is provided.

Some sites even offer a free introductory course. By taking these steps to explore and study the Web, you'll learn what the competition is doing and improve your online writing. You'll also be finding new markets for your work, but don't stop studying at this point. Make it a habit to regularly sniff out new sites. In fact, schedule this task into your calendar on a weekly basis.

Personal Traits Online Writers Need to Nurture

To be a successful online writer, you need to cultivate and practice many of the traits that print writers need. Because the Internet is a faster-paced medium, however, your pursuit of these traits will need to take on an added intensity.

Keep Curious

Every writer is naturally curious, but on the Internet, you need to put your curiosity into overdrive. Make a habit of keeping current on changes in the online content world by subscribing to e-mail news-letters that cover online writing. One excellent example of an e-mail newsletter that covers online content is Content Spotlight, which is part of Content-Exchange.com (www.content-exchange.com). Keep up with changes in Internet technology with Web Review (www.webreview.com) and Internet.com (www.internet.com).

Follow changes in your specific writing niche by subscribing to subject- or industry-specific e-mail newsletters. Find these newsletters by plugging in keywords that relate to your niche in search engines. For example, if you write articles on gardening, you might type in the phrase "gardening newsletters" in the search box of your favorite search engine.

You can also use search engines to satisfy your curiosity. Regularly scour the Web for the latest developments on the Internet and online writing by typing the following keywords into search engines: "online writing," "Web writing," and "Internet writing." Find market information on publications that pay writers by narrowing your focus to these specific keywords in search engines, "writers guidelines + pay." You can also type in variations of these keywords. Regularly seek out new search engines and use them to do keyword searches and research. They'll help you learn more about online writing and your writing niche. When you find a new writing site, read the articles and archives. Follow the resource links on these sites, which usually lead you to additional new writing sites.

In the wired world, clicking on a link can bring you a burst of new writing ideas. Be ready by keeping a virtual journal on your laptop or palmtop where you can capture ideas for future articles or your current project. Develop a systematic method to capture and organize your ideas by file names.

Be aware of what's happening in traditional media, such as television, radio, and print publications. Analyze this media and come up with some ideas that you can borrow and apply to the Web. This cross-fertilization of ideas is already taking place. Witness how some magazines and television news shows (e.g., Fox News, CNN) are beginning to take on the look of Web pages.

Energize Your Online Writing

Make your writing snappy and pull your readers in. The Web demands a quicker and punchier writing style. Your readers are surfing at top speed. You need to reach out and grab them. The Internet is a personal medium. You're talking to people on a one-to-one basis. Make sure that you put personality into your writing. You have to be more resourceful when you build your headlines, leads, and phrases. Do you want your writing to pulse with energy? Then you have to infuse your words and ideas with intensity. Your resulting originality will keep users reading.

Be Innovative

Find those words that dance by taking out the thesaurus and looking up new words. Check out various word phrase books (e.g., *Words that Sell: A Thesaurus to Help Promote Your Products, Services, and Ideas* by Richard Bayan). Purchase the IdeaFisher™ Creative Brainstorming Software (www.ideafisher.com). Take a different path from the usual bland presentation and you'll lead eager readers into the depths of your article. The Internet is not a one-dimensional world; therefore, you need to use a multitude of approaches to make your point.

Be Self-Driven

Print writers need to be self-driven, and online writers do, too, but online, the pace picks up. If an editor asks for an article in one week, you have to know where to find the research and the experts and complete the article on deadline. In the meantime, you have to juggle the other online writing assignments you have on your plate. And don't forget the ongoing marketing efforts you need to do. You have to continue to look for new markets, develop queries and contact editors, stay updated on any changes in the content world, negotiate contracts, and get paid. That's why the following paragraph is crucial.

Get Organized

Organize your business and office and you'll save time. Develop a filing system for the files on your computer and the paper files in your desk. When you're working on a specific project, make backup copies of the files on your hard drive. Regularly print out hard copies of your documents. Computers crash and equipment can break down. Periodically reorganize the bookmarks on your computer. Copy your bookmarks onto floppy disks. Create a spreadsheet to track your invoices. Develop separate address lists for editors, and experts and their specialties.

Develop Discipline

If you're a freelance writer, set up a regular working schedule and follow it. Let relatives and friends know your "working hours." Aim for a good balance of hours. If you devote just a few hours per day to your writing, you'll make a low salary; however, if you work 12 hours a day, six days a week, you'll soon burn out. Take a disciplined approach to finding and nurturing markets for your work. Make sure that you do something every day to find new markets, whether it's searching online job boards, sending out a query, or researching Web sites that may need online writing help.

Practice Professionalism

Be professional but easy to work with. Be well prepared by doing your homework before you begin any project. This effort will help you avoid potential problems. Demonstrate your professionalism to clients by meeting your deadlines and completing your projects on budget. Make it your goal that every project meets high-quality standards. Make sure that you do your research and double-check your facts for accuracy. Meeting and exceeding your clients' needs will increase the value of the online end product that you produce, whether it's an article, white paper, or press release. Maintain your credibility with clients by adhering to a high standard of ethics. You have a responsibility to both your clients and readers to provide accurate, well-researched, and well-written information. In the long run, your efforts will result in repeat business from your clients.

After you have demonstrated your professionalism to clients, they will be more receptive when you come to them with new ideas for online projects. Professionalism also includes being aware of your rights as a writer. Negotiate contracts that offer fair rights and payment to you, and make sure that you receive payment on time.

Be Flexible

Let clients know that you can provide more than just online writing services. Demonstrate that you are versatile and multitalented. You will increase your marketability and future career prospects by being willing to take on a variety of job opportunities. Offer to do online editorial work. If you lack editorial experience, take courses in copyediting and project management. If you have experience developing print training and educational materials, explore the world of online training. Determine how you can translate your training and writing skills to the distance learning field. You could write distance learning modules for corporations, colleges, or online writing schools. Visit the Web sites of established writing schools to learn how these schools operate. Some examples of writing schools include:

- Gotham Writers Workshop (www.writingclasses.com)
- Writer's Digest (www.writersonlineworkshops.com)

Learn to adapt to a wide variety of work arrangements, from telecommuting to working on site, from regular part-time hours to juggling a variety of freelancing assignments. Some clients pay by the hour, whereas other clients pay on a per-project basis. To get an idea of the going rates for specific projects, subscribe to writers' mailing lists (e.g., the online-writing list that is a service of the Poynter Institute), e-mail newsletters for writers, and visit online writing sites. You will often have to combine assignments from different clients to realize a full-time salary. If you proactively and regularly pitch story ideas (e.g., a series of articles or new approaches, possibly an online medical case study for students) to your clients, you'll increase your value in their eyes, and they'll come to you with future work. When clients know they can depend on you when they are up against a tight deadline, you can be sure they'll call you again for more work.

Go the Extra Step

Time schedules are tight in the online world. When you turn in copy that is clean, accurate, well researched, and edited, you are saving editors time and lessening their work responsibilities. You also make a good impression on the editor. The end result could mean future work.

Be Persistent

Persistence pays. To ensure a steady flow of business, you need to take a multifaceted approach of satisfying current clients while seeking out

new business through online job searches. Use technology to make and maintain connections. E-mail fellow online writers regularly. Participate in discussion boards. Create a mailing list or Weblog. Join local writers' groups and network with other online writers. That's what persistence is all about.

Nurture Excellence

Continue to nurture your writing reputation by producing excellent copy each time you take on a new project. Develop a distinctive voice. Your online writing efforts are your personal signature. That signature offers the potential of attracting bigger clients and higher-paying markets.

When faced with a challenging project, seek out the best way to tell the story online. Avoid the temptation of shovelware, where you take a client's print materials and slap them online without customizing the materials to suit the online environment. Instead, latch onto the opportunities that interactivity offers online writers and give readers an entertaining ride through the Web.

Listen to Your Readers

Invite your online readers to help shape your content, and you may create a successful new format for the Web site. During this entire time, you will also be learning and growing.

DEVELOPING A WRITING NICHE

If you promote yourself as a content provider who can write about any and all topics, you'll brand yourself as a generalist. You can't be all things to all people. You'll increase the editorial responses to your queries and your sales by establishing yourself as an authority on a select number of niches. After all, the Internet is composed of many, many small markets. Get updated first. Make the best use of your time by learning more about your specific niches. Then explore potential markets for your writing niches. Are your niches more suited to the world of articles on selling and e-commerce sites? Or are your niches more in line with developing training materials for corporations?

Use the Internet to research the types of markets that relate to your niche. This effort will help you develop customized queries that better target these markets. For example, if you want to write articles on selling, you might subscribe to a few e-mail newsletters or e-zines on selling,

study the tone and style of the articles, and then send in a query to the editor.

Doing additional research on the Internet will help you learn about new outlets for online writing that you may not have originally thought of. Maybe you have a marketing background and would like to write copy for catalogs that you've seen on the Web. If necessary, take an online course on copywriting to strengthen your knowledge of that subject. Start querying the small catalogs and work your way up to the higher-paying markets. Following are some more detailed ways on how to become an expert in a specific niche.

Use Your College Degree

Use the specialized knowledge that you gained from your college degree to start creating an online writing niche. Your nursing degree could help you get a job on a site that specializes in disease and health. If you majored in elementary education, try approaching a childrens' educational site. If you don't have any previous online writing clips, you may have to begin writing for smaller sites; however, those well-written articles you wrote for the small sites will provide you with clips that can lead to bigger markets and better pay.

Use Your Previous Jobs and Skills

Use the expertise you gained in previous jobs to develop your writing niche. Your 10 years in finance might make you an appealing candidate to a banking site. Your customer support background at a computer company could land you a column on a technology site.

Interests and Passions

Look at the special interests in your life. What are you passionate about? Maybe you traveled to all of the major countries of the world. Your first-hand look at the people and cultures of many countries could add vivid color to any travel site. Dig deeper; look at your collections, your hobbies. Are you a collector of antique furniture? Have your taught yourself a special skill (e.g., fabric painting)?

By specializing in a few niches, you will also distance yourself from the competition, especially the generalist writers. They will not possess your expertise or credentials. You'll therefore be able to command a higher rate of pay.

Submerge Yourself in Your Niche

Even though you may have earned a college degree or have job experience in a specific field, you'll still have to take the time to submerge yourself in your specialty niches before you begin querying editors. Update your knowledge in the field. Catch up with the latest research and trends and where the industry is headed. These efforts will become even more important if you're trying to break into a relatively new niche.

Specialty Sites and Publications

Every industry has specialized trade journals/newsletters and usually an associated Web site. For example, the Wheat Foods Council has a site at www.wheatfoods.org, where journalists and health professionals can get background information for their articles.

In addition, seek out and read both print and online articles to learn more about the recent developments in your industry or specialty. Subscribe to industry e-mail newsletter lists. Visit the Web sites of the leading advertisers in your industry and search their sites for background information and article ideas. Check the news sites (e.g., www.moreover.com) for the latest industry news in your niche.

Cultivate Contacts

Begin to cultivate a list of potential industry contacts so you have people to call on when you have to write an article or work on a project. One place to find these contacts is through ProfNet's Experts Database (www.profnet.com/ped.html). Their database offers profiles and contact information for more than 4,000 leading experts at institutions. ProfNet also sends out weekly tipsheets (e-mail newsletters) that focus on breaking news in different specialties. Because my interest is in health and business, I receive the "Profnet Health Care Leads" and "Profnet Business Leads" newsletters. Each newsletter contains brief blurbs and contact information.

Expand Your Skills

Expand your writing knowledge and skills by visiting sites that teach you about new disciplines within the field of online writing. For example, to learn more about marketing, e-commerce, and advertising, visit ClickZ.com (www.ClickZ.com). After you've done all of the work that is needed to develop your online writing niches, then it's time to pitch a story idea.

GETTING THOSE FIRST ASSIGNMENTS

If you lack published clips from the print and online world, you can take a variety of approaches to land your first online writing assignments. Begin writing for the smaller markets. The pay is not as high, but you will be building a portfolio of online writing clips and showcasing your talent. Those small gigs could turn into lucrative long-term assignments or help you land a better-paying salary.

You can use your published clips from the smaller markets to query editors in higher-paying markets. You never know when you will attract the big markets. Put your best writing into those pieces because even though the pay may be small, your writing will be seen by a large Web audience. At the end of your articles, self-promote your writing by providing a link to your personal Web site and/or e-mail address. There is always that small possibility that editors who scour the Web looking for new talent may see your clips.

If you're completely new to online writing, you might even try writing a few short pieces on spec to catch the attention of editors; however, don't make it a habit to write on spec or to accept low-paying jobs. Your long-term goal should be to continue to increase your salary as your online writing experience grows.

Shy away from those markets that say they will offer you online exposure in lieu of pay. This holds true for stock options, too, which could turn out to be worthless. Avoid markets that pay "per view." These markets offer writers an extremely low payment every time an Internet user reads their article or story. These markets often also offer contracts that contain an "all-rights" agreement. Chapter 17, "Contracts," offers more information on this type of agreement.

If you have a day job, begin freelancing on evenings and weekends as a second job. After you have built up a solid and diversified client base, only then can you think of quitting your day job. In today's volatile market, protect yourself by developing a client base that includes both online and print markets. Add corporate accounts to your client mix because they pay well and promptly. Keep plugging away and actively seeking those markets that include a budget for online content in their business plan and you'll eventually find success. Of course, a signed contract and fair pay is important, too.

DIVERSIFY AS AN ONLINE WRITER: CONTENT OPPORTUNITIES

The Internet is in continual flux. The only constant is change. Therefore, online writing demands that you keep up-to-date. Technology changes

daily, and so do online job opportunities. The dot-com failures at the end of the 20th century closed some doors as Web sites shut down; however, other doors opened and will continue to open as technology advances.

Stay on top of the changing needs for online content and new market opportunities. Keep your options open. Look for any type of job that involves the written word. Want bigger pay? Seek out bigger markets for your work. As your online writing experience evolves, look for those jobs that are long term and pay higher salaries.

Position yourself as an idea person; after you complete your first assignment, pitch an idea for the next assignment. Your clients will keep coming back with more work for you. Kickstart your idea factory by studying the client's site. Determine where you can make improvements and attract readers. Then proactively pitch ideas for stories, catchy leads, photo captions, or headlines, and increase your value in the eyes of clients.

In the long term, you benefit from taking on a variety of online writing jobs; they all add value to your resume. Cultivate contacts from a variety of companies and industries and work your network. Every week, schedule time on your calendar to contact a new online editor, Web developer, or marketing department. Talk to your friends, acquaintances, neighbors, and relatives about your work.

Job Opportunities for Online Writers

Corporations offer both full-time and freelance opportunities for writers and editors. Jobs can be staff, on a long-term contract basis, or on a per-project basis. Focus your marketing efforts here if you want to be paid well, compared to writing online articles. If you're just starting out, you should build a portfolio of clips before you set up any interviews. Get those clips by doing freelance writing for online trade magazines in the industry in which you hope to work full time. You can find many different types of online writing jobs in corporations. Many companies need timely and high-quality content on an ongoing basis. You could create content for a company's Internet, intranet, and Extranet. A company may need product and service information regularly updated, white papers written, and training sites developed.

To find online writing positions in corporations, search for individual Web sites that produce quality content in your field of expertise. Find contact information through the "Job Opportunities" or "Careers" page. If contact information is not easily found, search through the "Site Map or Index," "Help," or "Press Releases" sections of the site. If you still cannot find contact information, send an e-mail message to the "Webmaster" of the site. Ask the "Webmaster" for the e-mail address

of the human resources department or the e-mail address of the person to contact for online writing jobs.

After you have obtained the correct contact person's e-mail address, explain your interest in an online writing position. Let the contact people know that you visited the site and came up with some writing ideas they might be interested in. Develop a message that will grab their attention. Remember you're selling your online writing services through this e-mail message to them. Include your resume in the body of your e-mail message.

In addition to corporations, regularly surf the Web looking for the sites of smaller companies, online businesses, and e-commerce sites. These sites include business-to-business and business-to-consumer companies. Check their "Job Opportunities" section to see if they need copywriters and content providers.

E-Mail Newsletters for Companies

Look into writing content for e-mail newsletters. Both large and small companies could benefit from an e-mail newsletter. Focus on those organizations that match your own specialties. You'll have an easier time selling the concept if you're able to understand and use the industry language. Besides companies, you might want to approach nonprofit groups, associations, and institutions.

Find out if the company is currently producing an e-mail newsletter. If they're not, here's you chance to make an impression. Contact the public relations department to get some background information on the company. Study the information and determine the type of e-mail newsletter that would help promote the business to its target audience. What type of articles should the newsletter contain? How often should the newsletter be distributed?

If the company is local, set up an appointment to discuss your ideas. If the company is a long distance away, send a query briefly outlining your ideas. Once you gain the company's interest, create a brief proposal that emphasizes the benefits and cost savings of an e-mail newsletter. Make sure that you include any feedback that you received from the potential clients in the proposal. This will make the proposal more customized; however, don't include so many details in your proposal that you give away the complete concept. If you do that, there's a possibility that your potential clients will do the job themselves based on your ideas.

Network Locally

To get online writing jobs, you need to think out of the computer box. Attend the next Chamber of Commerce meeting in your town. Start

networking and looking for new clients. Start with the small businesses and work your way up. Don't forget about other potential local clients: city and state government, hospitals, colleges, and newspapers. Every one has a Web site today. Contact advertising agencies, public relations firms, and Web design firms and apply for the position as a content provider. Set up an interview to show your portfolio of online writing samples. It helps if you know someone who has done work for the agency in the past so he or she can put in a good word for you. Otherwise, you may have to make many calls before you can secure an interview. Get ready to work fast at these places. Go for an hourly fee and get a written contract before you start the job.

Markets for Online Writers

Online magazines and e-zines offer writers another source of income. Pay can be low, but after you build up a list of solid clips, your salary should start increasing. To ensure an ongoing revenue stream, it's important to regularly scour the online market listings on writing sites and general job search Web sites, job boards, and classified ads. Relentless querying of editors is your key to success.

Focusing Your Efforts

There are a wide variety of markets for online magazines and e-zines: consumer, business, trade, and vertical industry sites (e.g., VerticalNet®). Writing for vertical industries are similar to writing for trade magazines. Similar to print writing, first check the writers' guidelines for the online magazine by visiting its Web site. Other magazines offer their guidelines via e-mail request. Several sites offer extensive listings of magazines' guidelines in one convenient place (e.g., www.freelance-writing.com/guidelines/pages/). Follow the magazine's query policy. Most magazines accept electronic queries and submissions; however, a few still require snail-mail queries.

If past issues are archived on a magazine's site, study the articles so you get an idea of the type of material they are looking for. If the magazines also produce a print copy, request a sample issue from the publisher. Alternately, check out past issues of the magazine at libraries.

If you have written articles for consumer print magazines, demonstrate your versatility to editors by proposing article or column ideas for their online site. Obtain a signed and fair contract before you begin writing the article.

Online Trade Magazines

There are trade magazines for almost every industry and hobby. Search the Internet for online trade magazines and journals that are related to your specialty. You generally don't have to write traditional queries to get assignments from trade magazines. Experience in the subject matter, as well as writing experience, are more important. Send an e-mail message to a trade magazine that matches your area of expertise. Explain how your background can help them produce articles that meet readers' needs. The editors of trade magazines often supply ideas for articles, research information, and industry contacts.

Regularly Seek New Leads

Make it a daily habit to check the market listings on the Internet. Subscribe to writing e-mail newsletters, e-mail discussion lists, and e-zines to determine editors' current needs. After you have become a regular subscriber, you should bookmark those writing-related sites that usually offer the best leads. Check these bookmarked sites every day. As soon as you find a lead, send an e-mail query to the editor.

Cold Queries

The competition for writing jobs in the market listings and on the job boards is intense. Editors often receive hundreds of applications for one opening. Circumvent the competition by taking an additional route in your search for jobs. Try the "cold query," which is similar to the "cold sales call" in the business world. The only difference is that you will be "calling" on your potential client by e-mail.

Begin by searching for Web sites for which you are interested in writing. Make sure that your writing experience and background closely match the subject matter on the site. That way, you'll have a better chance at landing a job. In your e-mail message, introduce yourself. Tell a little about your background and writing experience. Ask editors if they currently have any need for freelance writers. Request their writers' guidelines if they are not mentioned on their Web site. I used the following "cold query" to land an assignment with an online trade magazine for a series of articles:

> I'm interested in learning more about writing positions within your company. I'm a registered dietitian and freelance writer. I have experience writing on assignment, doing interviews, and Internet research. Sample URLs and my resume (ASCII) are below.

Convince the editor that you are the most qualified person to write on the subject because of your past experience and educational background. Similar to print writing, it's important to send your e-mail to the appropriate editors and to spell their names correctly.

DOING RESEARCH BEFORE WRITING THE QUERY

Doing research on the Web will sharpen your query letter. Before you even write the query, you will have to analyze the magazine, analyze the audience, do some research on the topic, and identify the potential experts you will interview.

Analyze Back Issues and Current Issues of the Magazine

Although e-mail queries are a fast and easy way to obtain writing assignments, you still have to put as much time and thought into them as you put into your snail-mail queries. That's why it pays to analyze the e-zine, online magazine, or newsletter to which you are interested in pitching. Try to determine where the publication's interests and focus lie by looking at back issues and archives.

You also don't want to propose an article that has been done recently. Look at current issues, too, and take note of any editorial changes, such as shorter features or the addition of a new column. By reading current and back articles, you'll get a feel for the tone and conversation style of the e-zine.

Analyze Your Audience

Before you write the query, it's important to plant a picture of the magazine's audience in your mind. Your analysis of the magazine's archives and current issues should have given you a general idea of the type of reader you are targeting. Later on, when you get the assignment, ask your editor if he or she can provide you with the demographics of their readers so you can better match your writing to readers' needs. Also, ask for a copy of their Web site in-house style guide to learn more about your audience.

What Are the Goals of Your Article?

Before you write the query, determine the goals of your article. Ask yourself these questions. Why are you writing this article? What will readers learn, understand, or do as a result of the article? What problem will readers solve as a result of reading this article? Coming up with answers to these questions will help you write a stronger query that will sell the editor.

Researching the Topic

Do some research on the topic of the article you are proposing. Not only will this effort help you appear knowledgeable about the topic, but your research can also help you develop a catchy opening that will attract the editor's attention. You can often use this query opening for the lead of your potential article.

Determining a Web Site's Credibility

When you do research on the Web in preparation for an article, it's important to evaluate the credibility of every site you visit. Here are a few things to consider when you view Web pages:

- *Consider the source of the material.* Who sponsors the site? The URL can give you some indication (e.g., ".edu" for educational materials and ".gov" for government sources). Who are the authors and what are their credentials? Is there a credentials page that spells out the expertise of the authors? Is there a "mail-to" link where readers can submit questions or comments?
- *Look at the content.* What is the purpose of the information? Is the purpose of the document to educate the audience? To sell a product? If so, it's important not to take the information at face value.
- *Look for any evidence of bias.* What is the source of the information? If the article draws from other sources, the references should provide complete citations. How comprehensive is the information? Are external links provided to complement the content? Are these links relevant, credible, and appropriate? Check the pages for the dates when the information was posted. Rely on sources that provide current or recently updated information.

Later, when you're ready to write your first draft, double-check the facts you found on this Web site as well as other sites for accuracy.

Search for Secondary Reference Sources

Begin your research by using search engines to find secondary reference sources such as similar articles that have been written on your topic. This effort will help you in many ways. You'll learn what other writers have covered on the topic and you'll get a better idea of the competition. This initial research helps you refine your topic so you don't cover the same ground as others. This tactic will also help you add an innovative twist to the topic and bring up new ideas in your article. If you don't find relevant articles on your topic by using one search engine, try using a variety of other search engines. Different search engines cover different parts of the Web.

Search for Primary Reference Sources

Next, search for sites you can use as primary reference sources. These sites contain original research articles (e.g., *The Journal of The American Medical Association* http://jama.ama-assn.org/). Another example of a reputable reference site is the Food and Nutrition Information Center (FNIC), which is part of the U.S. Department of Agriculture (USDA). Later, you can refer to these sites as links in your articles. On some sites, you may have to pay for the full text of the article.

Search for Experts

As you do research on the topic, you may also find experts you can interview for the article. Note down the names and contact information of these experts. Better yet, start to build an address book of experts that includes their full names and titles, phone numbers, e-mail addresses, and snail-mail addresses. This effort will help you build a network of authoritative contacts that you can call when you get future assignments.

Seek Out New Facts

Write down any new facts, such as cutting-edge research, statistics, or trends that you uncover. During this entire period, keep a trail of your research by bookmarking reference pages. Because Web pages can suddenly move or disappear from a site, print out hard copies of the material, too. Make sure the hard-copy material contains the source of the content, the URL of the page, and the date of the document. If you think you might want to go back to a certain reference page when you're ready to write the article, print it out now. You may think the page will be easy to find later or that you will remember the site, but you probably won't. I learned this fact from experience. Printing out the page will save you wasted time and frustration.

Finding Experts to Interview

There are many online sources where you can obtain quotes from experts, get statistics, and verify up-to-date facts. One site mentioned earlier is Profnet (www.profnet.com/profsearchguide.html), which offers an e-mail query service where you can ask for experts to interview on a particular topic. Your request is distributed to public relations people at colleges, universities, research organizations, corporations, government organizations, and nonprofits. If the public relations people know of experts in their institutions who are experts on your topic, you'll receive an e-mail message with the expert's name and e-mail address or phone number.

When querying Profnet, you should provide the following information: your name, news organization, the subject you are researching, your deadline, and how the experts can reach you. There is a "turn-off service" that informs Profnet when you want to stop receiving leads and "boosters" when you need additional sources.

There is also the FACSNET site (www.FACSNET.org), where you can contact experts. The Poynter Institute (www.poynter.org/links) maintains an extensive list of journalism links that can help you with stories.

Journalists can subscribe to Xpress Press (www.xpresspress.com) to receive press releases suited to their particular interests. They can also reach public relations professionals, information officers, authors, and experts through The Press Query (PQ) List.

To reach experts at government agencies, check their Web pages and click on the "Press Room" or "Public Relations" section. Sometimes, this information is under "What's New" or "News." You will often find e-mail addresses to contact public relations officers or the experts directly. If all you can find is a recent press release, call the Press Officer listed at the top of the release. He or she can either provide you with more information or put you in contact with the specific expert you are seeking. After you get the article assignment, you can also get leads from your editor.

DEVELOPING E-MAIL QUERIES TO EDITORS

The Internet has sped up the querying process for both writers and editors. You can e-mail queries to editors much faster than sending snail-mail letters. You can receive editorial approval or rejection just as quickly, and you don't have to be concerned about including a self-addressed, stamped envelope (SASE); however, don't allow the ease of

e-mail to seduce you into overwhelming editors with queries or sending out sloppy queries. You will turn off potential clients. Likewise, avoid sending a generic query to the same 10 editors; customize your query to each online magazine. Make sure you are contacting the right editor for the article you are proposing and spell his or her name accurately.

Another advantage of e-mail queries is that they can help you establish a dialogue with editors. Maybe your proposed article idea doesn't fit in with the current editorial calendar, but the editor may be impressed by the conversational tone of your query or your credentials and writing experience. The editor may ask if you're interested in writing another piece for the publication.

Take the time to develop a well-thought-out query. Tell the editor what you plan to write, how you plan to write it, why you're qualified to write it, and how it would help readers.

Hook the Editor

Hook the editor by quoting research, statistics, or an unusual fact. Now's the time to tap into that research you did earlier on the Web about your proposed topic. You could also use a quote or short anecdote for your hook or open your query with an attention-getting headline. If you can hook the editor, you're halfway to making the sale. When writing your hook for the query, think of it as the introduction to your article.

How to Develop the E-Mail Query

After you write the hook, give a detailed, concrete explanation of what you plan to cover in the article. List the type of experts you plan to interview and the reference material you will be citing. Mention any experience and background you have on the topic. For example, tell the editor what makes you uniquely qualified to write an article for a magazine devoted to direct marketing. You might have a marketing degree and 10 years of corporate marketing experience. Finally, summarize how your proposed article fits in with the magazine's goals.

Your query should be concise but not to the point that you eliminate pertinent research and facts that could help land you the article. First impressions count. An e-mail query gives editors a first look at your writing style, knowledge, and professionalism.

Sample E-Mail Query

Here is a sample of an e-mail query letter.

Dear Editor:
Did you know that 50 to 70 million Americans go on diets every year?
And that many of these same people will go on diets next year? These
numbers are telling us that diets don't work. Americans need to find
a new way to eat.

Drawing on the latest research on weight management, my article
will give your readers the tips they need to eat well and lose excess
weight, without the dread of dieting. I will use my experience as a
registered dietitian who has counseled overweight patients. I will
also interview registered dietitians who specialize in weight manage-
ment. My article will include links to reputable sources that will
provide additional information on controlling weight.
Sincerely,

Formatting E-Mail Queries

When writing your query, follow any editorial formatting pref-
erences requested by the publication. This information can usually
be found on a magazine's writers' guidelines page. Create your query
in plain ASCII text. Eliminate special formatting, such as bold or
fancy fonts, because it may show up as something completely dif-
ferent on the recipient's screen if the person has a different e-mail
program. Print your message out and read the hard-copy version out
loud to do a final check on spelling, grammar, and punctuation. Save
a copy of your query in both an electronic and hard-copy folder.

Always compose an attention-grabbing subject line for your
e-mail query. Your subject line should contain keywords that compel
the editor to "Read Me." Make your subject line concise, clear,
descriptive, and informative. Avoid vague subject lines such as
"Query—Outdoor Gardening." If you are querying an editor for an
article, the subject line could say "Query—Breakfast on the Run" or
"Query—Exercise for Busy Boomers." If you are seeking a specific job
position, your subject line might state "Experienced Medical Writer
(Resume)."

ASCII Resume

Many editors prefer not to receive resumes as attachments because
computer viruses can be transmitted through e-mail. Make the editor's

job easier by including an ASCII resume in the body of your e-mail message.

An ASCII resume is a plain text document that doesn't include any special formatting, such as apostrophes, em dashes, or other special characters. You can produce an ASCII resume by using the "Save As" function on your computer and by creating a second version of your Word resume in ASCII text or rich text format (RTF). Print the document out and proofread it carefully to make sure that none of the information was changed during the reformatting process. Remove any nonsensical symbols that remain, and change the margins of your resume to 65 characters in width. End each line of text by hitting the Enter button.

Copy and paste your resume into the body of the e-mail message. After you have pasted the resume into your e-mail message, print a hard copy to give it a final check. Depending on your e-mail program, you may have to adjust the formatting again.

Writing Clips

If the market you queried requested clips, follow the editor's instructions. The editor may ask that you send the URLs of your articles in the body of an e-mail message. Check the URLs first to make sure they are still "live links."

Editors often prefer that you paste the clips into the body of the e-mail message. If you do this, first convert the clips to ASCII text and print out the document to make sure it can be easily read. Add white space between paragraphs to facilitate reading. Never send attachments unless the editor specifically requests them. The editor's software may not match your software, and he or she won't be able to read the attachment. If all else fails, make sure you have a supply of hard-copy printouts of your samples so you can quickly fax them to editors.

Signature Block

A signature block is a set of four to six lines of text placed at the end of an e-mail message. It can include contact information such as your full name, e-mail address, snail-mail address, telephone number, and fax number. If you have a Web site, include the site's title and a live link to your Web site URL.

Some people use their signature block to promote their products or services. If you're promoting your business, include a catchy advertising message. The message should emphasize benefits and create a sense of urgency. You can also promote special sales in your signature block. Customize your signature block for different audiences (e.g., one for business clients, another for editors, and one for friends). Other people add a slogan or quote to their signature block.

Make sure your signature block sounds professional. Forego any cute e-mail aliases such as "candy girl." You also don't want to send cutesy quotes or outrageous slogans to editors such as "writer of the bizarre" unless you're submitting queries to an online horror e-zine. Your e-mail address should look professional. It's also a good idea to refrain from using free e-mail services because you want to present yourself as a serious writer. After you initially create your signature block, on most software programs, the signature will automatically appear every time you send an e-mail message.

Responding to Editors

When responding to editors, use the same subject line you used in your original message with "RE:" at the beginning of the line. If you are replying to a message from the editor, briefly quote part of the original message. Edit the message so it communicates your intent with the least amount of words.

Handling Rejection

If an editor rejects your query, ask yourself the following questions:

- *Did you target the right publication?* If not, search the Internet for different publications for your query.
- *Did your query demonstrate that you did your research?* If not, make sure that your revised query includes concrete facts that will catch the editor's attention.
- *Did you tell the editor about potential experts you plan on interviewing for the article?* If you did, maybe you need to tell the next editor how the experts will enhance the story and be of interest to readers.

After you have analyzed your query, rewrite it by taking the aforementioned factors into consideration. Next, tighten up your writing. Then e-mail your query out to the publication that is the best fit for your specific query.

CONDUCTING E-MAIL INTERVIEWS WITH SUBJECT MATTER EXPERTS

The ease and quick response of the Internet makes e-mail interviews an effective way to query experts for articles. The drawbacks are that

you miss the chance to build rapport and observe the body language that you get with a face-to-face interview; however, the greater advantage is that the Internet gives you instant access to experts from all over the world; experts who might not have time for a telephone interview or who you might not have been able to reach through snail mail.

Get Prepared

Prepare for the e-mail interview just as you would for a face-to-face interview. Before you compose your e-mail questions, make sure you do some research on the topic by reading reference material and textbooks. Do some research on the expert's background, too. If the person has published research articles or books, attempt to read his or her work.

Learn the industry terminology, jargon, or language of the profession. If you are writing an article on diabetes, and you will interview physicians, you might read online journal articles and look up medical terms with which you are not familiar on the Web. This effort will give you credibility and help you compose well-thought-out and targeted questions. Decide what information you will need to write your article. If you are interviewing more than one expert, determine the information you will need from each expert.

Background Logistics

Let the interviewee know what magazine and audience you are writing for. Tell the interviewee what your deadline is; however, remember that many experts receive multiple queries and usually have full-time demanding jobs.

Ask the interviewees for their full title. In case of multiple affiliations, such as physicians who are specialists and head up multiple medical departments in hospitals or centers, ask the interviewees which title they prefer to use in the article.

Formatting and Completing the E-Mail Interview

Limit your e-mail interview questions to a total of three to four. Some writers advocate four to six questions. My experience has shown that

experts respond better when you ask fewer questions. Number each question and leave enough space between questions so that the interviewees can type in their answers. Ask open-ended questions. Avoid questions that will solicit a yes/no or one-word response. Make your questions clear and short. In your final question, ask the interviewee if there is anything else on the subject that readers should know about or be interested in.

When you receive a response to your answers, clarify any points about which you are not clear by sending a follow-up e-mail. Double-check facts if you have questions with the experts. After you have completed your interviews, thank the interviewees for their time by sending them individual e-mails. When the article is published, notify the interviewees and send them the article's URL or send them a hardcopy printout. This effort will help you build long-term relationships and assist you in securing future interviews with the experts.

Reluctant Interviewees

In my writing experience, some people are not comfortable with being interviewed by e-mail. They may be reluctant to put words to paper or screen or they haven't developed a trust factor with you yet. After all, they may never have met you or know much about your background. With these people, you may have to set up a telephone interview first to establish rapport with them. Later on, follow up with e-mail questions on any open issues.

EXPANDING YOUR ONLINE OFFERINGS

Increase your pay and job opportunities by offering employers more than writing content. Take every opportunity to learn new skills at any job you take—even if you have to put in extra hours on your time. Take online courses, or courses on-site at a university, or teach yourself new skills.

Editing and Managing Content

Acquire editing skills and you could be an online editor who manages the stable of writers on a site and scouts out the Web, seeking new writing talent. You could also offer copyediting skills to ensure that the site produces high-quality, consistent, and accurate material. To acquire editing skills, take online courses from a reputable university or organization. After you gain more experience, you could also par-

ticipate in creating the content strategy for a Web site and planning the evolution of the site. Another job possibility is managing content projects for individual companies.

Learn HTML Skills

To write online documents, it's not necessary that you know how to do programming. Learning hypertext markup language (HTML) isn't necessary either; however, HTML is a simple skill to learn, and it provides you with a good background. You'll have a better understanding of how Web pages are created. Knowing the basics of HTML will also make it easier for you to communicate with Web developers.

Instead of learning how to use WYSIWYG (what you see is what you get) HTML editors, such as Microsoft Front Page, learn how to write HTML documents. Many sites on the Web today offer free HTML tutorials. One site, "HTML Goodies" (www.htmlgoodies.com), provides easy-to-understand online lessons and even sends out a free e-mail newsletter. The author, Joe Burns, Ph.D., has also written a book called *HTML Goodies*. You can practice your new HTML skills by creating your own personal Web page.

Keep Skills Current

Because technology changes quickly, it's important to keep your online writing and related skills current. Besides taking online courses and on-site courses at nearby universities, attend writing conferences, workshops, and seminars. Go to technology and industry conferences. Attend trade shows. Subscribe to print writing and technology magazines as well as to e-mail newsletters.

KEEPING IN TOUCH WITH CLIENTS

As you develop your list of regular clients and contacts, you may want to periodically send out an opt-in e-mail newsletter, informing them of new services that you offer, any changes in your business, or useful information that may help their business. Respect your clients' time. Keep the newsletters brief, and make sure they offer your clients value. Limit the newsletters to monthly issues. In this way, you'll remind your clients of your services but not spam their inbox. In every issue, offer clients the option to unsubscribe.

CONNECTING WITH ONLINE COLLEAGUES

If you want your online writing career to get moving, start interacting with your colleagues. Search the Web to find discussion groups where writers and editors talk about the state of the online content business, online markets, payment rates, and share ideas. Here's your chance to network, ask questions, get potential job leads, get new ideas, learn of deadbeat markets, and discover new reference sites. In these discussion groups, make sure you give back to your colleagues in the writing community. Let them know of job boards, e-mail newsletters that have helped you, or new Web sites. If a writer asks for help in a discussion group, offer suggestions.

ARTICLE DEVELOPMENT FORM

Magazine/e-zine _____ Deadline _____

Ideas for titles _____

Ideas for leads_____

Focus of article: What do you want readers to do, learn, know or understand?

(Write a brief statement to explain the focus of the article.)

Experts to interview (full names, titles, mail addresses, e-mail addresses, phone numbers)

Primary reference/research information (source, document, author, URL, date information was posted, date accessed)

Background details (for readers who want more details on topic; source, document, author, URL, date information was posted, date accessed)

Potential internal links within text (URLs)

Potential external links at end of article (URLs)

Potential visual and multimedia elements (graphics, photos, illustrations, tables; source URLs, date information was posted, date accessed)

Interactive elements (reader feedback, discussion question, poll, quiz, game, contest)

Chapter 7
Writing Content for the Web

Words are the building blocks of text on the Web. Online text plays many roles: it provides readers with content, orientation, and navigation. According to Levinson and Rubin, authors of *Guerilla Marketing Online*: "The written word is the chief method of communication in the online world."[1] "Words are your last, best way to differentiate yourself online, to make yourself stand out, and give your site a unique voice," suggests Nick Usborne, author of *Net Words*, a book on online copywriting.[2]

A study done by Stanford University and The Poynter Institute indicates that online news readers look for text on a Web page before they look at graphics.[3] Although writing for online news sites requires different techniques than writing feature articles or documents for intranets, clear communication is essential for any venue. Crafting well-written online text will enhance your chances of attracting readers to your site.

PREPARING TO WRITE

When writing for the Web, preparation is just as important as writing the intitial draft. First, you need to identify your target audience and its needs. Then you have to determine your purpose for the article or document you are writing. In the final analysis, all of your efforts should focus on meeting the needs of your online readers.

Target Audience

Before you begin writing, you should identify your target audience. What needs do they have? What motivates them? Molly E. Holzschlag (www.molly.com), an author, instructor, and Web designer, says that your site's first critic is your audience. Holzschlag knows what makes the Web work. She has been honored by Webgrrls as one of the most influential women on the Web. Holzschlag believes that the audience determines whether they will return to your site or not.[4]

Target Your Content

This same idea of targeting may be applied to content. If your content doesn't meet the needs of your readers, they won't take the time to read the articles or documents you have written. That's why it's important to match your writing to the readers with whom you are trying to communicate. Identifying the needs of your audience will also help you organize and focus your thoughts.

Learn about Your Audience

Ask your editor for reader demographics so you can better tailor your writing. Read the Web site's in-house style guide to learn more about your audience. Look at readers' e-mails and read message boards. To better understand your target audience, try to answer the following questions:

- What is the age and gender of your target user? (e.g., female or male teenagers, young working mothers, male retirees)
- What is their educational level? (e.g., high school graduates, college graduates)
- What is their cultural background?
- What are their spending habits? (e.g., luxury items, books, CDs)
- What is their occupation? (e.g., programmers, vice presidents, teachers)
- What are their hobbies? (e.g., leisure activities, gardening, gourmet cooking, traveling)
- Where is their geographical location? (e.g., United States, Australia, Great Britain)
- Do they have prior knowledge and experience with the subject? Are they professionals? Consumers?

- What are their motivations? (e.g., do they want specific information for a term paper, are they looking for a tutorial on a subject)
- What is their reading level? This determines the language and terminology you will use.
- Are they novice or expert Internet users?
- How familiar are they with using hyperlinks, browsers, discussion boards, chat rooms, searching the Internet, and filling out forms?
- Will they access your Web site from home or from the office?

Learn Your Audience's Language

In targeting your audience, you should also be aware of the familiar or common language that your particular readers use to communicate in their daily work or lives. For example, a computer programmer uses a different vocabulary than a registered nurse. If you have to write a document for one of these audiences, you will need to become familiar with the appropriate vocabulary before you can even begin to think of writing.

The Web can be a strong ally in your preparatory work. Use the major search engines to help find reputable research sites and journals. There you can read authoritative articles and begin to pick up the vocabulary of your target audience.

Different Users Have Different Needs

There are many different types of users on the Internet. Some users may visit your site looking for specific reference information and then leave to visit another site. Other users are willing to scroll through long documents and read online. Others may print documents and read them offline at a later time.

Once you have thoroughly identified your audience, you should determine the purpose of your online document. Identifying your readers and determining your document's purpose will help you decide what to include and leave out in your document.

Determining Purpose of Your Content

Determining the purpose of your writing means establishing what you want your readers to know after they have read your document. It helps to develop a one-sentence statement that sums up the purpose of your document, but you have to be precise. The objective "Writers will

learn how to write training materials for call center representatives" is too broad. The following statement: "Writers will learn how to write one-page, online job aids for call center representatives" is a more focused objective. A clear purpose will guide you through the writing process.

ONLINE WRITING GUIDELINES

To make reading easier for your users, you need to follow some basic online writing guidelines. These guidelines come from years of usability research about how people use the Web and seek out information. As you gain experience in online writing, you may find that some of the guidelines are better suited to certain types of documents, whereas other documents require that you take an entirely different approach.

Because online writing is a relatively new discipline, once you learn the basics, you'll benefit from taking on the role of an inquisitive researcher. Continually experiment with your online writing and learn from your experiments by listening to your audience. Keep up with the current theories on online writing by reading what the experts have to say in both online and print publications.

Write Short Text

Research from usability experts shows that users read about 25% slower on computer screens compared to reading from paper. Jakob Nielsen suggests that you write 50% less text than you would for hard-copy publications. Your message should be clear and concise. Your goal should be to help readers find the information they need as quickly as possible. If you're new to online writing, begin by writing your first draft in your usual manner. Then go back over your document and cut out any extra words, redundancies, and complex sentences. Break long paragraphs into short chunks, but make sure that each chunk of information can stand on its own. Trim down your headings and subheadings to make scanning easier.[5]

Your goal in online writing should be to maximize the meaning of your words and sentences with the least amount of text. This effort demands that all of the words and sentences in your documents have to contribute to your main point or be cut from your copy. For example, if you replace the clumsy-sounding phrase "at the present time" with the action-oriented word "now," your sentence suddenly picks up speed.

After you have gone through the first revision of your draft, go back and ask yourself: Does each word, phrase, and sentence contribute to the whole of the article?

Write for Easy Scanning: Basic Guidelines

Serve up information snack-style and write for scanability. Online documents must be concise and structured for fast scanning. On the Web, less is more. Following are some guidelines that will improve the scannability of your documents:

- *Avoid complex sentences and replace them with short, simple sentences.* For example, instead of writing, "E-mail newsletters, which are cost-efficient and timely, can help small businesses promote their products," break the complex sentence into two sentences: "E-mail newsletters can help small businesses promote their products. The newsletters are cost-efficient and timely."
- *Think short and simple, clean and concise.* Users tend to scan text, picking out keywords, headlines, links, and sentences while ignoring sections that don't interest them. Eliminate excess information that will slow readers down. Long ago, William Zinsser advocated simplicity and pruning of first drafts of copy. This theory holds true for Web writing today.
- *Use shorter words and phrases to draw your readers into your article.* For example, instead of "This is a topic that" write "This topic." To enhance scanning, you should also write shorter sentences, paragraphs, and lines of text.
- *Make sure your headlines and subheadings provide meaningful communication instead of puzzling words that tease the reader.* The headlines should let readers know what the article is going to be about. For example:

Poor headline: FAQ Tips
Better headline: Writing Clear and Concise FAQs

- *Build in structure with headings, subheadings, and sub-subheadings to help readers navigate your document.* Try using headings and subheadings instead of introductory paragraphs.
- Other elements that enhance scanning include large type, bold text, captions, highlighted text, and graphics.
- You can also use table of contents, bullets and lists to facilitate ease of reading.

- Make use of white space to give your readers' eyes a rest and use graphics to break up the page.

Chunk Content

Shorter paragraphs are easier on the eyes and make for easier scanning. You can also hold readers' attention with short paragraphs. Break up text into digestible chunks of 100 words or less to lure readers into your documents. Long, rambling, unbroken lines of text turn users away. Because many readers scan only the first sentence of a paragraph, it makes sense to begin paragraphs with strong topic sentences. Use the rest of the paragraph to provide readers with more details that clarify your original point.

Jakob Nielsen suggests splitting text into coherent chunks, with each chunk focusing on a specific idea. The chunks should be self-contained because your readers may view your text out of order. They may also have reached your content through a search engine. Another advantage of short chunks of text is that the text can be displayed on a screen without causing users to scroll. If you chunk your online content, you'll also reduce the possibility that readers will miss text that is orphaned below the bottom edge of their browser window. Overall, chunking makes navigation easier for your readers. It also works well for sites that display content in narrow columns.

As you write your first draft, use keywords to gain and keep your readers interest, and to let them know what follows in the rest of the article. Place a hypertext link menu at the top of long, detailed articles or provide additional information via hypertext links to users who may want it. The longer a block of text is, the more likely readers will skim over it without reading it. Take the time to step back and look at the organization of your chunks. There should be a logical flow from each chunk of information to the next. As you develop freestanding chunks for your article, think of how each chunk relates to the other. Then begin to develop meaningful transition sentences between the chunks.[6]

Write in Simple Sentences

Short, punchy sentences tend to work well in online writing. Simple sentences are easier to read on the screen, and they are easier to understand than complex or compound sentences. Readers are more likely to begin reading your article if you grab them with a short, snappy lead. Eliminate connectors such as "in addition," "however," or

"therefore." If readers come upon your article and are faced with long, complex sentences, they won't stop to figure out what you're trying to say to them. They will click onto the next reader-friendly site.

Use short, familiar words in your sentences that communicate in the readers' language. For example, you would use a different set of vocabulary for an article on a mystery writers' site than if you were writing an article for a technology site; however, don't "dumb down" content to the point that you insult readers.

Variety in your sentences will engage your readers and have greater impact. Strive for a good balance of longer sentences interspersed with shorter sentences to hold readers' interest, but keep the focus on short sentences.

Ban the boring and bureaucratic text and meaningless marketing hype or you'll lose your readers. Instead, captivate readers with conversational sentences to create a comfortable online environment. Put the accent on a positive tone to reach more readers. Make it a point to review every sentence you've written. Cut out each word that doesn't contribute to the main point of the sentence.

Tight Writing

Tight writing is even more important on the Web than in print. Your words, sentences, and paragraphs will have more impact if you eliminate unnecessary words and phrases. Writing succinctly is a continual juggling act. Although unessential words should be cut, clarity should not be sacrificed for brevity. Use strong verbs to produce a stronger message in your documents. Avoid turning a strong verb into a noun or pronoun. For example, use "decide" instead of "make a decision."

Wordiness also results in the needless repetition of the same idea in different words in a sentence. An example of repetitive wording is: "On the Web, online writing should be clear and concise." Better to use this succinct example: "Online writing should be clear and concise." Write "now" instead of "at the present time." Write "because" instead of "as a result of." Use "this subject" instead of "this is a subject that." Use short, familiar words to get your point across to your audience, such as "record profits" instead of the phrase "unparalleled growth."

After writing your first draft, go back and revise your words so that you communicate by using the fewest words possible without changing the original meaning; however, don't revise so deeply that you change the essence of your communication. For example:

Original sentence: According to the CEO, the results of the first quarter were below projections by 40%.

Poor Revision: The CEO said that the first quarter results were far below projections.
Better Revision: The CEO said that the first quarter results were 40% below projections.

Use present or present perfect tense in your online writing. The Web has an immediate presence; use this asset to keep your text fresh.

Online readers are impatient and want concise information; however, if they like what they see, they also want the option of getting more details through hypertext links and a search engine on your site that will take them to interior pages.

Make Every Word Count

Because your document is only one click away from the competition, you have a limited amount of time to make your point. Therefore, it's important to make every word count in your documents. When writing your first draft, aim for clean-sounding prose. Snip unnecessary verbiage from sentences. Change phrases into single words to make your message stronger. For example, "The writer with the most talent" becomes "the talented writer."

Convert unnecessary clauses such as "that," "who," and "which" into phrases or words. For example, the sentence "The book which was published recently" becomes "The recently published book." Cut out redundant words. For example, the sentence "The gem was turquoise in color" can simply be changed to "The gem was turquoise." Remember to use words and categories that make sense to users instead of jargon or acronyms that may be unfamiliar to them.

Active Voice

Active voice is paramount on the Web. Online writing requires a greater sense of immediacy compared to print. Readers are in a hurry. If you take too long to tell your story, you'll lose readers before they even finish your first couple of paragraphs. They'll be reading those stories on the sites that command their attention with an active voice.

By using an active voice in your online writing, your sentences will be stronger, clearer, and less wordy. Active verbs give energy to your sentences. The direct quality of the active voice also grabs your readers' interest and keeps them on the page. Passive sentences are usually more wordy and difficult to understand. Writing in the active

voice will decrease your word count and increase your clarity level. For example, the following passive sentence, "It was reported by Marketing that the new campaign is failing," is improved by taking an active voice approach: "Marketing reported that the new campaign is failing."

Credibility

Readers will judge your credibility based on the quality of your content. The language and tone of your writing can also add to or detract from your credibility. When users read your content, they wonder about your qualifications, motivation, and trustworthiness.

Provide author and/or publisher contact information in your documents in case readers want to contact you via e-mail. Date your documents. Credible hypertext links can also add to the quality of your content. For example, the Health on the Net Foundation™ Honor Code icon tells consumers and health professionals that they can find useful and reliable online medical and health information on sites that display the icon.

Increase your credibility through careful spelling, correct grammar, and well-documented facts. Errors cause readers to question the accuracy of your information. Errors also send the message that you don't care about the details in your writing.

If readers notify you about typos or grammatical errors, act on the information and correct the problems. Continuous improvement should be your goal; to achieve it, you can benefit from user feedback and a commitment to excellence. The advantage of the Web is that users can instantly tell you what is not working, and you can immediately correct the problems. Unlike magazines or books, you don't have to wait until the next issue or edition is printed to make the correction.

Date Documents

It's important to date all of your documents. According to Jakob Nielsen, hardware and software may change, but data lives forever on the Web. On every page, indicate the date the document was first published and the date it was last updated. This helps users judge the credibility and relevancy of your content.

Even if the documents do become dated, the content may still be relevant to some readers. Older documents still show up in search engines and continue to get hits long after the original publication

date. Therefore, it's important to archive the documents on your site so users can find them easily.

Stickiness

Stickiness applies to the ability of a Web site to attract repeat visitors and to keep visitors on that site. It measures the amount of time a user spends at a site. A 1998 Forrester Research report concluded that content is what drives 75% of consumers to return to favorite sites.[7] Doug McFarland said that America Online (AOL) and others at the top of the stickiness list offer a mix of "the four C's: community, content, communication, and commerce." These sites give visitors a place to shop, chat, exchange e-mail, and entertain or educate themselves without straying elsewhere.[8]

Stickiness applies to your writing as well as to a Web site. To keep readers' attention, make sure you apply the sticky factor throughout your document. At the end of your document, ask for reader feedback via your e-mail address or discussion boards. Survey your readers to determine their interests, and write content to meet those interests.

User-Generated Content

Increase your site's value and stickiness by encouraging and managing user-generated content. When users submit ideas, they are creating the content for you. An arts-and-crafts site, for example, can contain techniques provided by volunteer experts, photographs of users' crafts, monthly contests for readers, and how-to instructions arranged in specific categories. A moderated discussion board can also encourage fresh content. One example of such a site is the Delphi rubber stamping craft site: http://www.drstamping.com.

Total Package

Content includes more than just text on the screen; it includes graphics, illustrations, animation, video, audio, and user interactivity. Design elements and content need to mesh. Web design professionals and writers must collaborate. Early in the developmental process, open communication between the two groups will ensure that the combination of graphics and text will enhance the site. The total package will then help users intuitively understand how to navigate the site.

STYLE AND VOICE

Successful online writers create relationships with their readers by developing a distinctive style and voice that is able to reach out and makes personal contact with individual readers.

Personality

Because the Web is a personal communications medium, people expect a unique voice from online writers. Your distinctive online voice hooks readers and sets the tone for your article. Online readers will be attracted to a conversational, friendly, energetic, and upbeat tone. Your positive energy will pull in readers.

Take a look at a variety of Web sites. Find those Web writers who project a certain compelling attitude in their articles that makes you want to read more. Notice how they adopt a "hip" and "up-close" way of talking to their audience. Their unique writing style transcends the barriers of the computer screen and draws you into their world as you scan their text. Analyze their style. What can you learn from them?

Imagine a typical reader as you write your article, and try to speak directly to that person. Are you writing to a sports enthusiast or an artist? Write as descriptively as possible using your imagination to convince your readers to spend more time reading your words. Readers will become more comfortable with you and come back for repeat visits to your site.

A unique voice also has the potential to annoy some readers, however. Your readers may not like your style of satire or blunt approach. Take the pulse of your online voice by listening to reader feedback via e-mails and bulletin boards. Weigh the positive and negative feedback you get from your readers on your writing.

Putting the "You" into Your Online Writing

The Web is a more personal medium compared to the passive watching of television or listening to the radio. Users are involved in an ongoing, two-way communication experience. They participate in online discussion boards and send e-mails to their favorite online columnists. To capitalize on the personal tone, write in a direct manner to your audience. When communicating with readers, use words like the second pronoun "you" or "your" or first pronoun "we," "ours," or "us." Use examples of events or people to which readers can relate. Be aware that about half of all users today are nonnative English

speakers. Therefore, avoid slang expressions. Similarly, keep away from corporate-sounding text borrowed from the pages of an annual corporate report or a hard-sell approach.

Humor

How should you handle humor in your online content? Analyze and monitor your site and audience feedback to determine its capacity for humor. A site that's heavy on satire can take more humorous risks than a news site; however, you might write an article that you think is funny, while some readers may think it is in poor taste. Listen to your readers' comments. What are most of your readers saying? Look at the number of hits your site is receiving. Did your last article generate a high number of visitors?

Humor can make a site more personal and human or it can be used to explain complex subjects such as computer technology; however, humor also has to be used with care because it's highly subjective, often culture-specific, and can be offensive to some people. It's all a matter of balance. By continually monitoring your audience through e-mail feedback and surveys, you should get an idea if they are enjoying your humorous take on life.

Write for International Readers

Creating content for international markets involves more than simple translation. You need to deal with cultural issues, legalities, and local regulations. Judith Broadhurst (www.ExcellentEdit.com), an online editor and writer, offers these suggestions:[9]

- Do not use contractions because readers in other countries or even within the United States might not understand them if English is not their native tongue.
- Avoid American slang or colloquialisms. Remember that some languages have gender-specific variations, but by no means all do.
- Try not to think so much as an American, but rather as a global citizen who is aware of and sensitive to other political and economic realities, beliefs, and cultures. To achieve a long-term strategic advantage, you need to "Think and act globally."

You may be called on to create content for another country. To effectively globalize your content, you should find a compatible partner in the

country where you plan to produce content. Your partner will under-stand the local market and how to deliver the content better. This effort will ensure that your translations are accurate and appropriate, and that you're sensitive to cultural considerations.[10]

WRITING STYLE AND FORMAT

As the Web continues to evolve, online writing styles are evolving, too. You should base your writing style on your target audience and the type of document you are writing. Before you begin to write, determine if your audience will want fast facts or a document that provides detailed information.

Because you are writing for the Web, make sure you include those keywords in your document to adequately describe your topic. This tactic increases the chances of search engines displaying your docu-ment when users do a search.

Inverted Pyramid Style of Writing

Newspaper journalists have long used the inverted pyramid style of writing. Many online content experts suggest that writers use this style when developing online documents as well. By using this approach, you offer your readers the main points (who, what, where, when, why, and how) of the story in the first few sentences and then the option of reading the rest of the article if they are interested. Make sure your story remains focused.

Before you even begin writing, ask yourself what is the one thing that your story must say. Begin your article by stating the conclusion first. For example: "Controlling your weight can help you lower your blood pressure, cholesterol levels, and risk for diabetes." Next, use the details section to provide readers with important supporting information such as quotes from experts or reference material from credible sources. Finish up your document by supplying readers with background information, such as statistics on obesity and other health problems that are associated with obesity.

On the Web, the inverted pyramid style offers a convenient option to readers. Because usability studies show that most readers don't like to scroll, readers will be able to obtain the most important information by reading the top part of the article. Those readers who want more information have the option of scrolling and reading the entire document.

Layering Information to Address Different Audience Levels

You can also use the technique of layering information to address different audience levels. For example, novice users may want only basic information on a subject like how to use search engines to find information on the Web; however, expert users may want links to more details such as how to use databases to do Web research.

To add value to your article, add a hypertext menu at the top of the page with links to the appropriate sections. Adding internal links within the article can provide information on terms that are unfamiliar to novice users or additional background information on the topic. Make sure that the links tell readers what information they can expect to find,[11] but do not add too many internal links or they will distract readers.

A good example of how to display hypertext menus and internal links in an online document can be found on the HTML Goodies (www.htmlgoodies.com) site. The site offers tutorials and primers authored by Joe Burns, Ph.D. His use of hypertext menus and internal links in each individual lesson makes it easy for users to learn about the subject matter.

Other Styles of Writing

Other writers recommend that online writing demands a new style of writing. Dr. Mario Garcia, of the Poynter Institute, suggests that online journalists throw out the inverted pyramid and experiment with the champagne flute instead. He believes that books have more in common with Web sites than newspapers. Garcia says to think of the story as a champagne glass where the story flows gracefully, narrowing to a point of interest or excitement. He suggests that in this format, the "story is told in smaller chunks, with excitement renewed every 21 lines or so." Garcia believes this approach helps maintain reader interest similar to how a good novel holds a reader's attention.[12]

Garcia reminds us that newspapers are intended for the masses, whereas the Web is more targeted. People know the kind of information they will find when they visit a news site, just like they do with books. On online news sites, Garcia recommends using titles, subtitles, an index, well-defined pages, and good-sized photos balanced with text and white space. He suggests paying more attention to headlines. He reminds us that titles sell books and that titles on Web sites are just as important.[13]

Online writing is still a relatively new discipline and the technology itself is constantly changing. The writing techniques we use today will continue to be perfected. Online writers should keep up with new theories and be open to experimenting with their writing style.

Long Documents

Long documents are difficult to read on screen because users have to scroll and attempt to remember the information that is off the screen. Most users either print long documents out or save them to their hard drive or disk.

If your content requires that you develop longer documents, subdivide the information and add subheadings, links, "jump-to-top buttons," and a menu (table of contents) at the top and bottom of the document.

If you are providing long documents on the Web, make printing an easy one-step process. Do not put your sections, or each paragraph, on individual pages and require readers to print out each section or page individually. Provide a separate link to the complete, printable document. Some sites do this by displaying a printer icon with the words "print version" next to it or a separate link to a "print version" of the article.

What about Readability Scores?

Word processing software usually comes with tools that can check the reading level of your documents, including readability scores. Readability scores base their ratings on the average number of syllables per word and the number of words per sentence. Although these tools can give you a general idea about the reading level of your documents, they are not foolproof. Instead, you might want to revise your first draft and then hand over the final copy to a professional copyeditor on the Web team staff.

Write to Be Found

Search engines find Web sites and pages based on the keywords or phrases that users type into the search box. The results of the search are then ranked by relevancy and displayed to users on a "results page."

Although you depend on search engines to bring traffic to your site, the search procedures and indexing criteria of these search engines are

continually changing. Here are some suggestions to gain more attention for your site:

- First determine the keywords for your site and then use these keywords to write the abstract for your home page and interior pages.
- Use keywords in titles, the introduction, headings, and subheadings of your copy.
- Make sure your site's name is in the URL, site title, and/or in the first 200 characters or less of the home page.

Write a Descriptive Abstract in the HTML Document

Increase your chances of being found by writing descriptive text in your site's page abstract. The page abstract is enclosed in a META tag with the name "description" in the page header of the HTML document. Page abstracts show up in search results listings when users conduct a search. A well-written abstract will give users a good idea of their potential destination and what your site/page is all about, saving them time and winning you possible visitors.

To see an example of how this is done in Microsoft Internet Explorer, visit a Web page. Look at the HTML document that is also known as "source code" behind the page. You can do this by clicking on "View" at the top of your computer screen. Next click on "Source." The HTML document will appear on your screen.

List Descriptive Keywords in the HTML Document

Another way to expand your rate of return is to add a list of specific keywords that illustrate your topic in a META tag in the page header. Most users will find your pages through keyword searches. Use both simple words and compound words. You could also include synonyms that generally and precisely describe your topic. Avoid words that have more than one meaning because they will produce meaningless search results.

Look at Keywords on Your Competitors' Sites

Make a list of all the keywords on your home page and interior pages. Use these keywords to search the Internet for competitor sites that are similar to your own. Now look at the top sites returned by the search engine and analyze the keywords on the pages of the competitor sites. Are the keywords in the pages you found similar to the keywords you use on your own pages? Are there any new keywords you can incorporate into your pages to help users find your site when they do a search?

WRITING NAVIGATIONAL AIDS

Navigational aids should provide a clear roadmap for users on the Web. These aids come in many forms: microcontent, titles and headlines, subheadings, leads, menus, hypertext links, annotated links, lists, sidebars, and captions.

As you create new documents, you need to incorporate navigational aids when writing your first draft, rather than inserting the aids after you are done writing or letting the designer make the final decision. Whether in the form of headlines or links, these aids help users understand the purpose of your site or document, its organization, and how to move around and get the information they need.

Microcontent

Microcontent can include headlines, subheadings, navigational bar text, and link texts. The text should be no longer than five to eight words in length. Microcontent should be written so it is self-explanatory and meaningful so that readers can quickly understand the nature of the text. Because a user can enter any one of your Web pages from a search engine or another site, microcontent can't depend on context (e.g., surrounding content).[14] The hypertext link "Breakfast Meals" doesn't let readers quickly know what will be covered if they click on the link, whereas "Breakfast To-Go Recipes" lets readers know they will get fast breakfast recipes by clicking on the link. Following are basic guidelines for writing microcontent.

Titles and Headlines

Titles and headlines play many different roles on the Web. Titles can direct readers to the information they are looking for. Used creatively, titles can draw attention to information that readers might otherwise pass over.

How to Write Titles

When writing titles, headlines, and subheadings, use a consistent approach to help readers navigate through Web pages. Titles should be written to tell users what the topic is about. A title often appears in bookmark lists, a list of retrieved topics from a search engine query, annotated lists, a listing in an e-mail newsletter, or in an index. Titles

that are context-dependent, such as "click here" or "chapter one," do not communicate anything to users and will frustrate them. Avoid beginning titles with "A" or "The." It is important to develop meaningful page titles because they are usually the primary reference to Web pages. Use recognizable words and plain language. Avoid acronyms and cryptic titles. Write titles so they are easily understandable to readers because titles usually have to stand on their own. Your title should not depend on the topic itself or other surrounding information to provide meaning. Because online users often select a specific item from a list of topic titles, it's important to clearly and accurately present the topic's contents. Otherwise, you are wasting the users' time.

Make Titles Easy to Scan

William Horton, author of the book *Designing and Writing Online Documentation*, suggests making titles scannable by making the meaning of the title obvious at a glance without further reading. He recommends putting the most important words at the front of the title. Horton says that "Users tend to select titles that promise specific answers to their questions."[15] This approach also facilitates scanning. The title will also have a better position in an alphabetized list. Begin your title with the concept or company addressed in the article. Avoid page titles that begin with the same word because users will not be able to differentiate when they scan a list.

Examples:

No	Yes
How to make nutritious lunches	Making nutritious lunches
How to increase your fiber intake	Increasing fiber intake

Avoid Teasing or Cute Titles

Teasing or cute titles require users to keep reading or follow a link to find out more information about the topic. This approach interrupts readers who are looking for specific facts. Although a clever heading can liven up an article, avoid headings that obscure clear communication and understanding. Give readers a good idea of what they will find if they read further. For example, the headline "Writing without sentences" may arouse curiosity in your readers, but it forces them to continue reading or to click on a link to understand your point. Better to say "Communicate with headlines."

Pull Readers in with Titles

Besides conveying its message, your title needs to perform double-duty and draw readers into your article. Take a look at good examples of Web sites. Look at some newspapers and magazines for additional ideas. What titles make you want to read a particular article? Do the titles use action verbs? Does the following title, "Make readers sit up and take notice," grab your attention? As you write your first draft, try to develop a catchy title for your article. After you are finished writing, take another look at your title. Does the title give readers a good idea of what you will cover in the article?

Subheadings

Many of the same principles that apply to titles also apply to sub-headings. Use subheadings to break up large blocks of text and to help readers skim text. Subheadings should sum up what each section covers.

Just as you do with titles, focus on meaningful subheadings to communicate your message. This technique helps users scan, find the sections that interest them, and get an idea of the main concepts of your document. Use color and fonts to make your subheadings stand out. To organize your document, author Crawford Kilian believes that: "Web writing, being hypertext, thrives best under categorical organization." For example, "Six ways to increase your fiber intake" or "Ten Best Wines of New York." "When users can jump from chunk to chunk, they get to their destination faster."[16]

Menu

After you have written meaningful subheadings for each section of your document, add the subheadings to the top of your document in a menu format. The menu will serve as a table of contents to your document and help readers to scan. Link the subheadings to the appropriate sections in your document. The hyperlinks will help readers easily locate the information they need. Similar to titles, it's important that the subheadings tell readers what each section will cover. A subheading such as "chapter one" or "section one" will only confuse readers and waste their time.

Leads

People reading on the Web have short attention spans. Reading on screens is difficult. Not only do many sites compete for readers' attention, but advertisements also call out from all corners of the screen. Grab your readers' interest by learning to write compelling leads that summarize the story.

The lead is where your readers will decide whether they will continue to read the rest of the article or click onto the next document. The lead should tell readers what the story will cover and what information will follow. A catchy lead with a tantalizing morsel of information will hook readers and give them an incentive to read the rest of your article.

In the lead, begin to build a strong relationship to the rest of your article. This approach will entice readers into finishing your article. Here is the lead from an article on the eDaycare Web site (www.edaycare.com) about how to teach children to whip up nutritious recipes:

> Add a scoop of nutritious food, toss in a group of children, sprinkle in some fun, and you have the recipe for healthy kids. But how do you jump-start the recipe?[17]

It is often easier to write the lead after you've written the first draft of your article. By then you should know where your article is going and the main points you will be covering. If you bury the lead in your story, you risk losing readers who won't take the time to scroll through your document to find out what you're trying to say.

Create good leads by asking a question, citing a quote, making an unusual statement, or directly addressing readers with the "You" factor. Or you can start with the action of the story and go back and fill in the details later.[18]

Hypertext Links

Links show up as words or phrases that are underlined or highlighted. For example, if readers click on a specific term like *intranet*, they will be taken to the definition of that term. Links can provide your readers with connections to other content, references, or definitions of complex terms. Links can provide more background information for readers who want the details behind the basic story. Links can also offer information to users who are less knowledgeable about a subject, such as a tutorial on how to use a search engine; however, links are also a distraction. Avoid disrupting readers with link overload in your

document. Limit your use of links and put only the most important and interesting links within the main body of your document. This approach helps retain readers so they finish reading your document. Choose meaningful words or phrases for links. Links that say "click here" or "next" waste readers' time because they don't communicate a message. Likewise, avoid the phrase "click here for more information." Avoid vague links that don't tell the reader what to expect, such as "tutorials" or "references." If the link is a button that is labeled "hiking trails," the user will expect to go to a page that provides a list of hiking trails. Write surrounding text to help readers understand what the link will show them. For example, *Writers sites* should provide a list of online writing sites.

Attempt to match the link text that the user clicks on with the title on the resulting page. If users click on the example "Writers resources," they should be taken to a page that is titled "Writers resources," not "Writers reference sites." Liven up dull link phrases by turning them into action verb phrases. For example, the phrase "application form" can become "join now."

Help users understand the value of each link because readers pay a "time penalty" for every link they follow. If readers find that the information at the other end of the link is not worth reading, they will have to back up to continue their searching.[19] When placing links within sentences, first write the sentence and then place the link anchor on the most relevant word in the sentence.[20] The sentence should help readers understand where the link leads.

Place all informative links, reference links, or links to external sites that provide information that your site doesn't offer at the end of the document.

If you are sending readers to another site, make sure the words surrounding the link tell readers that they will be leaving your site and entering another site.[21] Remember, however, that users who leave your site may never return.

Pay attention to broken links within your site. When users find broken links, they become frustrated and usually lose confidence in the site. If users tell you about broken links, thank them and quickly fix the problem.

How to Write Annotated Links

Annotated links offer brief summaries of the contents of a link's destination. The destination may be a page within your site or an external site.[22] A well-written annotation tells users what to expect and saves them time. An example of an annotated link might be:

Writers Grants for U.S. Citizens
descriptions and online application forms

Be consistent and specific when you write annotations. Use clear explanations, active verbs, and parallel construction. Provide the same amount of information to describe each link in a list. Help users get an idea of what the site might offer them. Avoid vague annotations that don't communicate a message.[23]

List Annotated Links at the End of an Article

Provide annotated links when you list a set of links at the end of your article. To facilitate scanning of the list, use bullets or add a descriptive title for each link. You should also include the actual URL of the destination sites in case users print your material to read later on. In that way, readers can easily locate the sites by typing in the URLs. If you list separate categories of links, write a brief introduction for each category.[24]

Think of Potential Links during Your First Draft

As you begin to develop the first draft of your document, start thinking of how much detailed information readers may want from your article in the form of links. Are they interested in additional reference materials? Would links to external sites be helpful? When I write articles on nutrition, I put links to government sites at the end of my documents. Readers can find more detailed facts on nutrition if they want it, and they can be assured that they are visiting credible sites. Putting the links at the end of the article also does not disrupt readers' attention.

Annotated Link Lists

You can offer readers a useful service by providing a list of annotated links on a separate page on your Web site. This service can also generate more traffic to your site. To create a focused list, first determine the main purpose of your list. For example, the purpose of your list could be to provide resources for writers. Next, define your specific audience. Your specific audience might be freelance writers.

Choose those links that relate to your list's purpose and that will interest your specific audience. If your list is lengthy, break it up into natural categories that your readers will understand. Natural categories

for an annotated list for freelance writers could include online references (e.g., dictionaries, thesaurus, quotations), writers' job boards, writers' e-mail newsletters, and writers' organizations. As you create the list, look at the entries from your readers' viewpoint. Each link should meet your readers' needs and interests.

At the top of the page, list the categories in a menu format. Write a brief introduction for each natural category so readers will know what to expect when they click on a link. You should also write a brief phrase or sentence for each individual link. Annotations for categories and individual links become especially important when you have lengthy listings, such as for large and complex companies or organizations. In all cases, let readers know the link's destination. For example, tell readers whether they will arrive on the Web site of ABC company or the DDD training site.

Develop a maintenance schedule to regularly review your list of links. Add new links, update links, and delete obsolete resources. Encourage readers to report broken links they find on the list and to tell you of new resources they find on the Web. Thank readers for their help.

Lists and Bullets in Documents

Using lists and bullets in documents makes reading easier for your users. Instead of presenting long paragraphs composed of complex sentences, use lists and bullets to highlight parallel words and phrases whenever possible. Lists are easy to skim, cut down on extra words, and are a good way to present related information such as a list of links or the benefits of a product.

How to Write Lists

Each item in the list should be about one to five words in length. Lists can be ordered in consecutive numbers or begin with an identical bullet. Use numbered lists when the order of information is important, such as in the steps of a project. Use bullets or unordered lists when the sequence of information is not important and when each item in the list is approximately of equal value.

To help readers understand how a list fits in with the surrounding sentences, provide adequate transitions before and after any lists. Use parallel sentence structure when developing your phrases for lists; each phrase in the list should begin with the same part of speech. To improve readability, use blank lines between each bulleted item. If the bulleted item is a few lines long, summarize the main point with a sub-

title. Aim for balance when using lists. Too many lists will make your article read more like a sales aid.

Sidebars

A sidebar is a short piece of text that is presented outside the chronological flow of the main online document. Sidebars can entice readers to read more of a specific article. Sidebars can be used to present interesting information that is related to the main document. Providing descriptive sidebars, along with hypertext links to the full text of an article, also gives readers more choices depending on their need for information.

Sidebars can also serve as navigation cues pointing readers to categories within your site, such as archives, user tools, printer-friendly versions of your articles, subscription signups, or search engines.

Captions

Captions can accompany photos, graphs, illustrations, or tables in a document. Write the caption so that it uniquely and clearly identifies the image.

WRITING CONTENT FOR PERSONAL DIGITAL ASSISTANTS AND MOBILE PHONES

Online writers face a greater challenge when they have to write content for wireless personal digital assistants (PDAs) and mobile phones. The screens of these devices offer a small space to display content. The information needs of users may be somewhat similar to the content presented on the Web, but the presentation capabilities are different because of the devices' space constraints.

Users of portable devices also have different requirements compared to users who view content through standard Web browsers. Mobile users usually want specific and quick information or wish to perform specific tasks. They may want to access the latest national news, local weather forecasts, stock quotes, or sports scores; locate local restaurants; and find out about the upcoming cultural events in their area.

These users need brief but strong text. Steve Outing, CEO and founder of Content Exchange, suggests that writers condense and tighten the text that will be displayed on the small screens of these

devices. Outing gives the example of taking 25% of the content that is on the Web and rewriting it for the smaller screens. Additional editing is essential when writing content for PDAs or mobilen phones.[25]

WRITING THE FIRST DRAFT

Now that you have read about the techniques that make online writing work, it's time to tackle the first draft. As you write your first draft, begin to develop subheadings for each section. This practice will help you organize your document and ensure that each section flows naturally into the next section. Think about the links that will support your article. These include links within the article that provide information to related sections within your site and links placed at the end of your document that direct users to external sites.

To help you organize your thoughts, storyboard your main chunks of information on separate four-by-six-inch index cards. Write down subheadings and topic sentences for each of these chunks of information. Write a rough idea of the contents of each chunk on the cards. List your reference sources on the cards. Start laying the cards out in logical order using the inverted pyramid (or another logical style) to tell your story. At this point, rewrite your subheadings if necessary. After completing this process, examine any leftover cards and determine if readers would be interested in additional information on the subject in the form of links.

Another method of organizing your ideas is to use the document outline function in Microsoft Word (or other word processing software) to help achieve a logical flow to your first draft.

Be Specific

Take a quick read through your document. Do your words create vivid images for your readers? Keeping users reading is all in the details. The phrase "double chocolate chip ice cream cone" paints a stronger picture than "ice cream cone." Look at the organization of your draft. Determine if your readers will find the document easy to understand. Search for any gaps in the information you presented.

Breaking Rules

Because the Web is a new medium, we're all still learning. The rules we apply to today's online writing may not work in tomorrow's world.

As marketing continues to play a bigger role on the Web and the boundaries between content and e-commerce merge, online writing will continue to change.

Use the Wonders of the Web to Your Advantage

After a print publication has gone to press, you can't make changes to the copy. On the Web, you can quickly correct errors, update statistics, and make changes. Take advantage of the wonders of the Web by looking at your documents as works-in-progress that can be continuously improved. Later on, if you find additional facts that will enhance the worth of your document, include the information. If your readers send you important input that you did not include in your original document, make the revision. By continually adding to your original document, you increase the value of your writing for readers.

FIRST DRAFT CONTENT CHECKLIST

After you finish writing your first draft, ask yourself the following questions.

- Did your document achieve its main purpose?____
- Did you target your content to your audience?____
- Did you print your copy out and read the hard copy version?____
- Does your lead tell readers what your article is about?____
- Is your message clear?____
- Does each paragraph present one idea?____
- Will the page title of your document remind readers of the document's contents? How will your page title look in a long list of bookmarks?____
- Do headings and subheadings communicate your message?____
- Did you bury your lead?____
- Have you used active verbs?____
- Did you overdo links within the body of your article?____
- Do your links tell readers what to expect?____
- Did you delete the "click here" links?____
- Did you cut excess words and sentences?____
- Did you tighten up your writing?____

- Is there a good flow between the chunks of your document?____
- Did you create vivid pictures in the reader's mind?____
- Did you test your writing by reading your copy out loud?____
- Will bullets get your message across faster than sentences?____

ENDNOTES

1. Levinson, Jay Conrad, and Charles Rubin. *Guerrilla Marketing Online: The Entrepreneur's Guide to Earning Profits on the Internet* (New York: Houghton Mifflin, 1997), p. 195.
2. Usborne, Nick. "The Last, Best Way to Differentiate Yourself Online," ClickZ Network, Permission Marketing (e-mail newsletter), December 30, 2000, p. 2. Reprinted with permission from www.internet.com. Copyright 2001 internet.com Corporation. All rights reserved. internet.com is the exclusive Trademark of internet.com Corporation.
3. Lewenstein, Marion. "Eyetracking: A Closer Look—A Deeper Probe Confirms Findings," Poynter.org, www.poynter.org/centerpiece/071200.htm. Accessed October 9, 2000.
4. Holzschlag, Molly E (www.molly.com). "Using Language to Persuade Web Audiences," *Web Techniques*, April 2000, p. 30.
5. Nielsen, Jakob. "Be Succinct! (Writing for the Web)," Jakob Nielsen's Alert Box for March 15, 1997, www.useit.com/alertbox/9703b.html. Accessed April 9, 1999, p. 1.
6. "Page Length," Guide to Web Style, Sun Microsystems, Inc., updated August 2, 1996, wwwwseast2.usec.sun.com/styleguide/tables/Page_Length.html. Accessed April 9, 1999.
7. Murphy, Kathleen. "Stickiness Is the New Gotta-Have," *InternetWorld*, March 29, 1999, www.internetworld.com/print/1999/03/29/news/19990329- stickiness.html. Accessed May 7, 1999. Reprinted with permission from www.internet.com. Copyright 2001 internet.com Corporation. All rights reserved. internet.com is the exclusive Trademark of internet.com Corporation.
8. Ibid.
9. Broadhurst, Judith (www.ExcellentEdit.com). "Multilingual Content Translates into International Success," Internet Content.net, November 7, 2000, www.internetcontent.net/Newsletters/Newsletter110/Newsletter110. html. Accessed March 21, 2001.
10. Ibid.
11. Nielsen, Jakob. "Inverted Pyramids in Cyberspace," Jakob Nielsen's Alert Box for June 1996, www.useit.com/alertbox/9606.html. Accessed April 9, 1999.
12. Garcia, Mario. "A New Media Renaissance; Producing, Editing & Designing Online News," a Poynter Institute Seminar, May 2–7, 1999, www.poynter. org/onlineseminar/mgarcia.htm. Accessed August 2, 1999, pp. 1–2.
13. Ibid.

14. Nielsen, Jakob. "Microcontent: How to Write Headlines, Page Titles, and Subject Lines," Jakob Nielsen's Alert Box for September 6, 1998, www.useit. com/alertbox/980906.html. Accessed April 23, 1999, p. 2.

15. Horton, William. *Designing and Writing Online Documentation*, 2nd ed. (New York: John Wiley & Sons, 1994), pp. 119–121.

16. Kilian, Crawford. "Effective Web Writing," *Web Techniques*, www. webtechniques.com/archives/2001/02/kilian. Accessed January 20, 2001, p. 7. Copyright CMP Media LLC 2001, used by permission.

17. Maciuba-Koppel, Darlene. "Snackin' and Lunchin' Fun," eDaycare.com, www.edaycare.com. Accessed November 13, 1999.

18. "How to Write Summaries," Good Documents, www.gooddocuments.com/techniques/summaryexample_m.htm . Last modified June 1, 1998. Accessed April 9, 1999.

19. "Links," Guide to Web Style, Sun Microsystems, Inc., updated August 2, 1996, www.sun.com/styleguide/ta . . . /Links.html. Accessed May 1, 1999.

20. Lynch, Patrick, and Sarah Horton. *Web Style Guide: Basic Design Principles for Creating Web Sites* (New Haven, CT: Yale University Center for Advanced Instructional Media, 1999), p. 104.

21. Ibid.

22. Sammons, Martha C. *The Internet Writer's Handbook* (Needham Heights, MA: Allyn & Bacon, 1999), p. 143.

23. Ibid, p. 144.

24. Ibid, p. 146.

25. Outing, Steve. (CEO and founder of Content-Exchange, http://content-exchange.com) Telephone interview, July 20, 2001.

Chapter 8
Editing Web Writing

After you have written the first draft of your copy and completed an initial revision, it's time to proofread and edit your work to prepare it for the Web.

EDITING PROCESS

Taking the time to carefully craft your words will result in copy that gets read. Thorough editing requires that you follow a set of specific steps to ensure that you have caught all errors. Mistakes in your copy could make readers question your credibility. Reference stylebooks, dictionaries, and an in-house style guide that has been customized to meet the needs of your site can help you produce accurate and reader-friendly documents.

Cooling Off Your Draft

Allow your first draft to "cool off" before you pull out your red pen or put your manuscript in edit mode on your PC. After a day or at least a few hours of setting the manuscript aside, you're more apt to spot clumsy prose and blatant errors in your text.

Initial Proofreading of Your Draft

In fact, it's better to proofread your work by printing out a hard copy of your document. It's easier to catch errors in a printed document.

Proofread in steps and check all the headings and subheadings first. Use a ruler to proofread. Sliding a ruler down the page as you read helps you perform a detailed, line-by-line review of the page. Take the time to read every single word. Read your copy out loud. Reading out loud forces you to slow down and read each word. This practice also enables you to take advantage of your two senses of both seeing the words on the page and hearing the words out loud. Listen for good sentence structure as you read out loud. To better catch errors, read backward through each line from right to left instead of normally reading from left to right. This tactic will make you focus on each word.

Scan your document for patterns of errors. Look for those errors that you usually repeat in the documents that you write. You might tend to use passive verbs or write wordy sentences. Make a master list of your most common mistakes. Check all of your documents against this master list to cut down on errors in future documents.

Look out for proper punctuation, correct grammar, and correct capitalization. Watch out for common errors: in titles and headings, in names, in long words, near the beginning or end of a line, near the bottom of a page, and in proper nouns. Proofread numbers out loud digit by digit. Use the spell-checker function in your word processor primarily for the first review of your manuscript. Remember that the spell-checker catches only words that are spelled wrong; it does not catch words that are spelled correctly but are used out of context. Use a good dictionary and thesaurus if you have any doubts.

Revisit Your Headings and Subheadings

Check your headings and subheadings. Do they communicate your message? Headings should give readers a summary of the content that follows. Headings should help readers jump to the right information in your text. Make sure your headings hook your readers. For example, by substituting the heading "Easy Dinner Meals" with the more descriptive heading of "15-Minute Dinner Meals," readers will get a better idea of the article's subject matter.

Power Up Your Lead

Does your lead pull readers into the document? Use the lead to introduce the subject, catch readers' interest, and draw them into the body of your text. Check your lead. If it's buried under clumsy and complex sentences, lighten it up by cutting words and phrases.

Take extra time to whip your lead into shape. It may mean the difference between readers taking the time to read your text or reading the competition's copy.

Checking Your Tone

Check the overall tone of the document. Does the tone suit the demographics of your audience? Does it match the language of your audience? Your tone on a corporate intranet would be different than the tone you would adopt in an article that caters to coin collectors on a hobby site. Either way, your document should be easy to read and approachable.

Double-Checking Accuracy

The Web shortens publishing schedules and writers' deadlines. In the rush to keep up, it's easy to get caught up in the frantic pace and forget the basics of solid writing; however, if you want to maintain your credibility, accuracy counts on the Web just as much as it does in print. If you have interviewed people, verify the spelling of their names and their complete titles. People don't like to see their names spelled wrong in print or online documents. Double-check the accuracy of quotes, and make sure they are attributed to the proper sources. If you provide links to Web sites at the end of your articles, make sure the links work and are clearly annotated. Determine if you need to get permission to link to another group's site.

Cutting Down Content

Take your first draft and cut out excess wordiness. Every word, sentence, and paragraph has to serve a purpose in your text. Look for redundant words and phrases. Jakob Nielsen suggests cutting the content of a document by 50%.[1] Simple is better on the Web for readers. Another way to cut word count is to read your document and look for ways to convert text to lists or to tables. Tables can offer readers essential facts without the extra words that sentences demand. You can use bulleted lists to present key points in an article, but don't go overboard. Too many lists will make your document look like sales brochureware. Readers will lose interest in scrolling through pages of lists that don't communicate a message.

Are your pages heavy on text? Make your content more inviting to readers by using white space, graphics, and a variety of font sizes.

Active Voice

Amy Gahran, of *Content Spotlight*, says that users are "action-oriented." They actively navigate through the Web, which puts them in a more engaged and action-oriented state of mind. She says that writers should capitalize on this opportunity by using action-oriented language in their Web writing, including the active voice and appropriate imperative statements such as "Order now."[2] Using the active voice will help you produce shorter, livelier, and more effective sentences.

Natural Flow

Check the flow of your document. Make sure there is a logical and natural progression from each chunk of content to the next chunk. If you are presenting sequential information, such as how to create an HTML document, you would give readers instructions in a specific order. Presenting the sequential information in a numbered format makes the list easier to scan. When you provide readers with non-sequential information, give the facts that readers would want or need most first. For example, readers who are on a tight deadline may first want to get advice on how to write press releases that get attention before they learn why well-written press releases are important.

If there are organizational issues in your text, reorder the paragraphs and, if necessary, rewrite the subheadings and topic sentences.

Confusing Text

Read your document through to the end. Are you clearly making your points or are you rambling off your main topic? Does your language sound stilted? Readers should be able to understand your words the first time that they read them. If readers have to stop reading to figure out what you are saying, you will have already lost them to the next site. Eliminate awkward sentences and paragraphs by writing uncomplicated sentences. Use the active voice, and delete excess words.[3]

Renee Hopkins says: "When the content works, the reader acts. Words are read, the page is bookmarked, the link followed, feedback is posted. A product may be purchased. Web content that works is content that is actionable."[4]

Do a Chunk Test

Check to make sure you have put your text into easy-to-read chunks. A dense screen of text turns potential readers away. Your first sentence should contain your topic sentence and introduce the material that follows.

Language Test

Make sure you are speaking in your readers' language. Keep away from jargon, slang, and acronyms. Even if your site is based in the United States, a large percentage of your audience speaks English as a second language. You're writing for a global audience now.

Grammar Check

Good grammar and punctuation are just as important on the Web as they are in print. Use the grammar checker in your word processor to find common mistakes in punctuation, word agreement, sentence length, repetition of words, and wordiness. Then do another edit by looking at the hard copy of your document to further refine it; however, remember that the Web is more informal and conversational compared to print publications. Incomplete sentences work better online than they do in print. Think of your readers as you edit. What is their conversational style?

Consistency

Be consistent in word usage and style usage throughout your document. Maintain a consistent voice, too. Your consistent voice will help you build a relationship with your readers. Make sure that your headings and subheadings and your headers and footers are consistent from page to page. This overall consistency creates an inviting environment— a place where you want your readers to hang out.

Polishing Prose

At the editing stage, it's time to make your words shine. You may think your document is ready to go public, but first you have some more polishing to do. Look at your copy again. Cut out those complex and

run-on sentences that you didn't catch in the earlier draft. Revise any faulty parallel structure in the body of your text, in lists, in bullets, in headings, or in subheadings. These changes will help you cut your word count and clarify your meaning.

Navigation

Readers should be able to easily navigate through your document. Provide navigational cues so they can find more detailed information if they need it. Make it simple to find your archives, order your products and services, and contact you if necessary.

Hypertext Links

Check each link within the text and at the end of the text to make sure that all of the links are live. Verify that the description of each of the links tells readers where they will go and gives them a good idea of the information they will find on the other end of the link.

Interactive Package

Content is more than just text. Look at the total package you have created. Have you taken advantage of the multimedia format and interactivity of the Web to offer readers an enriched experience? Discussion boards will help build communities on your site and relationships among your readers. Asking readers to respond to your articles and posting their responses encourages interactivity.

PRINT STYLE AND REFERENCE BOOKS

Use the stylebooks and dictionaries that have been chosen as the reference sources for your site. Some print stylebooks offer URLs to companion Web sites where readers can access updates to the print book. Use a thesaurus to help you come up with fresh ways of expressing ideas. Following are some examples of stylebooks and reference books:

- *Web Style Guide: Basic Design Principles for Creating Web Sites* published by the Yale University Center for Advanced Instructional Media

- *The Columbia Guide to Online Style* published by the Columbia University Press
- *E-What?: A Guide to the Quirks of New Media Style and Usage* published by the editors of EEI Press
- *Wired Style: Principles of English Usage in the Digital Age* published by the editors of *Wired* magazine
- *The Chicago Manual of Style* published by the University of Chicago Press
- *The Associated Press Stylebook and Libel Manual* published by the Associated Press
- *The Elements of Style*, 4th edition, by William Strunk and E.B. White
- *The Elements of Editing* by Arthur Plotnik
- *On Writing Well*, 6th edition, by William Zinsser
- *Merriam-Webster's Collegiate Dictionary*, 10th edition

IN-HOUSE WEB SITE STYLE GUIDE

Every Web site should have an in-house style guide that describes specific standards for its writers. If you are writing documents for a business or consumer site, ask the editor for a copy of the in-house style guide. Use the in-house style guide and print stylebooks and dictionaries they recommend to guide your writing efforts. Web sites also compile audience demographics that can help you better target your writing. Ask the editor for a copy of their most recent demographics.

How to Create an In-House Web Site Style Guide

If you are in charge of the content for your site, you'll save yourself, your staff, and freelance writers time if you create an in-house style guide. The guide will help both your current and new writers and editors maintain the same tone, consistency, and accuracy in their online documents. The guide will help you establish standards for spelling and word usage. The guide should also help you anticipate any problems before they come up in the middle of a project. Make sure that the guide is tailored for your particular Web site by identifying your target audience and their specific interests. Their interests will determine the content that appears on your site. Address the writing style and tone (e.g., businesslike, conversational, or hip?) that your site should present to readers. This will help your writers create more targeted copy. In your in-house style guide, list the print stylebooks

and dictionaries that will be used as reference sources for the site's style. List other specialized books with an explanation of when the books should be used. For example, for articles targeted to physicians, use the *American Medical Association Manual of Style: A Guide for Authors & Editors*, 9th edition, edited by Cheryl Iverson (Philadelphia: Williams & Wilkins, 1997).

Suggested Standards for an In-House Web Site Style Guide

Listed as follows are some suggested standards for an in-house Web site style guide. Adapt these standards according to the needs of your organization.

- Establish standards for your logo, photographs, images, captions, sidebars, links, headings and subheadings (fonts and sizes), headers and footers on each page, and site colors.
- Provide examples of how lists and tables should be formatted.
- Determine word count standards for your various types of documents.
- Establish the number and type of links that should appear in a document.
- Create a style glossary that tells writers how to address abbreviations, acronyms, capitalization, gender, italics, numbers, quotes, product names, proper names, and trademarks.
- Provide standards for bibliographies, references, and punctuation that deviate from the standard style and spellings that deviate from your recommended dictionary.
- Include preferred terminology, any medical or technical terms, and Web-specific style issues.

Regularly Update Your In-House Web Site Style Guide

As your site grows and changes, you may have to develop many revisions of your in-house style guide to reflect these changes; however, it's critical to keep the guide up-to-date because it will serve as a model for your online writers and editors. Putting your in-house style guide on your company intranet saves time and cost, eliminates distribution

concerns, and ensures that everyone has access to the latest version of the guide.

Create a Writers/Editors' E-Mail List to Facilitate Communication

In a large organization, freelance writers and in-house writers and editors may never meet face-to-face or meet rarely. To build rapport among your team, you could establish a writers/editors' e-mail list to explain style changes, encourage cross-communication, compare notes, discuss upcoming writing and editorial needs, answer questions, and exchange ideas.

EDITORIAL STYLE SHEET

After you have developed your in-house style guide, create and use an editorial style sheet to ensure consistency across all of the documents on your Web site. The style sheet can serve as a final checklist for writers, proofreaders, and copyeditors. This style sheet should be used in combination with your in-house Web site style guide and your recommended reference stylebooks. In fact, use your in-house Web site style guide to develop this concise editorial style sheet. Aim for about two pages in length for the style sheet.

Whenever you update your in-house style guide, you should check your style sheet to make sure it reflects all of the updates in the guide. Depending on the complexity of your Web site, you may need to develop only one style sheet or create a separate style sheet for each document or set of documents.

Style Deviations

Sometimes you need to deviate from the standard procedures set forth in your in-house Web site style guide. In these cases, you should document all of the content changes you are making on your editorial style sheet, along with the name of the person requesting the change and the date of the change. For example, a client may request that you spell out acronyms only on their first occurrence in the text of an online document. Or, the client may ask you to display headings in a specific font on a Web page. Documenting style deviations will save you time and help you track changes if you need to go back and retrace your steps. Set up a simple filing system, either by project number or client name, so that you can easily locate a specific style sheet.

COPYEDITING

After you proofread and self-edit your document, it's important that a copyeditor review your work. All documents should go through a central quality control process—editorial department—before the information is posted on the Web.

FINAL EDITING OF WEB PAGES

After the document is coded and loaded onto the site, it's ready for a final edit by the copyeditor before the document goes live. To ensure that all errors are caught, it helps to print out a copy of the document and make any corrections on the hard copy. The corrections can then be made on the actual online document. Next, the marked-up hard copy should be checked by the copyeditor against the actual online document to ensure that all of the corrections have been made.

A final multimedia review should also be performed at this point. Make sure that the text can be easily read on the screen; avoid text colors that clash with the background color of the screen. To aid scanning, there should be a good ratio of white space to text and visuals. A final check of the links should be made again to make sure they work.

Use a standard method to name your document files to save yourself time and frustration. The file name should include the date that the file was created so that you can easily locate specific versions of each document. For example, the file name "DigestiveDisorders-MJ-01-21-02" means that the document "Digestive Disorders" was created by Mary James on January 21, 2002. Accurately and specifically dating your files will also help you in case you have to do an audit trail.

TAKE A VISITOR'S TOUR

After your document has been posted on your site, review your work by looking at it from a visitor's perspective. What can you change to make the document more reader-friendly? How can you make the document easier to navigate? Make those enhancements to the online document now. You can then guarantee that you remember to apply these enhancements to future documents by making them a part of your in-house Web site style guide and style sheet.

EDITORIAL CHECKLIST

Editor Name _____ Today's Date _____

Document Name _____ Date due to Programmer ————

Author Name _____

Does the Title/heading communicate a meaningful message?____

Do the subheadings communicate meaningful messages?____

Does the lead hook the reader?____

Is the tone and language appropriate to the topic?____

Is the information concise?____

Does each chunk of content begin with a topic sentence?____

Does each chunk address one topic?____

Are the chunks of content short?____

Is there a natural flow to the document's content?____

Is the document easy to navigate?____

Are the hypertext links correct?____ Do the links work?____

Are the facts accurate?____

Is there overall consistency?____

Spelling (overall, names of places, people)____

Grammar____

Active voice____

Clear wording____

Logos/trademarks/symbols____

Are the photo captions in place?____ Are the captions clear?____

Lists (numbered, bulleted, parallel construction)____

Abbreviations/acronyms____

Is there orphan text below the computer screen?____

Punctuation____

Unusual spelling/industry terms____

Web-specific style issues____

ENDNOTES

1. Nielsen, Jakob. "Be Succinct! (Writing for the Web)," Jakob Nielsen's Alert Box for March 15, 1997, www.useit.com/alertbox/9703b.html. Accessed April 9, 1999, p. 1.

2. Gahran, Amy. "Grammar and Punctuation for the Web: What's Proper?" *Content Spotlight*, July 24, 2000, www.content-exchange.com/cx/html/newsletter/2–5/tb2–5.htm. Accessed February 23, 2001.

3. Brusaw, Charles T., Gerald J. Alred, and Walter E. Oliu. *Handbook of Technical Writing*, 3rd ed. (New York: St. Martin's Press, 1987), p. 65.

4. Hopkins, Renee. "Editorial Style, Even More So on the Web," Internet Content.net, October 2, 2000, http://38.144.115.20/internetcontent/index.asp?news = 5723. Accessed November 3, 2000.

PART THREE

Online Writing Opportunities

Corporate Communication (Internets, Extranets, Intranets)

The Web is crowded with corporate sites that are struggling to be heard above the clatter of their competitors. Every company wants customers to explore its site and purchase its products and services. But online, the customer is in control—choosing the sites to visit and the links to follow. To command your customers' attention, your writing must be compelling. You have the choice of creating a corporate site that looks like a series of slapped-together brochures, or you can craft a site that will be a valuable resource for your customers. To work well together, writing, navigation, and design must evolve simultaneously. Decide what your company does best and build a Web site to reflect that promotional positioning. Put a "human face" behind those graphics and content by personally communicating with your customers. Make every effort to understand your customers and anticipate their needs.

THE WEB HAS CHANGED COMMUNICATION

Merry Bruns believes that communication in general has been changed forever by the Web. Bruns is an online content strategist, editor, and

producer. She teaches a course entitled "Web Communications: Writing and Editing for the Web" at Georgetown University's Networked Media Center, the National Press Club, and to companies in-house nationwide. According to Bruns:

> Communication is no longer a one-way street, from sender-to-receiver. Readers (including us) increasingly expect to find that a Web site is tailored around their needs and expectations, and that a company's material is written and organized so readers can understand it quickly, and see its relevance to their tasks.... Companies that manage to accomplish these goals through their sites score high with readers. Readers prefer using a site that's approachable, well-organized, and relevant to their needs....We are also readers (as well as the producers), and it's necessary for all Web writers and editors to have this dual mind-set when developing their material for their companies' sites.[1]

SETTING CONCRETE GOALS AND OBJECTIVES FOR YOUR WEB SITE

Create a sound marketing model by setting concrete goals and objectives for your site and by measuring the results of your efforts. Use your company Web site as one of your key tools to help achieve your company's sales goals. At the same time, dip into your promotional arsenal and reap the benefits of traditional direct mail, sales literature (brochures), trade shows, and magazine, radio, and television ads to enhance your Web efforts.

HOME PAGE

Visitors should immediately know your company's main reason for doing business. The home page of a company site should instantly tell customers WIIFM (what's in it for me?). Navigation should be designed from a customer's point of view. Customers will then be able to intuitively navigate through your site. Customers should be able to quickly find the specific information they need. The content on your site should answer customers' questions. But how do you know what questions are on your customers' mind? Sit down with users and find out their product and service wants and needs. If that isn't possible, survey your customers via an opt-in e-mail survey, telephone survey, or use one of the online survey services. Your focus should be on identifying your target audience's needs. Then meet those needs through

the content you place on your Web site. Throughout your copy, stress to customers how your company can fulfill their expectations.

TELLING CUSTOMERS WHO YOU ARE

Define your company upfront. Tell customers what type of business you are in and how to reach you. You'll build credibility by identifying yourself in simple language. Don't make customers navigate through multiple pages to find out about the products and services you provide.

The Web offers customers an endless amount of alternate choices. By proactively identifying your company and its offerings, you get a chance to show the value proposition you can offer to customers; however, don't borrow the text from your corporate annual report. Traditional print annual reports are dry and stuffy.

Get together with the members of your Web team and brainstorm innovative approaches you might take to tell your story. Customers will be more interested in an entertaining but informative story than in a dry rundown of your corporate history. For example, the colorful, official Peeps® Web site (www.marshmallowpeeps.com/start.html) tells the history of Marshmallow Peeps® and the candymaker Samuel Born, who began his candymaking company, Just Born, Inc., in the early 1900s. Of course, a business-to-business Web site might tell its story differently; however, this doesn't mean that corporate sites cannot be innovative.

OFFERING CUSTOMERS BENEFITS

Let customers know what you do, but don't stop there. Tell customers how your business will benefit them. Tell customers the benefits of your products and services first and then list the features. Benefits are what cause potential customers to buy your products or services. Benefits answer that familiar customer question: "What's in it for me?" Cater to your customers' self-interest by answering that question. Make sure that the benefit statements of your products and services pop out at customers on your site and give them a compelling reason to purchase.

PROVIDING CONTACT INFORMATION

Whether you offer products or services, you're also in the business of offering customer service, yet many companies bury company contact

information on their sites. Other times, only a Webmaster e-mail address is evident on sites. These negative signals tell potential customers that you aren't interested in listening to their feedback. In effect, you're saying that you only want to tell them about your company. Customers don't like when you "talk at them."

Because the Internet is an interactive medium, customers expect to be able to easily contact and receive prompt feedback from you. If you want to differentiate yourself from your competition, put customer service procedures into place to answer e-mails promptly. Otherwise, your lack of response could negatively impact your business. Provide complete contact information through e-mail addresses, telephone number, toll-free number, fax number, and a snail-mail address. Make this information easy to find by providing a link on your home page that connects to your company contact information.

LISTENING TO YOUR CUSTOMERS

Listen to your customers; they'll tell you what to do. It's an old concept that worked in the bricks-and-mortar world, and it works in the online world, too. Get customers to see you as the company that solves their problems. It's also important and valuable to keep in continual touch with customers through e-mail response mechanisms and/or surveys.

YOUR WEB SITE'S GOALS

As a writer, you should determine what you want your company site to accomplish. Are you providing white papers to engineers? Or are you selling products and services to other businesses? Once you determine the purposes of your site and analyze your audience, it will be easier for you to develop targeted content that meets customers' needs. If you're selling products and services, make sure you ask for the customers' orders on your site. In your copy, remind customers of the benefits of your products and services. Design an order form that is easy to use.

DEFINING AND TARGETING YOUR AUDIENCE

Target your audiences and develop customized content for each segment of that audience. A large company can serve many different segments: small business owners, partner corporations, vendors, and potential employees. After you define your audience segments, rank

them in order of importance, and identify the specific information needs of each segment. Use this data to develop content for your site.

Making Your Site Customer-Focused

Your Web site should focus on your customers' needs. If the structure of your site revolves around your company's internal organization, you need to do a complete turnaround. Customers aren't interested in the details of your organization's structure, such as the names and titles of upper management. Redesign your site so that it focuses on fulfilling customer needs. List the things your customers want to know when they first visit your site. Make these things easy to find through hyperlinks, buttons, and a search engine. For example, if you know that customers come to your site to read your white papers, make this section readily accessible as a clearly labeled link on your home page.

CONTENT COUNTS

Banish the pumped-up, empty marketing lingo and stilted language that sounds like it came from the memo pages of the office of your CEO. These approaches reflect poorly on your company. Instead, look for ways to make a lasting impact on your customers. How do you do that? Create content that counts. Develop high-quality and useful content. Offer information, services, and interaction on the Web that is consistent with the objectives and unique positioning of your company. But the content should also serve the needs of your audience. Look for innovative ways to entertain, educate, and catch the interests of your audience. Engage online readers by telling pertinent stories about people, places, or things that relate to your company as well as your customers. Your readers will remember you and come back for repeat visits. Good content will also add value to your site.

Offer Customers Valuable Information

Enhance your Web site by offering your customers the following:

- Useful advice
- Meaningful information
- Helpful tips

Your customers will come to view you as a resource they can rely on when they are ready to buy the products and services you offer.

Look at what your customers do on your site. Do they purchase fine art supplies? Then offer mini-art lessons online. Alternately, post a feature article on how your readers can set up an art studio in their homes. You could also offer a state-by-state listing of upcoming art exhibits in major museums or provide direct links to well-known museums. Increase the value of your content by offering customers an opt-in e-mail newsletter so they remember to visit your site. Feature customer success stories. Use a storytelling approach to these articles that both informs and entertains your readers. Customers will see right through blatant advertorials. Instead of taking the typical public relations approach and focusing on your business, focus on how your business can benefit customers.

Conduct Research on Your Customer Base

Before you can offer valuable information, you need to obtain a good understanding of your customers by conducting research. Some of the Internet research groups that provide custom research, industry information, and subscription reports include:

- Forrester Research (www.forrester.com)
- Jupiter Media Metrix (www.jmm.com)

These Internet research groups also offer some limited free information on their sites. You can also obtain additional research information through customer focus groups (small-scale qualitative research), quantitative (larger-scale) print surveys, and e-mail surveys.

Wake Up Your Content

Quality content will certainly help you attract customers, but to really draw your customers in, you need to go one step further. Create content that not only entertains, but surprises your customers as well. Get fresh with words and language; inject attitude into your copy. Anything's better than boring. Customers have seen enough of the marketing messages that don't offer anything but a string of the current buzzwords in both print and online company collateral. Strike out that standard copy that you usually put in your brochures and create a rich tapestry of language that will compel customers to explore your site. Will you be taking a risk? Maybe. But the bigger risk is producing

content that doesn't get read. Not only will potential customers leave your site, but they also won't come back for more of the same tired and trite phrases.

Content Formats on Your Web Site

On your site, try experimenting with a variety of content formats to hook your readers' interest. You might start simply by making changes in a small section of your site (e.g., by adding a "Q&A Corner" written by a well-known expert). Or, your site could test different formats, such as a column, customer success stories, or a series of articles on a particular subject. You might add resource links that are related to your business operations and that are of particular interest to your readers. You could also offer an opt-in e-mail newsletter.

Ask customers for feedback on the new content, which you add to the site. Use e-mail surveys, an e-mail feedback form, or focus groups if possible. Analyze your Web site traffic statistics to identify the sections of your site that attract the most interest. Then revise your site to reflect your readers' feedback and interests. Continue to test any new changes by soliciting customer feedback.

Customize Your Content to Meet Customer Needs

Take the basic content of your Web site and adapt it to meet the needs of your different target audiences—you'll reach a wider audience. Andy Bourland, former CEO and publisher of the ClickZ Network, calls this "re-versioning" your content. The ClickZ Network re-versions daily ClickZ articles to create weekly executive summaries so their busy readers can review the summaries over the weekend.[2] The content that you re-version could include business articles, white papers, research reports, or archived material.

Look at the technical white papers on your site. By summarizing and repackaging the white papers, you could provide information that is easily accessible to your internal marketing managers or to your vendors. You could also sell these repackaged white papers to other companies.

Search through your archives, seeking documents with common themes. Bundle these documents together and create a promotional tool that you can offer to potential customers. Your customers will view these packaged reports as valuable resources that can help them in their business. These reports will also keep your name in front of customers, increasing the chances that they will buy products and

services from you in the future. For example, you could offer a packaged report on how to grow your business to small business owners.

Multilevel Content

Company sites should offer multilevel content to address the different levels of readership interest. Web sites that cater to different levels of readers' interests result in satisfied visitors. You can help your readers find the specific information that suits their interests by writing clear, meaningful document headings that tell readers about the information that follows. Short summaries of articles can satisfy readers who only want the quick facts. Annotated hyperlinks can provide brief descriptions so that readers who want more information will know the type of detailed content to expect when they click on the link.

Archived Content Creates Value on Your Web Site

Extend the life of your content by archiving it on your Web site. Jakob Nielsen suggests that the cost of maintaining old content may be about only 10% of what the original cost was to develop the content; however, the old content more than doubles the value of your site.[3] Of course, it's important to regularly review your archives. Delete obsolete data and replace it with current information. Check the links to make sure they still work and are relevant to the preceding content. Add new links that will add value to your content.

BRANDING YOUR COMPANY

Take advantage of all the different ways to brand your company. Try to get your company name as your domain name. For example, the home page of Binney & Smith, the manufacturer of Crayola® crayons, is www.crayola.com/index.cfm. Ideally, your domain name should be easy to remember and easy to spell. A simple name will help you attract more customers. If the name of your company does not have a catchy name, develop a catchy domain name (e.g., www.kayaker.com) that has a tie-in to your product. To increase your branding efforts, put your company's Web site URL on all of your printed collateral.

BEWARE OF MISSION STATEMENTS

Do these phrases sound familiar? Value-added services, high-impact features, state-of-the-art technology, committed to far-reaching excellence. You'll usually find these vague phrases incorporated into the mission statements of corporations. The corporate acronyms and buzz phrases often make sense only to the employees inside the company, and sometimes even the employees don't understand what the sentences mean.

Yet, many of these corporations put their mission statements on their Web sites, even though mission statements don't tell customers what a company does. Mission statements don't belong on your Web site because your site should reflect your customers' interests, not your company's internal interests. Instead, put your mission statement on your intranet because the statement's purpose is to motivate and unify your employees. Even then, before you post the statement on the intranet, simplify the language and delete any excess words. Corporate-speak gets in the way of clear communication with employees, too.

USING NATURAL LANGUAGE

When writing for online markets, use words that have real meaning to customers; use language that the average person can understand. Writers should talk directly to customers. The interaction between writers and readers online demands a more intimate writing style. Writers should sweep the dullness away from their pages and ban boring and dense text. Writers need to offer original content and resource links instead.

Marketing expert Susan Solomon suggests that companies should kill corporate-speak. She states that the "Internet is all about making connections with people, not regurgitating your six-color annual report....Superlatives are what truly sets your organization—and site—apart from all others." Readers should understand your company's superlatives when they first link to you or at least on your "About" page.[4] A superlative can be "the country's best-selling chocolate." The book, *The Cluetrain Manifesto: The End of Business as Usual*, and companion Web site (www.cluetrain.com), by Christopher Locke, Rick Levine, Doc Searls, and David Weinberger, demands that corporations talk to customers using human communication. They believe that writers should communicate by sounding like real people.[5]

CONSISTENCY COUNTS

Your design, style, tone, and navigation should be consistent through-out the site. If your site is not consistent, your readers will have to work harder to find information and understand your content.

Wording also needs to be consistent. For example, on a company site, don't use the word *customer* on one of your pages and then use the word *client* on another page. You'll confuse visitors and lose cred-ibility. Use those terms that are recognized by your industry peers. At the same time, don't overload your pages with buzzwords and acronyms. Balance in the use of words is important. You could also provide a glossary of terms on your site to help visitors who are new to your industry.

Stick with the standards. Use those terms that are widely accepted on the Web. Don't call the search button "Surf" when the standard term is "Search." Proofread for consistency in headings and sub-headings in your documents, too.

CLARITY COUNTS

Clarity makes online writing easy to read, whereas ambiguity in word usage can confuse the reader. Let's say you wrote an academic article about diabetes. It was professionally edited and posted on the company Web site. You believed you covered all your bases, but then a physician e-mails you with a complaint. She disagrees with your concluding points. Did you clearly get your message across to your readers? Although the words in your article were clear to you, they may not have been clear to your online readers. Before you post a docu-ment, test the document by letting colleagues or potential users read it.

Why is clarity so important on the Web? Online readers are look-ing for specific information and they want to find it quickly. Complex words, phrases, and sentences only slow them down and causes them to question the information that is presented. If they don't understand your words the first time, they'll seek another site.

USING FRESH WORDS AND LANGUAGE

The right choice of words can make all the difference on your com-pany Web site. Do you want to make a strong impact on your readers? Then use active verbs to get your points across. Active verbs will make a stronger impression on readers.

Persuade and motivate your readers by grabbing their attention with powerful words and phrases. Telling readers that your site will "increase their creativity" won't generate as much interest as saying that it will "unleash their creativity." Likewise, "ABC product increases employees' productivity" isn't as compelling as "ABC product jumpstarts employees' productivity." Make reading on your site easy. Put important information at the beginning of sentences. Place important sentences at the beginning of paragraphs. Mainly use short, simple sentences; however, vary the length of sentences to add interest. In your effort to be concise, don't strip the energy from your copy. Use bullet points to help cut down on words and to organize content for the reader, but make sure those bullet points are peppered with powerful words that capture readers' attention. Stick with tight writing.

Use standard and simple phrases for your link names, such as "Contact Us." Avoid cutesy and metaphorical phrases that may confuse customers, such as "Y'all Come On In." Keep your message short and memorable. Use informative headings to tell readers what follows, such as "Low-Cost Pennsylvania Bed and Breakfast Inns." Use headings and subheadings to introduce new topics, add interest, break up copy, and encourage reading.

For example, the following subheading could encourage people to keep reading: "Low-Cost Beach Picnics." To give more impact to your headings and subheadings, use fewer, action-oriented words and verbs. For example, the heading, "Chop, Sauté, and Eat Healthy" uses few words but arouses curiosity.

As an added precaution, print out your copy before you post it to the Web. Read the pages carefully and delete every unnecessary word.

VOICE

Is your Web site lacking a human voice behind its well-developed design? Many corporate sites are colorless in tone. Other sites palpitate with a strong voice that commands attention and provokes customer interest. Prospects are not seeking a corporate, buttoned-down voice when they visit your site. They're looking to communicate with you. Energize your writing, and you will soon energize your customers. They're looking for that unusual voice that will pull them into your site. How do you infuse a distinctive voice into your site? Write in a conversational tone. Paint pictures with your words. Aim to be a unique corporate site.

NURTURING SITE PERSONALITY OR IDENTITY

Depending on your type of organization, you might want to create a personality or identity for your Web site. The meta search engine Ask Jeeves[sm] (www.askjeeves.com) uses an Internet butler mascot to help users find information on the Web. The site promotes Ask Jeeves[sm] as the world's first Internet butler. Look at the products and/or services that you sell. Decide if you could link your offerings with a personality or identity that will inform or entertain potential customers. A mascot may not be suitable for your corporate site; however, you could still come up with a specific site identity that differentiates your company in the minds of your customers.

REDESIGNING YOUR WEB SITE AND CONTENT

If you're redesigning your Web site, determine what changes you can make to the current content to make it more reader-friendly. Take a look at one of your documents and ask yourself the following questions:

- Can you cut the word count in your documents? Concise text offers readers the benefit of less information to process.
- Would your documents benefit from a table of contents, bullets, bold headings/subheadings, or numbered lists? These elements help readers to scan documents and find key information.
- Can you tone down the marketing hype? Studies show that customers do not like to be inundated with marketing language.

WHITE PAPERS

On corporate sites, white papers usually address technical subjects. This doesn't mean these papers have to be difficult to scan online. On the contrary, the nature of white papers requires that they be properly formatted for easy online scanning. For each white paper, create an executive summary (synopsis) at the top of the page. The executive summary will give readers a quick idea of what the white paper covers. Some readers may be interested in reading only the executive summaries to obtain fast updates on the latest technological changes. Follow the executive summary with a menu of hypertext links that correspond to the relevant sections in the white paper. Break the long document into chapters, with about three screens of information in each chapter. Use descriptive headings, subheadings, bold text, and bullets to help readers find the information they need.

Collection of White Papers on a Corporate Site

If you usually post a collection of white papers on your corporate site, you need to arrange the information in an orderly format. First, separate the white papers into natural categories. For example, in a simple listing, you might have three separate subject categories: Internets, Extranets, and intranets. Depending on the subject matter, place the white paper under one of the appropriate categories. To help readers find the specific white paper they need, develop an annotated link for each of the categories. Next, hyperlink each category to the pertinent documents that are associated with this category. For example, there may be three annotated hyperlinks under the Internet category. By annotating each document, you make it easy for readers to understand what the document will cover.

EXTRANETS

Extranets allow companies to share resources over the Internet with suppliers, partners, customers, and other groups outside of the company. Extranets can be used to manage inventory, reduce costs, and provide 24/7 customer service.

INTRANETS

Many companies use intranets today; they are like private versions of the Internet. Intranets can function as both information and news resources, and learning tools for employees. Putting information online can cut costs, increase productivity, and give employees fast, easy accessibility to information. The intranets function like self-service tools for employees. Human resource departments can offer employees personnel handbooks, benefit information, and forms online. The Marketing department can provide the newest product and service information to their sales force online. Marketing can also make PowerPoint slides available online so that salespeople can use the materials to give presentations to potential customers. Through the intranet, companies with business units around the world can collaborate to develop new products and services. To be successful, the development of intranets requires a continual loop of communication between the content providers and users in a company.

Do You Need an Intranet in Your Company?

Your first step is to determine how your company might benefit from an intranet. What are your organization's needs? (e.g., to cut costs). What are your users' needs? (e.g., to find information quickly). The answers to these questions will help you develop an intranet that fits your requirements.

You also need to segment your target audiences according to their information needs and to determine the type of information they will be seeking on a daily basis. Depending on the nature and size of your business, you may need one intranet or multiple intranets. For example, you could develop one intranet that is an internal human resource and news source for all of your employees, and you could create another intranet that is a training resource for your customer service representatives (CSRs). Each business unit in your company could have its own intranet.

Basic Company Intranet

A basic company intranet should have a home page that is attractive and uncluttered. The home page should have a menu that lists all of the content on the intranet, an internal search engine, a "What's New" section, and an archives section. Good design standards and easy navigation will increase employee productivity. For more detailed information on intranets, read the book, *Designing Web Usability: The Practice of Simplicity*, by Jakob Nielsen.[6]

It's important to regularly update the content on your intranet. An outdated intranet sends a negative message to employees just as an outdated Internet site does to customers. To ensure that your intranet is kept up-to-date, dedicate staff to the project and set up a content creation maintenance schedule.

Using an Intranet as a Training Resource

Customer service representatives (CSRs) can greatly benefit from an intranet that is used as a product/service and training resource. Here, CSRs can find all the promotional, product, and price information they need in one place; however, you must do some careful planning to ensure that you develop a useful and cost-effective intranet site for training. You have to determine the types of content and functionality that will offer the most benefits to CSRs. You need to determine how the site will contribute to the company's operational efficiency. You

also have to anticipate the future growth of the intranet as your corporation expands.

Developing Successful Training Intranets

How do you ensure that you will develop a successful training intranet in your company? Talk to the users or the CSRs. Better yet, bring them to the planning table to increase the usability and usefulness of your future site. Users will tell you what information they need to do their jobs— what works and what doesn't. Talk with the managers of the CSRs, too; they can also provide inside information on what works on the intranets.

If your company currently uses a training intranet, CSRs will let you know if it takes too long to find certain product or service information. They can point out broken links in your documents and obsolete price information. The CSRs are the closest to your customers because they talk with them on a daily basis. Therefore, CSRs often know what your customers want even better than you do. Make changes based on the CSRs' feedback to build a stronger relationship with your employees. Later on, continue to keep the lines of communication open and solicit ongoing feedback from your CSRs.

Enhancing Your Training Intranet

Look at your product and service offerings. Determine the different types of online documents that will help CSRs do their job. Do they need product and service descriptions? Do they need details on specific promotional campaigns? How often do you need to update your price lists? Do you need to develop an FAQ list for certain products? How about puting an internal keyword search function on the intranet? This function can help CSRs locate specific documents by typing in a keyword or a group of keywords. You could also develop self-paced training modules for your CSRs on your intranet. The CSRs can take these modules during their downtime at work.

A "What's New" page that is revised on a daily basis on your intranet can keep CSRs updated on changes occurring within your organization. The "What's New" page can contain urgent announcements that CSRs must pass on to customers. These short announcements should provide a high-level overview. The announcements can then hyperlink to documents that provide more detailed information about the product, promotion, or change.

Managing a Training Intranet

Managing a large volume of information on an intranet and keeping the information relevant to the users' needs is a big undertaking.

Depending on your type of intranet, different processes need to be put into place.

It's essential to have a systematic process for monitoring the potential for obsolete information. Assigning an expiration date to each document will alert your staff to look for those documents that need to be removed from the intranet after a certain period. You could also issue a monthly deletion report listing the documents that will soon expire and distribute the report to managers, editors, and writers. This extra step will serve as a safeguard for those documents that may still be relevant and need to remain on the intranet.

You also need to develop procedures for updating text. To save time, will your writers be using templates? These foregoing points address only some of the content issues. You'll need to develop a set of policies and procedures for your particular intranet. For example, writers and programmers need to know the specific handoff and submission process for documents. Each document has to be logged so it can be tracked. The editing process has to be established. Daily, weekly, and monthly deadlines will have to be set up. Depending on your type and size of organization, you may need to address additional issues. Include these policies and procedures in an in-house, intranet style guide. Put your in-house style guide online so your writing/ editorial staff can easily access it. Put a schedule in place to regularly update the guide.

Content on the Training Intranet

When it comes to developing training intranets, writers should follow the same content principles they used for Internets. "User-friendliness" is crucial. If your online documentation is simple for CSRs to read and use, relying on the intranet will be a positive experience for them. This positive experience will encourage CSRs to use the intranet repeatedly. The end result will be satisfied customers who receive accurate information each time.

Organization is key on the intranet. Both categories and documents themselves have to be well organized. CSRs are on the telephone with customers who are usually impatient. The CSRs have to find online information quickly. They don't have time to read lengthy, complex documents or sentences. Long, wordy sentences only slow them down and confuse customers who are trying to retain the information they hear. Content should be clear and concise. Sentences should be brief. Information should be presented in short blocks of text so CSRs can quickly locate the data they need. Headings and subheadings should be informative because they tell CSRs what the documents will cover. Well-written headings and subheadings can also help CSRs find the

information they need when they do keyword searches. A hyperlinked and clearly written index of topics or products/services can be a time-saver. An FAQ format can often offer the pertinent information that CSRs need about a product or promotion. This format is easier to read than a lengthy document.

For longer intranet documents that describe more complex products or services, put a brief summary at the top of the page. Next, list a table of contents or menu. Each item in the table of contents should be hyperlinked to the appropriate text in the document. This formatting will help CSRs quickly find answers to questions that customers might have.

To facilitate scanning, use bullets or numbered lists in these documents. Take advantage of including hyperlinks within the documents so that CSRs can easily access more detailed or related information that will help them during their calls if customers need specific facts.

Increasing Intranet Traffic

You might use your intranet as a news source to inform employees of important company news, such as changes in how to submit travel vouchers or updates on employee benefits. It's in your best interest to drive employee traffic to the intranet to get the latest company news because you will save the printing and distribution costs that a news-letter requires.

If you use an intranet as a training resource, you save the printing and distribution costs of creating training binders, product and service catalogs, and print job aids. More important, an intranet ensures that CSRs are giving customers the most up-to-date and accurate information. Because CSRs can bring up specific product and service details on the computer screen, you do not risk the chance of them impro-vising important information or giving incorrect details to customers. The advantages of training intranets increase even more if you have multiple call centers.

Whether your intranet is used as a news source or a training source by your employees, it has to be put to use to make it a valu-able tool. Use promotional techniques to get employees to visit your site and then to make repeat visits. Hold contests and award prizes. Call on your Marketing department's expertise for ideas on how to lure employees to your site. Get upper and middle management to back the intranet at meetings. Regularly update your content with information that is useful to employees and that will help them in their jobs.

Measuring the Success of Your Intranet

On a typical Web site, success is measured by the number of users that visit your site and then come back for return visits or purchase your products and services. Success is measured differently on intranets. Here, the goals are for readers to find the information quickly and understand it. The information should also be helpful for the users' purpose, timely, accurate, and effective. Likewise, well-written and edited content contributes to an intranet's success.

TESTING THE EFFECTIVENESS OF YOUR WEB SITE AND INTRANET

Test, test, and retest. You'll learn a lot from your users, both customers and employees. There are many ways you can test the effectiveness of your sites. You can perform the following tasks:

- Observe end users.
- Hold focus groups.
- Conduct surveys.
- Review customer and employee e-mail responses.
- Monitor customer service calls.
- Do beta tests.
- Put e-mail response mechanisms into place on your training intranet to track problems.

Observe End Users

Observe how end users use your company Internet, intranet, and Extranet. Take detailed notes. Look at the areas of your site with which users have the most trouble. Note down the questions they ask while they use your site.

Hold Focus Groups

Organize informal focus groups with your CSRs, employees, or customers. Hold separate sessions for each of these groups. The groups should be small, about a total of six to eight people each. Appoint a facilitator to lead the group sessions. Prepare a list of about 10 to 15 questions that the facilitator can use as a resource to guide the discussion and to obtain information from the group that will help improve

your sites. The facilitator should remain flexible but in control of the session. Don't allow one or two participants to dominate the conversation.[7]

Keep the sessions short—from 45 to 90 minutes long. Show participants sample Web sites, pages, designs, and graphics and record their input. Use both a computer and paper examples to display your concepts to the focus group. Invite members of your Web team to observe the session through a one-way mirror. If the Web team has additional questions, a note should be passed to the facilitator. (If you cannot afford a formal focus group facility, allow your Web team to sit in the room and quietly observe the session.) Because focus groups are only a small sampling of your total population, they're not conclusive; however, focus groups can provide insight into where additional research is needed, give you additional ideas to try, highlight areas for improvement, and help you locate trouble spots.[8]

In the past, I worked with CSRs who used a company intranet as a tool for information on products and services when they received calls from customers. I usually conducted informal focus groups with these CSRs to find out how the company could improve the intranet. The sessions always provided me with valuable information, but what really made a difference was putting the CSRs' ideas into action. This step demonstrates to the CSRs that their opinions were important. It also improved the relationship between management and the CSRs and, most important, improved the intranet. The latter result benefited the customers in the long run.

Conduct Surveys

Send out opt-in e-mail surveys to your customers asking for feedback on your Web site and its content. Post surveys on your site. To increase the response rate, offer prizes for completed surveys.

Monitor E-Mail Responses from Both Customers and Employees

Read the e-mails that customers and employees send to your Webmaster and to customer support. These e-mails can point out areas that need improvement and help you locate trouble spots on your site.

On your training intranet, put an e-mail response mechanism into place so CSRs can directly e-mail their concerns/questions about specific documents to the writers on your Web team. For example, there could

be incorrect prices in your online catalog. Or, a product warranty may contain confusing language, which is causing customers to make multiple calls to your center. When CSRs can notify you of these concerns through e-mail messages, you can easily make the corrections on the intranet. The quality of your documents will then be increased. Put a two-business-days turnaround process into place so writers can make the corrections by the end of that period.

Monitor Customer Calls

Sit down with supervisors and monitor customer service calls. You'll quickly learn what is and isn't working for your employees and customers. You will be in a better position to correct and enhance the content on your site.

Do Beta Tests

Before you post documents to your Internet or intranet, do a beta test with a group of users. Test your headings, subheadings, summaries, hyperlinks, and text. Ask your test group what you can do to improve the content.

ONLINE IN-HOUSE STYLE GUIDES

As mentioned in Chapter 8, "Editing Web Writing," an in-house style guide can help your staff produce consistent Web pages. The guide can also be used as a reference source to bring new content providers up to speed. It thereby becomes an instant training manual for new employees. If you don't use an in-house style guide as your main source of reference, content providers will tend to develop their own approach to writing copy. This will result in Web pages that lack cohesiveness and will not present a good corporate image.

Depending on your organization, your in-house guide could address just editorial content. In addition to editorial content, some in-house style guides include sections on page design, Hypertext Markup Language/Cascading Style Sheets (HTML/CSS) coding, and templates. When you create your online in-house style guide, follow the same rules that you use to write material for your Internet, Extranet, and intranet. The online style guide should be easy to use and to

read. Include menus and hypertext links. Provide examples of good content and formatting for your writers to follow.

To ensure that your online in-house style guide is always up-to-date, put a regular schedule into place to make sure that your team or a designated person reviews and revises the guide on a consistent basis. Any time you make a writing, editing, or other procedural change that will affect your site, you should include this change in your online style guide. This effort will help you develop a coherent presence on your Internet, Extranet, and intranet.

Web Site Policies and Procedures

Make sure there are written policies and procedures in place to ensure high-quality standards on your site. These policies and procedures can be part of your online style guide. For example, look at your proofreading procedures. Documents should be proofread after they are written and edited, and again after they are coded. During coding, it's easy for text to be dropped, words or phrases to be retyped incorrectly, or alignment of text to be off.

SMALL COMPANIES NEED GOOD CONTENT, TOO

Because of limited budgets, many small companies may not have an online content provider on staff. Web developers, salespeople, or the owner might be writing the content in these small companies. The owners may think they are saving money, but they are usually hurting the image of their company and ultimately negatively impacting their revenue. Their sites may be flooded with industry jargon. Their business, products and services may be inadequately defined. Awkward and amateurish content could be sending potential customers away. By hiring a part-time content provider or consultant, these businesses will bring a professional look to their pages. If you're a freelance content provider, here's your chance to gain new business. Analyze the sites of local small companies. Contact the companies and let them know you have some ideas that will help them improve their site. Once you gain their interest, set up a meeting. Tell them how improving the content on their site will result in increased business. The goal of your meeting should be to win a signed contract to do the job. If the company asks for a proposal instead, make sure you assign a cost to the

proposal and get a written contract to do this part of the job. Your time is worth money.

DOING CONTENT WORK FOR NONPROFIT ORGANIZATIONS

Even nonprofit organizations are in the business of "selling" themselves on the Web. A nonprofit group has to sells its mission and goals to lure potential contributors, volunteers, and sponsors. Educational sites need to sell themselves to students, alumni, and contributors. You might want to approach nonprofit organizations to do online content work. Developing content for nonprofit organizations is usually lower paying; however, the principles of professionalism, proposals, contracts, and fair pay still apply.

CORPORATE WEB SITE CHECKLIST

Use the Corporate Web Site Checklist to ensure that you have created a customer-focused site.

- Does your home page tell customers what business you are in?____
- Does your home page answer the customers' question of WIIFM (what's in it for me)?____
- Is your navigation well designed to meet your customers' information needs?____
- Does your site anticipate your customers' information needs?____
- Can customers quickly find the information they need?____
- Does the content on your site answer customers' questions?____ Provide useful information?____
- Does your site provide complete contact information on your company (e-mail addresses, telephone number, toll-free number, fax number, snail mail address)?____
- Can customers easily contact you?____
- Do you use storytelling techniques to tell customers about your company?____

- Do you tell customers how your products and services can benefit them?___
- Do you listen to your customers and solve their problems by responding to their feedback?___
- Have you defined your target audience(s)?___
- Have you created customized and valuable content that is tailor-made to your different customer groups?___
- Is your site focused on your internal organization or on your customers?___
- What distinguishes your site from your competitors' sites?___
- Are you taking challenging content risks that will differentiate you from the competition?___
- Are you experimenting with different content formats on your site?___
- Are you promoting your company brand name online and off-line?___
- Have you banished your mission statement from your corporate Internet site?___
- Is there a human voice behind your site?___
- Are you "talking" to your customers instead of "writing" to them?___
- Do you regularly test your site (observe end users, hold focus groups, do surveys, review e-mail responses, monitor customer calls, do beta tests)?___

TRAINING INTRANET QUICK CHECKLIST

Does the content on your training intranet follow these guidelines?

- Have you used short sentences in your text?___
- Have you broken down your content into short blocks of text?___
- Have you written informative headings and subheadings?___
- In your longer documents, have you included a summary and hyperlinked table of contents?___
- To increase scannability, have you used bulleted lists or numbered lists?___
- Do you provide hyperlinks to more detailed information?___

TRAINING INTRANET TRACKING FORM

Use this form to manage and track the documents on your training intranet.

Date _____ Writer _____

Title of document _____

Type of document _____
(product/service description; promotional campaign; price list; training module; What's New)

Requested expiration date _____

Requested keywords (for internal search engine) _____

Action Required:

Add new document ____

Update document ____ Existing URL _____

Delete document ____ Existing URL _____

ENDNOTES

1. Bruns, Merry, e-mail: mbruns@nasw.org, principal of ScienceSites Communications, www.sciencesitescom.com, e-mail interview, July 22, 2001.
2. Bourland, Andy. "Re-Version Your Content for a Wider Audience," ClickZ.com, October 20, 2000, www.clickz.com/cgi-bin/gt/print.html?article=2643. Accessed October 21, 2000. Reprinted with permission from www.internet.com. Copyright 2001 internet.com Corporation. All rights reserved. internet.com is the exclusive Trademark of internet.com Corporation.
3. Nielsen, Jakob. "Web Pages Must Live Forever," Jakob Nielsen's Alertbox for November 29, 1998, www.useit.com/alertbox/981129.html. Accessed April 23, 2001.
4. Solomon, Susan. "They Snooze, You Lose," ClickZ.com, October 10, 2000, www.clickz.com/cgi-bin/gt/print.html?article=2573. Accessed October 17, 2000. Reprinted with permission from www.internet.com. Copyright 2001 internet.com Corporation. All rights reserved. internet.com is the exclusive Trademark of internet.com Corporation.
5. Locke, Christopher, Rick Levine, Doc Searls, and David Weinberger. *The Cluetrain Manifesto: The End of Business as Usual* (Cambridge, MA: Perseus Publishing, 2000).
6. Nielsen, Jakob. *Designing Web Usability: The Practice of Simplicity* (Indianapolis, IN: New Riders Publishing, 2000).
7. Maciuba-Koppel, Darlene. *Telemarketer's Handbook: Professional Tactics & Strategies for Instant Results* (New York: Sterling Publishing, 1992), pp. 114–115.
8. Ibid.

Chapter 10

The Web and E-Commerce

On the Web, clear and concise writing is important whether you are writing ad copy, product descriptions, order forms, guarantees, or press releases to sell products and services. The tone and style of your content also need to be consistent throughout your site, from your home page to your product descriptions to your informational articles. Take the time to cultivate a consistent voice throughout your site.

FIVE RULES FOR WEB COPY

Herschell Gordon Lewis, author of *On the Art of Writing Copy: The Best of Print, Broadcast, Internet, &Direct Mail*, suggests the following five rules for writing Web copy:[1]

1. Copy length is not a factor. Substantial copy length within a single copy block is a negative factor.
2. With every headline, every sentence, ask yourself: If I were reading this instead of writing it, would my interest stay high?
3. Don't be afraid to sell.
4. Subject to the First Rule, copy length can expand in ratio to the amount of promise it makes.
5. Announcements cannot compete with salesmanship. Technical expertise cannot compete with salesmanship. Gadgetry cannot compete with salesmanship.

After you write the first draft of copy for your e-commerce site, test it against the rules that Lewis recommends. How does your copy compare? Can you make any changes to the copy that will stimulate the readers' interest?

DESIGN OF WEB SITE

Make sure your online sales literature offers a common look, style, and tone on every page of your site. The material on your site should be well organized so prospects can easily find the information they need. In fact, to ensure a consistent sales message for your company, both your print and online sales literature should have the same look, style, and tone. Your end goal is to present a unified image to your customers.

IDENTIFYING YOUR COMPANY

On your home page, provide a link to a page that tells customers who you are and how to reach you. Make sure you provide your company's complete contact information: snail-mail address, toll-free number, fax number, and e-mail address. Customers need to be reassured that you are a reputable e-commerce company and that you can be easily contacted. Here's your chance to build trust with your customers and let them know that you won't disappear from the Web.

ANALYZING YOUR TARGET AUDIENCE

You have to know who your target audience is before you can write successful sales copy. Dig into your demographic data. Maybe you have more than one target audience. If you do, then you have to develop different sales messages for each of those audiences. Each target audience will buy what you're selling for different motivations. That's why you need to explore the reasons why each target audience is buying your products.

This analysis of your target audiences will help you determine the benefits that your prospects are seeking. Begin by developing a profile for each of your target audiences. The profile could include prospect age, gender, marital status, educational level, occupation, income level, and personal interests. Look at the different characteristics in each of your target audiences. Develop targeted copy that addresses those characteristics.

Examine your audience's needs and wants. In your copy, tell your audience how you can meet their needs and wants with the benefits of your products and services. Position yourself as a problem solver to sell more products now and in the future.

For example, if your Web site offers cosmetics and makeup to females, you may have two target audiences. One of your audience groups could be composed of teenage girls. In this instance, your goal is to write copy that appeals to their desire to wear makeup that makes them part of the current "in-group." To write the copy, you need to study what is happening on the fashion runways and to analyze the fads that are cropping up across the world. Trends are global now; you can't be country-centric.

Your other target audience may be mature baby boomer women. Studying female baby boomer demographics will help you sharpen your writing. Your copywriting goals will need to reflect their preoccupation with appearing youthful. Your cosmetic ads may sell hope and the promise of youth in a bottle.

Your work isn't done after you have identified your target audience(s). Things change quickly on the Web. Continue to analyze, track, and measure your target audience and marketing messages. These efforts will help you create more effective marketing content.

STUDYING YOUR PRODUCT'S FEATURES

When you are ready to write copy, study your product's features and list every conceivable service it performs for your customers. After you've completed your list of product features, link these features with customer benefits. In copywriting, your end goal is to sell benefits, not products in your copy. For example, you might sell discounted office supplies on the Web to small business owners. How do customers benefit from your business? Customers benefit from the convenience of one-stop shopping from the comfort of their home, a wide and unique choice of supplies that they can't get at their local office supply store, deep discounts, low-cost delivery to their front door, customized products (e.g., personalized pens), and the elimination of travel to several office supply stores to find the products they need.

TALKING BENEFITS TO CUSTOMERS

Because people buy for emotional reasons, it's important to sell the benefits instead of the product or the product's features. You need to get inside your customers' heads. What daily problems do they face?

How can your products solve those problems? What needs do your customers have? How can your products fulfill your customers' needs? Write copy that provides answers to your customers' concerns. Hammer away on the benefits of your products instead of its features.

Products usually have more than one benefit. When writing your copy, start with your product's primary benefit first and then list the secondary benefits in order of their importance.

Put the "You" in Your Copy

The most important word of value to customers is "You." That's why you should always write customer-centered copy. Customers care about their needs and wants, not about you, your products or services, or your company. Your copy needs to reflect this "You" perspective. Put your focus on the customers instead of on your company and products.

COPY GUIDELINES

Write copy that is concise, conversational, and that stresses benefits. Talk to customers in their language and you'll catch their interest. Use the power of headings and subheadings to invite readers into your copy. Bump up your headings and subheadings with benefits that will make readers want to know more about your products and services and cause them to keep reading. Begin your short blocks of text with informative topic sentences. Your copy will be easier to scan. Avoid marketing speak or a hard-sell approach. These tactics will turn prospects away from your site. Be honest in your copy and promises. Otherwise, you'll lose credibility on the Web before you even get a chance to make that first sale. Following are more details on how to write copy for the Web.

Sell with a Slogan on Your Site

Come up with a catchy slogan that defines your business. This brief slogan should tell customers what your business is all about. For example, the slogan "Door-to-Door Caterers" lets potential customers know that you offer a customized catering service in peoples' homes. Put your slogan on your Web site, in your e-mail newsletter, in your e-mail signature block, and on all of your print sales literature and packaging (e.g., print brochures, business cards, print bookmarks, order forms, invoices, and delivery cartons).

Hook Them with a Headline

Your potential customer is surfing the Web, clicks on a link, and your page appears. The right graphics are important, but it's the headlines that will get their attention. Entice readers with powerful headlines. If you don't hook them with your headlines, they probably won't read the rest of your copy. Experts say that the headline is the most important element of any marketing copy. Therefore, spend some time crafting a catchy headline. Think of your headline as a complete and easy-to-understand message. Its goal is to pull your prospects into your copy. Forgo cute and humorous headlines that may fizzle. Prospects may not think the headline is cute or the attempt at humor funny.

Make use of active words in your headline. Strengthen your headline with a benefit statement telling customers how your product will enhance their daily lives—and remember to include the "You" in your hook. A headline announcing your company's newest self-improvement tapes might not stir customers' interest; however, a headline that promises to "Wake Up Your Creative Genie" will make customers want to hear more about the tapes. Remember, customers are more interested in hearing about themselves than about your business.

Put Your Subheadings to Work

Get more mileage out of your subheadings by crafting informative messages. Your subheadings should tell readers about the material that follows and engage their interest at the same time. Your readers will be more likely to read your copy.

Leads

When you write copy, make an impact with a strong lead-in paragraph. Your lead should focus on the specific benefits your prospects will receive from using your products and services. The "You" factor is an important component of your lead paragraph, too. A good lead will keep prospects reading. To keep your copy crisp, make sure that every word in your lead serves a purpose. Delete any wordiness. Read your lead out loud. Listen for a smooth flow to your words. Does it sound like your lead will capture your prospects' interest? Test your lead out on a few colleagues. Listen carefully to their reactions and then rewrite your lead.

Energy, Enthusiasm, and Excitement

Write lively. Writing on the Web has a certain unique quality. Words can be full of energy, enthusiasm, and excitement. Capture those elements and incorporate them into all of the content you produce on your e-commerce site. These characteristics are contagious and will give your site a vigorous presence. More important, these characteristics will sell your products and services.

Conversational

Connect with your potential customers. Use human language, not "sales" language. Talk to your customers, one on one, as if you were having a personal conversation. Your copy will sound like there is a real person behind the site instead of a distant, bodiless voice. Your writing should sound accessible and friendly to readers.

Write Clearly and Concisely

Your goal should be to write clear and concise content. Prospects should understand your marketing message on the first reading. They should have no doubt in their minds about what your products and services can do for them. Clear and concise writing is so important because on the Web prospects can't get the "touch and feel" of your offerings like they can in a store. Your words have to bring your products to life and simulate that "touch and feel" that prospects find in a store. Your challenge is to convince customers with your words that you provide the best products and services.

Complex, convoluted sentences will muddy your marketing message. If customers don't understand your message the first time they read it, they won't take the time to e-mail you with specific questions. They'll find the online business that knows how to clearly communicate about its product and service offerings.

Write Tight

Tight writing is always important on the Web. It's even more important when you sell products and services online, where you're competing with thousands, or more, of other businesses. Unnecessary words, sentences, and explanations get in the way of your marketing message.

Copy Detractors

Poorly and hastily written text detracts from your site and weakens your marketing efforts. Typos, incorrect grammar, and unedited copy all send negative messages about your business. Incorrect price information causes your prospects to doubt your business practices. Copy that is infrequently updated "silently tells" prospects not to bother shopping at your site. Why should they? Your dated copy tells them that no one else is shopping at your site either. Put schedules and procedures in place so your copy is regularly updated and professionally edited. Make sure the information on your site is accurate.

ACT NOW!

Busy, overwhelmed, exhausted, and impatient—these are the characteristics of your typical prospects today. Keep these characteristics in mind while you write copy. The products on your site may kindle your prospects' interests but, in the back of their minds, other sites are beckoning to them. If your offer sounds good to them, other sites might have even better offers. You have to "STOP" their departure from your site. How?

Briefly summarize and build on your key benefits, zero in on your prospects' self-interests (the "You" factor), and give them a clear call to action. You need to create a sense of urgency. Tell them to "Order Now." Give your customers a reason to "ACT NOW!" Advertise a limited-time offer, an enticing discount, free shipping, a small free gift, or a two-for-one price. Motivate your customers with a money-back guarantee.

For customers who may be hesitant to place an electronic order, offer them other options such as a 24-hour toll-free number, fax number, or snail-mail address.

NURTURING YOUR NICHE

Determine your business's niche and nurture it. Your unique niche will separate your business from other online competitors. Do you sell a unique product or service? Then make sure your copy emphasizes the specific characteristics that make your product unique. Reinforce your message by telling customers how your unique products will benefit them.

For example, you might sell "customized care packages" that are based on the recipients' personality. When customers place an order

for one of your packages, they fill out an online form that gives details about the recipient's special likes and interests. You then create a "customized care package" and send it to the recipient. Your online copy would emphasize your unique offering and how each of your packages is tailored to the recipient's special interests. Your online copy would also talk about the warm and fuzzy benefits that customers receive by sending a thoughtful gift that caters to the interests of the recipient. Last, you could reinforce the benefits that recipients get from receiving such a package.

If your product is similar to other products, then focus on those attributes that make your particular product stand out. For example, if you sell computers online, you might offer 24-hour customer support in case customers have questions when they are first hooking up their computers. Or, your online store might have the widest selection of goods imported from all over the globe or better prices at a higher value compared to your competitors. Let your customers know these facts and link them to customer benefits.

Don't forget about your offline competitors. What characteristics differentiate you from the bricks-and-mortar businesses? How do your customers benefit when they place an online order with your company? Convenience may be the first thought that comes to your mind, but dig a little deeper. Do you offer products that are unavailable in local stores? Maybe you offer specialty chocolates that are made by hand? Whatever the differences in your products, promote this information and the associated benefits to your customers.

CUSTOMIZING YOUR CONTENT TO MEET AUDIENCES' NEEDS

Enhance your marketing efforts by customizing your content to meet the different needs of your customers. First, look at the profiles you have created of your typical customer groups. Then, develop content that will meet the needs of each of those groups. Offering customized content and interactive tools will help build relationships with customers.

For example, you might categorize customers on a health site by their age, exercise goals, and weight-loss goals. Your site could offer content tools that will help them enhance their health. The tools could include an online aerobic exercise program, reduced-calorie menus, a body mass index calculator, a nutrition database, and discussion boards. If you offer a different exercise and new menu with recipes each day, you'll increase traffic to your site. Your customers will view

your site as a resource they can depend on to obtain useful tools. Offering customers beneficial and reputable information will help you sell health-related products such as workout apparel, exercise videotapes, and equipment.

Offer Objective Content

You need to balance your editorial and promotional efforts. You can't merely post a discussion board or a couple of articles alongside your product and service offerings. Customers quickly get a feel for your site. They'll know right away whether you are putting up content that is relevant to their interests or merely providing a vehicle to sell your products. You have to constantly be careful about the integrity and objectivity of your content on an e-commerce site. That's why regularly cycling fresh, objective content is important to the viability of your e-commerce site.

DEVELOPING MULTILEVEL WRITING TO SUIT CUSTOMERS' INTERESTS

The content on your site should be written and designed so that it meets the needs of the different purchasing styles of prospects who visit your site. A thorough understanding of your customers base will help you develop content that meets their needs. Just like there are different types of shoppers in the offline world, there are different types of shoppers online. Some customers like to quickly choose an item, complete their purchase, and leave the site. Other customers prefer to read about the details of your products and examine your site before they make a purchase. Therefore, you need to develop content that satisfies customers' various levels of interest. Brief product summaries will satisfy your "click-and-run" customers. Providing links to more detailed product information will satisfy more analytical customers. Similar to the offline world, there are also "browsers" who will visit your site, leave, and come back later to make their purchase. You'll increase your chances of future sales with these prospects if you create a site that is attractive and easy to navigate. Prospects should also be able to quickly find the information they need. If these browsers have a pleasant experience on your site, they'll be more likely to return when they're ready to make a purchase.

FAQ PAGE

An FAQ page on your e-commerce site can proactively answer many of the questions that potential customers may have about your business. Put an FAQ button on your home page that directly links to the FAQ page so new prospects can easily find the answers they need. The FAQ page can contain a list of questions and answers that address ordering information, payment methods, shipping and handling charges, return policies, and privacy policies. Keep the list of questions and answers brief. Revise the list as the nature of your product offerings and policies change. Add any new recurring questions that you begin receiving from customers in e-mail messages, over the telephone, or in the mail.

ORDER FORM CONTENT

Your order form is another type of content on the Web. Your wording should be clear and concise. Stick with simple words and sentences. Steer clear of ambiguous language. Fuzzy wording creates doubt in your prospects' minds. Include a "Clear" or "Cancel" link on the order form to help your prospects feel more comfortable in case they change their mind about ordering your product. Use checkboxes to make the form easier to complete.

Design the form so that it is easy to print out because many customers may want a hard copy of the transaction. On the form, include your company's complete contact information (including snail-mail address, toll-free number, fax number, and e-mail address), your company guarantee, and delivery and return policies. The form should be professionally edited for any spelling or grammar errors. After you have written the copy for the form, test it out with potential users to determine if your language and instructions are understandable.

Customers should receive an automatic e-mail confirmation of their orders. Deliver a simple message confirming the specific order(s), costs (product costs, shipping and handling costs, taxes), and approximate delivery date. Tell customers if part of the shipment will be delayed.

ONLINE CONSUMER BROCHURES

The text in your online consumer brochures should be at least 50% shorter than your traditional print brochures. Avoid the "brochureware" look of taking your material directly from print brochures and planting it on your site. Instead, highlight key points with informative headings

and subheadings to increase scannability and to lead readers into the copy. Catch your prospects' interest by presenting the most intriguing information first to give readers a reason to continue reading. Take advantage of bulleted items; they help readers scan, are easy to read, and cut down on words.

SELLING PRODUCTS AND SERVICES ONLINE TO BUSINESSES

Companies that sell products and services to businesses need to provide more detailed content on their sites versus e-commerce consumer sites; however, this doesn't mean that their sales literature (print brochures and other related print material) should be put directly onto their Web sites without being rewritten.

Creating Online Sales Literature— Business-to-Business

To attract business prospects, writers need to reinvent their company's print sales literature and adapt it to the online environment. Prospects may still need the type of detailed product and service information that the company's print materials provided, but the information will have to be presented in a useful, clear, and readable format. The text that worked in a print brochure won't necessarily work online because reading online is more difficult. The use of headings and subheadings, short blocks of text, and concise writing will make the material easier to read online.

Writers can also take advantage of hypertext links that lead to more detailed product information for those prospects who want more facts. Online, writers can offer photographs of products, video clips, audio clips, price lists, white papers, and direct links to dealers. Some of these materials should be offered in a "print version" format in case prospects want to print the information and read it later or show it to colleagues.

Update Sales Literature

As your product offerings or pricing changes, your online sales material should be regularly updated to reflect these changes. Obsolete information in your sales literature will reflect poorly on your company. Put

a daily or weekly maintenance schedule in place and appoint a team (or person) to update the sales literature on your site.

Make Information Easy to Find

Test the internal search engine on your site. Better yet, watch new users as they test the search engine. Can information be easily found? Did the search engine bring up outdated information? Were broken links found? How long does it take to find the information? Your search engine should effectively give customers the information they are looking for. Prospects should also be able to easily compare different products and services on your site.

Serving Different Customer Groups

If you have more than one set of business customers, you could create different links on your home page for each customer group (e.g., small business, corporate, or nonprofit organizations). These links could connect to separate pages for each group. On your home page, you could also create a separate link for journalists that connects to an individual page. On this journalists' page, you could list press releases, company background, and contact information for your company's public relations staff (e-mail addresses and phone numbers).

Providing Targeted Sales Literature

Regularly analyze the types of requests for sales literature that are received by your fulfillment center and sales and marketing staff. Capture the different types of prospects who are making these requests. These efforts will help you determine the kinds of targeted sales literature to create and place on your Web site.

Create Industry-Specific Online Communities

Create and nurture industry-specific or profession-specific online communities. These communities can offer the latest industry news, discussion forums, feature articles, and an events calendar. These communities give you the opportunity to provide solutions-based marketing messages that promote your products and services; however, don't

blatantly use these communities to sell your products and services. Instead, create communities where everyone equally gives, receives, and shares resources.

PROMOTING YOUR BUSINESS

Make the promotion of your business a daily habit. Promote your business by cultivating a robust e-commerce site and by becoming an active member of the online global community. Use both online and print advertising to get the word out about your business.

Promote Your Web Site URL

Think of your Web site URL as your professional calling card. Drive traffic to your Web site by adding your URL to your print advertisements in magazines and newspapers, brochures, catalogs, order forms, letterhead, package inserts, and Yellow Page ads. To gain additional online exposure, set up reciprocal links with other e-commerce Web sites that complement your business.

Keep Your Site Fresh

In the offline world, storeowners constantly change the layouts and displays of their stores to keep customers interested. Demonstrate to your online customers that your site is buzzing with activity by continually posting new content. Even brief, updated content is better than static, stale content.

Keep the content relevant to your business to make a stronger impression on your customers. Don't offer a section on recipes if you sell local real estate. Offer a brief article on "How to Make Moving Day Less Hectic" instead. Make sure the content has a high-interest component and that it offers a valuable benefit to your customers.

You might include a "What's New" section or a "Customer Question of the Day." A "Tips" column would be easy to write and provide a quick read for busy prospects. You could also feature daily or weekly "news summaries" that have a strong tie-in to your business. Bottom line, your goal is to attract repeat visitors. Outdated content could cost you lost business. Why should a prospect do business with a company that doesn't care enough about its site to constantly improve and enhance it on a regular basis? Prospects may think that you might show the same indifference to serving their needs if they place an order with you.

Send Opt-In E-Mail Newsletters to Your Customers

Create an opt-in e-mail newsletter that focuses on topics that are related to your business and that offers helpful information to your customers. For example, if you sell bookbinding supplies to artists, your newsletter might include an article on "How to Make Simple Accordion Books." The newsletter could also tell readers of the new varieties of book cloth that you now offer. A newsletter that merely hawks your products and services, without providing any useful tips, will turn customers off. Offer your newsletter on a regular schedule so that readers will know when to expect it.

Before you develop the newsletter, look at your resources. Determine if you or your staff has the time to write a newsletter. A newsletter may be difficult to publish every week, but a biweekly newsletter may be more practical. E-mail the newsletter only to those prospects who sign up for it. Sending out e-mail newsletters to people who did not request them is considered spam. That tactic is one of the quickest ways to lose potential customers.

Targeted Opt-In E-Mail Announcements

Opt-in e-mail announcements can tell customers about special sales or discounts that you are currently offering. These announcements are usually short. You might include an e-mail coupon with a code number in the announcement that entitles customers to an exclusive offer. (When customers place their order online, they can type in the code number on the order form to receive the exclusive offer. If customers place their order over the telephone, they can provide the code number to the customer service representative.)

Your opt-in e-mail announcements should address your customers' specific interests or needs. Offer brief but valuable information in your announcements just like you do in your newsletters. Customers will be more likely to read an announcement that contains a list of helpful tips. The more relevant your messages are to your customers, the more effective your sales efforts will be. To maintain good customer relationships, ask customers if they want to be notified of upcoming sales on specific products or services through e-mail announcements. Ask this question on order forms, your Web site, or through opt-in e-mail newsletters.

As your customer base increases, develop different marketing messages and announcements that address your different customers' interests. For example, if you sell art supplies and one of your customer groups recently purchased oil paints, you might create a targeted

e-mail announcement informing these customers of special discounts on canvases and brushes.

Offer a Resource Section on Your Web Site

Offer an online resource section on your Web site for customers. The resources should be related to your business and be reputable Web sites. You should visit the sites first and check out the quality of the pages before you post the sites to your resource list. The Cheap Joe's Art Stuff home page (http://cheapjoes.com) offers visitors an extensive listing of "art links" resources. By offering a valuable service to your customers in the form of a resource list, you'll increase your credibility and attract repeat visitors. The resource section can be formatted like an annotated list of links. See Chapter 7, "Writing Content for the Web," for details on how to develop such a list. Make sure you keep your Web site's resource list updated regularly. If one of the resources that you recommend no longer maintains fresh content or disappears from the Web, remove it from your list. Regularly check for broken links and fix them immediately.

Stay in Touch

Treat your customers like they are your friends. Send e-mail thank you notes after customers make a purchase. Use the person's name in the salutation of the e-mail message to personalize the note. Surprise your customers and you'll build stronger relationships. Send e-mail discount coupons unexpectedly. Through opt-in e-mails, tell customers when new products and services that meet their needs arrive in your warehouse; however, don't abuse your e-mail relationship with your customers. They can easily delete your message or unsubscribe and you will have lost a long-term customer relationship.

Write Articles for Your Web Site

On your site, professionally written articles can add value by providing interesting information that is useful to customers. Your content will be even more memorable if customers receive some tangible benefits from your articles and apply them to their own work or life. Well-written articles can also differentiate you from the competition. The article should have a tie-in to your business but not be an obvious advertisement.

You can also offer professionally written articles free of charge to other online and print publications in return for including your name, e-mail address, and the URL of your business Web site. Think of this effort as free publicity for your business. For example, if you're a career coach, you might write an article on "How to Land Your Dream Job."

E-Mail Signature Blocks

Jay Conrad Levinson, author of *Guerrilla Marketing Online: The Entre-preneur's Guide to Earning Profits on the Internet*, suggests that e-mail signature blocks are the business cards you leave wherever you go on the Web.[2] Think of your signature block as free advertising. Use signature blocks to sign all of your e-mail messages, in discussion groups, and in online mailing list postings. Take advantage of your e-mail signature block's online visibility by including some of the following identifiers: your name, e-mail address, company name, the URL of your business Web site, toll-free number, and telephone and fax number.

The look of your signature block will depend on your type of business. Your signature block should be no more than six lines long. Customize your signature block based on the new products and services you are offering, special sales, or new feature articles that are posted on your site. If you are referring prospects to your new products, a link in your signature block should take them directly to the new products page and not to the home page of your site where they will have to search for your new products.

WRITING E-MAIL PRESS RELEASES

Print and online editors and reporters are on information overload like the rest of us. As a writer, your press release has only a few seconds to grab their attention. The first critical test that your press release has to pass comes down to these three words: "Is it newsworthy?"

Target Your Audience

When you write press releases, you have to think like a reporter. You have two audiences to persuade: first the reporter (or editor) and then the online prospect. They both are looking for the answer to this typical and egotistical question: What's in it for me? (WIIFM). If you don't

immediately convince the reporter, then your press release could be the victim of the delete button.

Writing a memorable press release is only part of the battle. It's also important that you send your release to the right person in the right department. Check your contact information before you forward your press releases. Is the editor still at that publication? Do you have the most current e-mail address? Take the time to personalize each of your e-mail press releases. Don't send out mass generic e-mails.

You also have to determine if the online publication covers the subject matter of your press release. Sending a press release on new fiction novels to e-zines that publish only nonfiction book reviews won't win you any points. If you're in the business sector, find out if the editor covers your industry and topics. Sending a press release on fiction writers' courses to an online publication that strictly covers journalism is poor targeting.

Expand Your E-Mail Press Release Audience

Expand the audience for your e-commerce press releases by posting them in the journalists (or pressroom) section of your Web site. Arrange the press releases in a list of annotated links, with the most recent press releases placed at the top of the page. Include an informative title and date for each press release, with a hypertext link to the complete press release facts. Keep the press release list updated and journalists will view the page as a reliable resource when they need the latest news and information for a story.

Write Informative and Catchy Subject Lines for E-Mail Press Releases

Write informative subject lines that capture readers' attention (for example, "New Fuss-Free Silk Painting Kits"). Inject energy and enthusiasm into your words. Avoid vague promotional words and phrases and tired clichés. A good subject line means the difference between a press release being read or deleted.

What's the Story Behind the E-Mail Press Release?

Write a strong lead-in paragraph to carry readers into your copy. First examine the "who, what, where, when, why, and how" of your story; then look for the unique angle in your story. How does your product

solve a customer's problem? Does the product reduce the need for costly repairs? How does your service fulfill a customer's need? Does the service save a busy customer time? What benefits does your product provide? Does the product make a customer look younger? The answers to these questions will help you develop the positioning for your press release.

Offer Solid Information in Your E-Mail Press Release

In your press release, offer solid and relevant information that will stimulate readers' interest about your product or service. State the facts briefly and clearly and be upfront. Use short, simple sentences. Avoid marketing hype. Online press releases are shorter then print press releases. Word count can range from 200 to 400 words, with about two to four brief paragraphs. Provide a live Web site URL in your press release so recipients can easily obtain additional background information on your company products or services. Include the company's physical address. Put contact information for your public relations staff (names, e-mail addresses, and phone numbers) at the end of the press release.

Make sure that all sections of your site reflect the updated product and service information that is mentioned in your press release. This includes updating your online catalogs, product/service descriptions, and price lists.

Advantages of E-Mail Press Releases for Editors and Reporters

E-mail press releases offer editors and reporters many advantages. The live URLs in press releases help editors because they can easily check background information by clicking on the links. When editors are writing a news story, they can also quickly massage the information in the e-mail press releases to suit their specific needs—and use the provided statistics and quotes without doing substantial rewrites. This ability to "cut and paste" material from the press releases saves editors and reporters time.

Formatting the E-Mail Press Release

If you are writing a press release, date each release to alert editors and reporters of its' timeliness. Create the press release in plain ASCII text.

Avoid HTML formatting and attachments. (Some editors won't even open attachments because of virus problems.) Add a line of space between each brief paragraph of text to make the press release easier to read.

INTERNATIONAL VISITORS

Your e-commerce Web site can attract visitors from all over the world. Are you ready for them? You need to examine your content and determine if it is appropriate and understandable to an international audience. Avoid slang and acronyms that may confuse visitors from other cultures. Let visitors know if your products are available only in the United States or worldwide. Provide specific shipping and pricing information for each country.

BREAKING INTO ONLINE COPYWRITING

As e-commerce grows, copywriting will become a lucrative career for online writers. But how do you break in? Nick Usborne, author of the online copywriting book *Net Words*, gives writers this advice:

> The Web as a commercial environment is still in its infancy. Within Web development groups, there are some roles that are very clearly defined—like those of the programmers and interface designers. But in the area of copywriting and content writing, it's still hard to tell exactly where these jobs fit in, or what they encompass. As the role of the commercial writer online becomes more clearly understood, and more highly valued, we'll see a lot more books being written and training courses being developed.... In the meantime, whatever online writing skill someone is aiming to master, they'll just have to get out there and study the Net. See what others are doing. Find out what works and what doesn't. Find those sites and discussion lists where writers gather together and share what they know. Dig deep and be passionate about what you're learning. And, of course, write. You can learn nothing about copywriting online if you're not practicing the craft, day in and day out.[3]

Usborne further states that:

> Building a freelance career in copywriting is a tough call in the online world, where even in-house copywriters are under-valued.

However, to follow this path, it certainly helps if you have first learned your craft in a salaried position. It's difficult to pitch yourself as an experienced online copywriter if you don't have any solid experience behind you. Beyond that, one way to get your name known and recognized is to start writing articles or a newsletter on the subject of copywriting online. When you are a published "source" or "authority" on the subject, that immediately adds a lot of credibility to your claims as an expert.[4]

E-COMMERCE SITE CHECKLIST

Use this E-Commerce Site Checklist to ensure that you have developed a site that focuses on your customers and meets their needs.

- Identify target audience(s)____
- Profile of target audiences(s)____
- Marketing message for each target audience____
- Product Features: Product Benefits:

 _____ _____

 _____ _____

 _____ _____

- Site Slogan (tag line)____
- Headlines (catchy, complete, easy to understand, pulls readers into the copy, benefit statement, "You" factor)____
- Subheadings (informative)____
- Leads (focus on customer benefits, zero in on the "You" factor)____
- Include the three Es (energy, enthusiasm, excitement)____
- Conversational copy____
- Clear, concise copy____
- Tight copy____
- ACT NOW offers____
- Nurture your niche (differentiate your products, emphasize products' uniqueness)____
- Customize content to meet customer needs and interests____
- Multilevel writing to suit customer interests____

- FAQ section (include ordering information, payment methods, shipping and handling charges, return policies, and privacy policies)____

- Order form (clear, concise, complete company contact information; guarantee, delivery, and return policies)____

- Promoting your business daily (cultivate robust e-commerce site, participate in online communities, use online and print advertising, put URL on all sales literature, set up reciprocal links with other sites)____

- Keep site fresh (regularly post new content that is useful to customers, "What's New" section, "Customer Question of the Day," "Tips" column, "news summaries")____

- Opt-in e-mail newsletters____

- Targeted opt-in e-mail announcements____

- Resource section page (for customers)____

- Stay in touch with customers____

- Write helpful articles for customers____

- E-mail signature block that promotes your business____

- Professional Web site design____

E-COMMERCE SITE AUDIT CHECKLIST

After your e-commerce site has been on the Web for a while, your pages of content will continue to multiply in proportion to the growth of your site. Depending on your type of business, there are articles, press releases, product and service descriptions, FAQ sections, resource pages, archives, and order forms all organized into categories or pages on your site.

Changes or updates will often be made in one section of your site but will not be updated in another section. This situation can result in incorrect information appearing on pages or a chorus of different voices promoting your business.

To remedy the situation, it's important that your categories and pages portray the same look, tone, and voice throughout your site. How do you do this? To ensure that your site presents a consistent image to your customers, you should schedule a regular audit of your Web site. Here are some of the areas that you should check to make

sure that they are up-to-date and that your content carries the same tone and voice throughout the site:

- Look of Web site (consistent throughout each page)____
- Voice and tone of content (consistent on each page)____
- Accurate, updated information on each page____
- Company contact information reviewed and updated____
- Products and services (descriptions, features, benefits updated)____
- Sales literature, e.g., brochures (accurate and updated)____
- Price lists updated____
- Shopping cart page text correct____
- Order form reviewed and updated____
- Shipping and handling policies reviewed and updated____
- Guarantee policy reviewed and updated____
- Return policies reviewed and updated____
- Automatic e-mail confirmation of order to customer reviewed and updated____
- Privacy policy updated on site____
- Subscription information for e-mail newsletters correct____
- FAQ sections (all questions and answers reviewed and updated)____
- Online communities (delete old postings; note lack of activity; enliven discussion by posting stimulating topics)____
- Press releases (posted in "Press" section; annotated list of links, including informative titles and dates)____
- Resource section (accurate up-to-date and links working)____
- Complete company backgrounder updated____

FEATURE AND BENEFITS EQUATION FORM

In order to successfully sell the products and services on your e-commerce site, look at every feature of what you are selling. Determine how the feature benefits your customers. Then blast that initial benefit with another benefit that benefits the customers. See the example below.

Type of Product: ABC face cream

Product Feature	Benefit Based on Feature	How the Benefit Benefits the Customer
vitamin E enriched	fine facial lines diminish	facial skin appears younger

PRESS RELEASE CHECKLIST

Use this Press Release Checklist to make sure that you included all the important points.

- Is your press release newsworthy?____
- Does your press release answer the question of WIIFM (What's in it for me?) for the reporter (editor) and for the customer?____

- Does the publication cover your business or industry?____
- Are you sending the press release to the right person? Right department? Is your contact information (e-mail address) up-to-date?____
- Did you personalize the press release?____
- Did you write an informative and catchy subject line for your press release?____
- What's the story behind the press release? (Did you write a strong lead-in paragraph? Do you answer the "who, what, where, when, why, and how" of the story? Do you offer an unique angle to the story? Do you talk benefits?)____
- Is your press release brief but complete? (200 to 400 words, two to four short paragraphs, includes your Web site URL, public relations contacts)____
- Did you also post the press release on your Web site?____ Are your press releases easy to find on your site?____
- Do the contents of your site (updated product/service information, price lists) reflect the information in the press release?____
- Is the press release format easy to read?____

ENDNOTES

1. Lewis, Herschell Gordon. *On the Art of Writing Copy: The Best of Print, Broadcast, Internet, & Direct Mail*. E-mail interview, July 20, 2001.
2. Levinson, Jay Conrad, and Charles Rubin. *Guerrilla Marketing Online: The Entrepreneur's Guide to Earning Profits on the Internet*, 2nd ed. (New York: Houghton Mifflin, 1997), p. 195.
3. Usborne, Nick. *Net Words*. E-mail interview, June 22, 2001.
4. Ibid.

Chapter 11

Online News

New technology places many additional demands on today's journalists. Most journalists have to develop an adaptable set of skills. They may be writing articles for the print edition of their newspaper on Monday and writing for the online version of the newspaper on Tuesday. They also have to be flexible, learning how to operate video equipment, possibly appearing on the evening news, or learning new software in the newsroom.

Online journalists need to know how to develop original material that follows the principles of good online content. At the same time, they have to incorporate the basics of good storytelling. They need to understand the needs of their online audience. Today, journalists are held more accountable to readers through the instant feedback of reader e-mails. The demands are many, but they will continue to change as technology progresses and the Web evolves.

BUILDING YOUR NEWS SITE AROUND YOUR USER

According to Andrew DeVigal, of the Poynter Institute, you need to determine the primary goal for your online site. Is your site news related or is it an entertainment guide? Determining your primary goal helps you focus your content.

DeVigal believes it's also important to identify your audience by analyzing the technical statistics gathered from your server. He suggests that newswriters use language that is familiar to users. Because people tend to think in categories, he says to create logical categories, all the

while focusing on the goal of the site. DeVigal recommends the use of intuitive navigation that helps users to easily move through your news site. It's essential to make information easy to find. DeVigal suggests that journalists build a "toolbox" of techniques so they don't have to reinvent the wheel of technology as they repeat storytelling devices.[1]

A CALL FOR SIMPLER NEWSPAPER DESIGN

Dr. Mario Garcia, of the Poynter Institute, believes the design of newspaper Web sites calls for functionalism, organization, and clarity over aesthetics. He suggests that Web site users expect these qualities. In newspaper design, the accent should be on simplicity; simplicity rules over complex design.

Online, newspapers should look like newspapers. Emphasize good headlines. Garcia believes that front pages with many headlines do better than those with only a few headlines. The front page should have as many NEWS items as possible, even on Sundays. This tactic gives readers the sense that the news is timely.

Garcia says to create a hierarchy for navigation. Time-crunched readers should be able to easily distinguish between what items are most important and least important to them. With photographs, choose quality over quantity.[2]

ONLINE NEWS GUIDELINES

Larry Pryor, executive editor of the USC Annenberg Online Journalism Review (OJR), suggests that for online news to survive, it has to come wrapped in a sophisticated bundle of news, services, and e-commerce. He also believes that it's essential to produce original content for the Web.

Pryor believes, when you plan your news product, you match it to the specific group of people that you want to attract—whether they be news hounds or sports fans. He claims that it's important to define your international community as part of your business plan and to stick with the plan.

Pryor says that your audience expects you to have expertise on the topics that you display on your front page. You have to demonstrate that expertise and let readers know they can depend on you for additional information on those topics.

Pryor encourages online news sites to promote a two-way dialogue with readers through e-mail and e-mail newsletters—but first you have to know who your audience is. He suggests that news sites be available

to readers through feedback buttons and bulletin boards. This means that everyone at your news organization should perform the following tasks:

- Be an active list participant.
- Answer board postings.
- Exchange e-mail with readers.

Pryor encourages news sites to look three to five years ahead and then figure out what the news of the future will look like. He claims online news will be a "totally interactive digitally immersive experience, having little resemblance to today's news on the Internet."[3]

ONLINE JOURNALISTS CAN BRING NEWS STORIES TO LIFE

Through the technology of the Web, online journalists can offer readers an enhanced news experience. Journalists aren't restricted to the linear narrative that is common to print publications to report the news. Online news stories provide journalists with a rich variety of tools to tell their stories, through text, photographs, graphics, audio, video clips, and other interactive elements. Generally, journalists should build their stories by using a catchy heading, enticing lead-in paragraph, and photograph to pull readers into the body of their stories. Steve Outing, senior editor of the Poynter Institute for Media Studies, and CEO and founder of Content-Exchange (http://content-exchange. com), states that because online news readers have a shorter attention span, you have to grab them with a lead. Outing believes that you have to figure out a unique way of developing a conversation with your readers (i.e., give distinctive voice to your words). You also have to build in interactivity. Outing says that Web writing is closer to the print style of *USA Today* than to the *New York Times*, where you write in short blocks of text and provide catchy headings.[4]

Internal Hyperlinks Enhance a News Story

Internal hyperlinks, within the body of the text, offer readers the option to follow links that contain background and reference information that is related to the story. These links must lead to information that is accurate. The background information should also include an identifiable author, such as a research expert, or reputable source, such as a well-known and highly regarded organization. It's also important for

the background/reference information to be regularly maintained so that the material is up-to-date, and that the links are in working order when readers want to access the data.

Use the Power of Video Clips and Audio Bites

Video clips and audio bites bring a story to life in a way that no print newspaper or magazine can. By offering readers a menu of choices with each news story, you are enhancing their user experience. Journalists can also dip into the news archives and create links between current events and relevant historical information to provide readers with the "full story." For example, a news story that covers the renovation of a previously abandoned historic building can contain a link that offers information on the unusual history of the building.

Interactivity

Journalists need to infuse their online news stories with interactivity. Get your readers involved. Encourage readers to express their opinions about your articles by sending you e-mail messages. Add a bulletin board where readers can discuss your current articles. If the bulletin board starts to get quiet, stir things up a bit and post a thought-provoking or controversial topic. Use a reader opinion poll to provoke interest on your latest article. Send out opt-in e-mail newsletters to let readers know when you posted a new article or column on your news site.

Attitude Is In

On the Web, the old media tone of black and white newsprint is out. Attitude is in. Take a look at some of the news stories on the Web. You'll notice a more hip reporting style. Writers are more conversational and intimate. They are talking to the "You" that is sitting in front of the computer screen instead of a sea of faceless and nameless people who read conventional newspapers.

WEBLOGS

Weblogs contain brief, frequently updated posts. The ongoing commentary may refer readers to links to sites, articles, or discussions. The

nature of Weblogs can range anywhere from updates on a specific industry to company news to personal diaries covering bizarre topics. Weblogs can be used at work where team members share information on projects. They can be set up as family blogs so relatives can share personal news.

The entries are arranged chronologically, with the most recent entries appearing at the top of the Weblog. Older entries are put into chronological archives. The phenomena, which began appearing around 1999, is also known as *blogging* or *blogs*. A person who writes a Weblog is a *blogger*. It's easy to set up a Weblog. Visit Blogger (www. blogger.com), where you can create a free Web-based blog. On the site users will find easy-to-use templates to help them create their Weblog. Bloggers can submit Web forms to add and update entries to the online site.[5,6] Another Weblog site is Weblogger.com (www.weblogger.com), which charges a fee for establishing a Weblog. As a writer, a Weblog offers you the opportunity of instant publishing. If you create compelling content, you'll get feedback from people who read your blog. Other bloggers might drive traffic to your site.

E-Media Tidbits: A Group Weblog

Steve Outing is editor of E-Media Tidbits: A Group Weblog. The Weblog is written by some of the sharpest and most experienced minds in the field of online journalism and media, and published by the Poynter Institute for Media Studies. Outing claims that Weblogs don't fit one neat description. Weblogs range from those that reflect the thoughts and focus of one person to those that are extremely interactive and invite readers to participate. Some Weblogs are collaborative communication vehicles, with industry experts providing regular input. The main point is to experiment with Weblogs. Offer a mechanism for reader feedback. Outing suggests that Weblogs may someday develop into a new form of column writing.[6]

Weblog Writers

Here are some of the Weblog writers who cover news, technology, and online media:

- Dan Gillmor's News & Views (e-journal), http://web.siliconvalley. com/content/sv/opinion /dgillmor/weblog

- Jim Romenesko, Media News, http://.poynter.org/medianews
- Steve Outing, E-Media Tidbits: A Group Weblog, http://poynter. publishmail.com/login.html

JOURNALISTS' ORGANIZATIONS

Many Web sites offer working and new journalists helpful information and tips. Visit these sites and explore their links. You'll learn a lot of information that will improve your news writing. A few of the sites include the following:

- USC Annenberg Online Journalism Review (OJR), http://ojr.usc. edu/content
- Poynter Institute for Media Studies, www.Poynter.org
- Editor and Publisher Online, www.editorandpublisher.com

ONLINE NEWS STORY CHECKLIST

- Do you know who your audience is?____
- What is the focus of your story? (Describe the story in one sentence.)____
- Does your headline grab the reader?____
- Do you make your central point quickly?____
- Does your lead paragraph pull the reader into the story?____
- Are you writing in the reader's language?____
- Do you artfully blend the "who, what, where, why, when and how" of the story?____
- Is your tone appropriate to the topic? (keeping in mind that Web writing requires more attitude)____
- Did you use strong verbs?
- Were your sentences concrete and specific?
- Have you correctly spelled names, titles, organizations, and institutions?____
- Have you double-checked your facts?____
- Do your links enhance the story?____ Do the links work?____
- Does your story take advantage of the Web? (by including photographs, graphics, video clips, audio clips, hypertext links)____

- Does your story include interactivity (your e-mail address, bulletin boards, opinion polls, and opt-in e-mail newsletters to inform readers of your newest story)?____

- Step back and pretend you're the reader. (Did you tell your reader a story using a setting, chronology, action, conflict, motivation, and dialogue?)

ENDNOTES

1. DeVigal, Andrew. "Design Guidelines for Online Sites," Journalism Tips You Can Use, The Poynter Institute, www.poynter.org/special/tipsheets/newmedia/design.htm. Accessed January 9, 2000.
2. Garcia, Mario. "A Return to Simpler Newspaper Design," www.mariogarcia.com/english/news/news.html. Accessed May 5, 2001.
3. Pryor, Larry. "Some Guidelines from One of Online News' Walking Wounded," Editorial, USC Annenberg Online Journalism Review, June 30, 2000, http://ojr.usc.edu/content/story.cfm?request = 397. Accessed July 19, 2000.
4. Outing, Steve. CEO and founder of Content-Exchange, http://content-exchange.com. Telephone interview, July 20, 2001.
5. Lasica, J.D. "Blogging as a Form of Journalism (Weblogs offer a vital, creative outlet for alternative voices)," USC Annenberg Online Journalism Review, May 24, 2001, http://ojr.usc.edu/content/story.cfm?request = 585. Accessed May 30, 2001.
6. Fleishman, Glenn. "Been 'blogging'? Web discourse hits higher level," Business & Technology, Internet, Special to The Seattle Times, April 1, 2001, http://archives.seattletimes.nwsource . . . /display?
slug = ptblog01&date = 20010401&query = Fleishma. Accessed June 2, 2001.
7. Outing, telephone interview.

Chapter 12

E-Mail Newsletters and E-Mail–Based Discussion Groups

E-mail newsletters offer many advantages. A well-written newsletter gives you the opportunity to instantly communicate with your subscribers through the personal medium of e-mail. Printing and distribution costs are no longer a concern. Once subscribers learn that they can depend on you for useful information, they come to see you as a valuable resource. By appearing in your subscribers' inbox on a consistent basis, you get the chance to remind readers about your site and encourage them to make return visits.

John Funk, creator of InfoBeat, suggests that one of the most important things to focus on if you want to succeed with e-mail publications is the end-user experience.[1] He says that an e-mail publication is not about you; it's about the end user. Every interaction your reader has that relates to your e-mail newsletter should be a positive experience.

TARGETING YOUR AUDIENCE

E-mail newsletters succeed when they are developed for a specific target audience. Sending out a generic newsletter to a general audience will result in readers hitting the delete button before you even have a chance to develop a relationship. If you want to produce a newsletter, you first need to determine the size of your potential audience. You

could have a potential audience of 100 people or thousands of people who are interested in your newsletter. Next, you need to determine your target audience. Maybe you have more than one target audience. If you do, you might need to develop more than one newsletter to meet the specific interests of each of your audiences. A small business owner's needs are different from a midsize company's needs. To begin, create a profile of your typical reader: gender, age, education, occupation, geographic location, Internet experience, Internet usage (i.e., number of hours spent online, type of things done online), Internet skill level, language, and personal interests. If possible, hold an informal focus group with likely subscribers. Develop a list of questions, focusing on your potential readers' concerns, interests, and needs. Ask the group what an ideal newsletter would look like and what content it would contain. If you can't hold a focus group, send out a brief survey. These efforts will help you develop focused content for your newsletter. Each issue of your newsletter should be written so that it centers on the interests of your particular audience.

WHAT'S YOUR NEWSLETTER'S BIG IDEA?

What's your newsletter's big idea or goal? Your newsletter's big idea should be something that you are really excited about and interested in because you will be spending a lot of time on the project. Your big idea also needs to attract the interest of online readers. Ideally, your big idea should benefit readers in some way so that they look forward to receiving your newsletter. Describe your newsletter's big idea in one to two brief statements. For example, your big idea statement might be "ABC newsletter offers small businesses low-cost promotion tips with high potential profit." A big idea statement(s) will help keep you on track as you are developing the concept of the newsletter and as you publish each new issue.

BRANDING YOUR NEWSLETTER

Chris Pirillo, author of the book *Poor Richard's E-Mail Publishing*, suggests that you think of an original name for your e-mail newsletter. He recommends that "No matter what name you choose, your goal is to brand your title/name in the minds of your Web readers when you're using it in your e-mail publication. The more they see your newsletter's name in your issues and on the Web, the more they'll trust you." Pirillo maintains: "Don't be afraid to have fun with the name." The name of Pirillo's newsletter is Lockergnome (www.lockergnome.

com), which used to be his nickname in high school and his online BBS handle.[2]

ANALYZING YOUR COMPETITION

Do some research on the Web. Make sure that a market exists for your particular newsletter. If there are too many newsletters covering your niche, you'll have a more difficult time being heard among the voices on the Web. If no newsletters cover your niche, there may not be a big enough audience that is interested in your topic.

Next, do some in-depth study on the Web. Identify your major competitors in the e-mail newsletter industry. Subscribe to their newsletters for a few months. Ask yourself what makes their newsletters unique. Look at the information and content they cover. Check out both the internal and external links they include in their issues. Analyze their tone and writing style. Are their articles reader friendly? How about their formatting? Is their Web site easy to navigate? How do they market their newsletter? Who are their advertisers? Do these newsletters offer a free or paid subscription?

Note those things that don't seem to work for the competition. Can you think of better alternatives that you can apply to your newsletter? Determine how your newsletter will be different or similar to the competition? Capitalize on those differences. Can you develop a newsletter so unique that it sets you apart from the competition, pulling in traffic and subscribers?

Randy Cassingham believes that if you have a compelling offering, you'll get noticed. Cassingham writes "This Is True," which is one of the most popular weekly columns on the Internet. The weekly column reports bizarre-but-true news items with a short comment written by Cassingham at the end of each story. The column is available for free by e-mail subscription. There is also a "premium" (paid) version of "This Is True." Cassingham also compiles his stories into books that he sells online.[3]

As part of your analysis of the competition, it's also important to look at newsletters that are outside your particular niche. Although these newsletters don't focus on your topic of interest, they can still provide you with valuable ideas on how to handle subject line development, content, formatting issues, and advertising.

WRITING STYLE

E-mail newsletters are a one-to-one marketing medium. You need to follow the same online writing guidelines that you use when you write

content for Web sites. Readers are looking for a personal and conversational tone from newsletter writers, just like they are with other online writers. Develop a voice that readers can trust. Because readers' e-mail inboxes are overflowing with dozens, even hundreds, of other competing messages, you need to write tight. Your newsletters should be easy to scan; readers want their information fast today. Brief, clearly written messages will be read sooner than densely packed text.

COMPELLING CONTENT COUNTS

Compelling content is important in e-mail newsletters. Provide your readers with valuable and useful information that is specific. Avoid writing newsletters that are merely vehicles to sell products. Provide helpful information to stand out from the spam and lookalike messages that are clogging readers' inboxes.

GENERATING STORY IDEAS THAT ARE "YOU-CENTERED"

Coming up with good story ideas and new columns will keep the content in your newsletter fresh. Run every one of your story ideas past the "You-centered" factor. Call your team together on a regular basis to come up with new "You-centered" articles. Your stories have to focus on capturing the readers' self-interest.

Think like your readers by getting inside their heads, hearts, and feelings. What concerns and issues do they face on a daily basis? What articles would make their life easier? What news items would provide them with useful information? What topics would they like more in-depth information on? Based on your demographics, what particular subjects interest your readers? Maybe you could write a series of articles on these topics.

Collect Ideas

Collect ideas by subscribing to a variety of e-mail newsletters. Read both online and print articles, newspapers, and books. Search for and visit new Web sites. Try to anticipate future trends by subscribing to e-mail newsletters on technology. Seek out well-known experts in your niche and interview them for your newsletter.

Look at your own past newsletter articles. In every article, try to find at least three to five more new stories to write about for future

issues. Start a tickler file to capture all of your story ideas. Put the file on your hard drive or your ideas in a manila folder.

Editorial Calendar

After you have come up with a good variety of story ideas, plan your editorial calendar for the next three to six months. Take any seasonal changes and holidays into consideration and plan stories for those events.

CULTIVATING A GOOD CONTENT MIX

If you cultivate a good content mix, you will enhance the value and longevity of your newsletter. Offering timely information, such as news or limited-time offers, will entice your subscribers to read your newsletter now.

You could also include how-to, service articles, and useful tips that will encourage subscribers to save your newsletter as a reference source. This tactic may keep your newsletter's name in your readers' memory bank. If you keep these latter articles in your site's archives section, where they can be easily found, this may encourage readers to make repeat visits to your site. Include a link to your archive section on your home page.

Contests, giveaways, and freebies will add excitement and appeal to your readers' WIIFM (what's in it for me) self-interest. Of course, the type of content mix and promotions depend on whether your newsletter is targeted to consumers or to businesses. Consumers will have different information needs compared to businesspeople.

In each newsletter issue, test and retest different topics, columns, approaches, and authors to determine what your customers like. Ask your readers for feedback via e-mail response. Offer readers a small incentive to encourage reader feedback. For example, a fitness newsletter might offer readers a free e-mail tip sheet on "Ten-Minute Exercises for Busy People" if they send in feedback to your newsletter.

SURVEYING SUBSCRIBERS

To keep tuned into the needs of your newsletter subscribers, periodically conduct an e-mail reality check. Ask subscribers what's on their minds through an e-mail–based short survey. The survey will help you determine if you're meeting subscribers' needs. You can also ask subscribers

for ideas for future issues. Don't try to gather personal information in your surveys. Make customers feel comfortable so you will receive honest feedback, but don't send too many surveys to your readers or they'll soon be opting out. Remember to thank your subscribers for their time and contributions—they're busy, too.

NURTURING YOUR RELATIONSHIP WITH YOUR READERS

Similar to the Web, an e-mail newsletter is an ongoing interactive medium. Make it easy for subscribers to communicate with you. Your subscribers are the reason your newsletter exists. Once you decide to publish an e-mail newsletter, it's your responsibility to respond to e-mails from your subscribers. Readers will write to you with questions, concerns, complaints, or for advice. Answering these e-mail inquiries from readers is an important part of building a strong customer relationship.

Depending on your type of publication, include a variety of response mechanisms in every e-mail newsletter that you send out. For common questions, you can use an e-mail autoresponder. A list of frequently asked questions (FAQs) on your Web site is another way of providing answers to commonly asked questions.

The best approach, however, is to personally reply to your readers' questions. This approach shows that you are interested in your customers' concerns. Ignoring customers' e-mails will result in lost subscribers and eventually poor public relations as word gets around on the Web. If you receive a large quantity of e-mail messages and you are a one-person operation, hire a person to handle customer inquiries on a part-time basis. If you work in a larger organization, include specific feedback links for comments to the editor, sales, or customer service. Make it easy for your readers to unsubscribe from the e-mail newsletter. Include "subscribe" instructions, too, in case your newsletter was forwarded to other people by your subscribers.

PULLING READERS IN WITH A CATCHY SUBJECT LINE

The subject line is your first chance to gain readers' interest. Depending on the wording of your subject line, your e-mail newsletter may be read or deleted. Make the most of that limited space. Grab readers' interest with an intriguing subject line that tells them what the newsletter will cover. For example, you might use the following subject line for a writers' newsletter: "Tips to Crack Your Writing Block."

E-MAIL NEWSLETTER MASTHEAD

In the masthead, include the title of the e-mail newsletter, date of issue, volume number, and issue number. If your newsletter has a companion Web site where subscribers can find the archives of your newsletter or more detailed topic information, list its URL in the masthead. Other items to list in the masthead include the publisher, copyright statement and your International Standard Serial Number (ISSN) if applicable, complete contact information, and "subscribe" and "unsubscribe" instructions. If you want to encourage subscribers to forward the newsletter to others, tell them to forward the entire newsletter instead of excerpts. After the masthead, list the table of contents.

LINKING YOUR NEWSLETTER AND YOUR WEB SITE

Use e-mail publishing and a Web site to expand your subscriber base. You can increase the number of repeat visitors to your Web site by regularly publishing an e-mail newsletter. The newsletter can tell your readers of updates that you've made to the site such as feature articles and new product and service offerings.

Some e-mail newsletters consist entirely of "teaser" briefs, with live links, which summarize the articles or material that appears on a Web site. These types of newsletters are known as "action alerts" or "bulletins." The newsletter updates remind customers about your presence, which causes them to visit your site more often. If you write these types of newsletters, make sure that your articles contain information that is useful to readers so they won't be disappointed when they click on the links and visit your site.

On your Web site, invite prospects to sign up for your e-mail newsletter. To catch readers' interest, put the subscription link on the home page of your Web site near the top of the page. Make it easy for your readers to subscribe and avoid asking personal information. Prospects are naturally reluctant to divulge personal details. After all, to them you're a stranger and you haven't built a relationship yet.

Maintain Archives of E-Mail Newsletters on Your Site

Your prospects can get an idea of the nature of your newsletter if you provide archives of your back issues on a separate page on your site.

Make the archives easy to find either through a direct link on your home page and/or through an internal search function on your site. Ensure that the archives are easy to read by creating an annotated list of hypertext links. Label each issue with an informative title and the date it was published. For example, an e-mail newsletter on "book arts" might feature an issue on:

Decorating Paper—January 10, 2002
Collage, Stenciling, Rubber Stamps

Put the most recent issue at the top of the archives page, with the other issues listed in descending order by date. Your archives will be a great resource for your readers and will enhance the value of your site.

PUBLICATION SCHEDULE

Publish your e-mail newsletter on a regular and consistent basis. A regular publishing schedule will increase your credibility. Readers will view you as a dependable business operation. During your planning stage, take a realistic look at your time and monetary resources and decide how often you can afford to publish (e.g., weekly, biweekly, or monthly). Readers may be interested in receiving news and useful, information-based content on a weekly basis; however, they probably will not be interested in receiving weekly primarily promotional-based messages. If you write newsletters for businesses, limit promotional messages to biweekly or monthly issues. Even then, make sure that your newsletter contains content that is useful and valuable to the reader.

ACQUIRING OPT-IN SUBSCRIBERS

Compile an opt-in (in-house) list by inviting visitors to subscribe to your e-mail newsletter when they visit your Web site. Encourage opt-in subscribers by placing an opt-in offer on every page of your site. An opt-in strategy will give you better results because people are choosing to sign up for your newsletter for specific needs (e.g., information or news). Avoid mass opt-out mailings (spam) because you'll hurt your relationship with prospects.

On your Web site, give readers an incentive to sign up for your e-mail newsletter. Offer them something in return such as a "free tips sheet" or "mini-tutorial."

Add to your opt-in list in other ways. Ask your customer service representatives (CSRs) to obtain customers' e-mail addresses when they speak to new prospects. On your printed forms, include a spot where customers can fill in their e-mail addresses to receive an e-mail newsletter.

Be upfront. When customers subscribe, tell them how often they will receive your newsletter and the type of content it will contain. Let customers know that you will keep their e-mail addresses confidential. When you send your e-mail newsletter to subscribers, you may want to remind them that they signed up for the newsletter. Make it easy for readers to unsubscribe by placing the unsubscribe directions at the top or end of your e-mail newsletter.

E-mail communications to customers saves time and costs versus print materials. In the future, e-mail marketing will begin to replace some of the traditional direct mail marketing.

HTML/MULTIMEDIA VERSUS PLAIN TEXT (ASCII) E-MAIL NEWSLETTERS

Offer your readers a choice when they subscribe to your newsletter— either HTML/multimedia or plain ASCII text. Customers who have fast connections to the Internet may prefer HTML newsletters. In fact, HTML newsletters are becoming more common and will soon replace plain text altogether. They look more attractive and are easier to read for users. The key factor is offering your audience a choice that meets their needs.

If you're sending your newsletter out in plain text, develop a consistent design that is simple and reader friendly. Format your newsletter for easy scanning. The subject line grabs the readers' attention, but it shouldn't also be listed in the body of the newsletter. In the body of the text, at the top of the page, list the masthead and table of contents information (as mentioned earlier in this chapter). Organize your newsletter into sections. Put a line of space between each section (news/information item) and between paragraphs. Avoid excessive use of caps; it represents shouting and is harder to read. Include relevant, live URLs to your site, other sites, or to specific product information on your site. Don't make people hunt all over your site for a special product offer. Instead, provide a link that connects directly to that offer.

For more details and excellent information on the mechanics of e-mail publishing, read the book *Poor Richard's E-Mail Publishing: Creating Newsletters, Bulletins, Discussion Groups, and Other Powerful Communication Tools* by Chris Pirillo.[4]

MARKETING YOUR NEWSLETTERS

You want to maintain credibility with your readers. That's why it's important to keep the lines between your editorial content and

advertising clearly drawn. Avoid any possible appearance of conflict of interests. You goal is to build trust with your readers.

Generating Exposure and Revenue with Ads

If you're just starting out and need initial exposure, trade ads with other e-mail publications of similar subscriber size. Don't approach a newsletter with a subscriber base of 30,000 if you have a subscriber base of only 300. Choose newsletters that have subscriber bases that are comparable to your own.

To generate new revenue, in every issue tell your readers that you offer advertising space and encourage them to contact you for more information. Another approach to try is to offer a premium (paid) edition of your newsletter in addition to your free newsletter. Of course, you will have to prove the value of your free newsletter before you attempt to offer a premium edition. Many publishers are now offering free and paid editions of their newsletters.

Creating Text Ads for E-Mail Newsletters

Larry Chase, author of *Essential Business Tactics for the Net* and publisher of the *Web Digest for Marketers* (http://wdfm.com), offers these tips when writing text ads for e-mail newsletters. The headlines of text ads should stir readers out of their lethargy and capture their attention; the headlines need to touch readers emotionally. If you write ads that don't touch readers, then you've created wallpaper ads that are invisible to your readers. Instead, write headlines that create pictures in the minds of readers.[5]

Chase says that you should first develop a dialogue with your readers before you display a text ad in your e-mail newsletter. Readers first need to understand who is talking to them when they receive an e-mail newsletter. This approach will help you establish context with your readers because online publications do not provide the look and feel that print publications do.[6] In the e-mail newsletter industry, there has been debate about how many lines to include in a text ad. Chase suggests that eight lines of text allow advertisers to tell their story better. Six lines are more suitable for a telegraphic offer (machine gun copy), in which advertisers quickly get to the point and then provide a call to action. Advertisers should provide both their e-mail address and Web site URL in their text ads.[7]

CREATING PERSONALITY IN NEWSLETTERS

Your newsletter will be more memorable if it projects a personality. Introduce readers to the person behind the writing. Invite them into your world. Build your newsletter around your own personality or create a virtual environment that catches readers' interest. For example, you might develop a "stylistic New York City" personality. Or, you could create a virtual environment populated with the ironies of corporate life. Because e-mail newsletters are a more intimate medium, readers expect a personal voice from you. Cultivate a distinctive voice that readers can count on from issue to issue. Even if you're the editor of the newsletter and include content from other writers, you can still establish a tone and style that is unique to your newsletter.

USING NEWSLETTERS AS A PROMOTIONAL VEHICLE

Even promotional e-mail newsletters can help you build relationships and community with consumers. Capture your readers' attention with a headline in the subject line that tells them what the newsletter is about (e.g., "Affordable Fashions for the Fall Season"). Then in the body of the text, put a table of contents at the top of the page. Offer useful information that will benefit readers. For example, write up a brief list of tips on how to pack for a "fall getaway weekend." Keep e-mail news-letters short and targeted to your audience. Direct readers to your Web page for more details.

Some companies use "announcement lists" to let consumers know about special sales or new products and services. These short lists help drive traffic back to their Web site. Even though these lists are brief, you should still include some type of useful content to attract readers' interest and to provide them with a benefit.

TARGETING YOUR CONTENT FOR BUSINESS-TO-BUSINESS NEWSLETTERS

A business-to-business e-mail newsletter can help you retain and enhance your relationship with your customers. If you're creating a business newsletter, review the content that you have already pro-duced in-house and separate it into categories that meet the needs of your specific target audiences. Rewrite the content to meet the unique medium of the Web. If necessary, research and develop new content for each specific audience.

For example, a telecommunications company could produce several e-mail newsletters each targeting a specific target audience. Small business owners would appreciate receiving an e-mail newsletter that focuses on tips for setting up and running a small business. Medium-sized companies would benefit from an e-mail newsletter that tells them how to set up and run a call center. Marketing managers at large-sized companies might be interested in a newsletter that tells them how to use the Internet to cut their marketing costs. If you're writing content for a corporate client, you will have to get the copy approved by the marketing and legal departments.

PROOFREADING YOUR NEWSLETTER

Even though e-mail newsletters are an informal communications medium, take the time to produce good copy. Poorly written newsletters will detract from your reputation. Before you send out your newsletter, print out a hard-copy version. Look for grammatical errors, incorrect punctuation, and typos. If you don't have editorial resources, ask another person to read the hard copy for you. They'll pick up errors that you miss.

FINDING WORK AS A FREELANCE WRITER
FOR NEWSLETTERS

To find work as a freelance writer of e-mail newsletters, search online job boards and online classified ads. You could also proactively approach online clients by visiting their company Web sites. Contact clients in your local area and propose doing an e-mail newsletter for them. Based on an analysis of their business, suggest content that would interest their customers. You could come up with ideas for specific story ideas. Or, ask your potential clients if they have part-icular industry information they want you to cover.

Before you begin any work with the client, estimate the amount of hours that each newsletter issue might take. Include time for research, writing, and revisions. Then develop a contract that stipu-lates the number of newsletter issues, length of issues, number of rewrites, your specific duties (e.g., writing, HTML formatting, lay-out), deadline dates, and payment rates. Meet with the client and negotiate the details of the contract, realizing that you may have to be flexible on some points.

E-MAIL–BASED DISCUSSION GROUPS
(MAILING LISTS)

E-mail discussion groups are made up of e-mail–based lists of people who share common interests or goals. The common interests could be nonfiction writing, online writing, calligraphy, or book arts. The goals of some groups could be to publish a novel or short stories. Discussion groups offer members an opportunity to network, support each other, critique each others' work, share industry information, offer marketing tips, announce conferences, and give advice. In these discussion groups, the ease of e-mail enables you to communicate with people from all over the world while sitting in front of your computer screen.

After members subscribe to the list, they receive a "Welcome" e-mail that describes the purpose of the list and its rules. To post a message, a member will send an e-mail to the list address, and the list server sends the e-mail message to all of the members. (In a moderated group, the list moderator will either accept or reject the e-mail message before it is distributed to the group.) Other members then reply to the post, which then creates a thread of discussion. Members can choose to receive either individual messages as they are posted or the digest version that contains all the messages that were posted to the list on that day, week, or other time interval.

Build a Companion Web Site for Your
E-Mail–Based Discussion Group

Pirillo suggests building a companion Web site for your e-mail–based discussion group. The Web site could serve as a resource for your members. Here, you could put the FAQ page, links to related reference sources that are of interest to the group, subscription instructions, and discussion group archives.[8] Many online discussion groups maintain searchable archives of their postings. These archives may be open to anyone or limited to subscribed members of the group.

FAQ List for E-Mail Discussion Groups

When you initially subscribe to an e-mail discussion group, read the FAQ list. The list will outline the rules of the group, detailing what is and is not acceptable for posting. The list should also give you an idea of the focus of the group. The FAQ list might also give you answers to the questions that you are seeking on a specific topic.

When you first join a group, lurk (listen in) for awhile and read the messages. You'll get a feel for the type of people on the list and the type of topics that are discussed. Before you post a query, do some preliminary research on the topic on the Internet; and check the list archives. This upfront work will prevent you from appearing to be an amateur and asking a question that has already been discussed in depth on the list.

Posting Messages to E-Mail Discussion Groups

When posting a new message, write a descriptive subject line that lets people know what your message is about. Turn off e-mail formatting when posting to a list; send ASCII text instead. When replying to a long e-mail posting, include only those parts of the message to which you are responding.

Carefully choose your wording in your postings; they are a permanent record and can be easily forwarded to other people. Avoid flaming (publicly criticizing people) in discussion groups and shouting (using all caps). If the topic is an emotional issue, put your response aside for 24 hours, then reread your message the next day. You'd be surprised at how differently your message sounds from the perspective of a new day. Now rewrite the message and send it out to the list. If you're writing and posting long e-mail messages, use your word processing program. This way you can use the spell check and grammar tools. Then you can copy and paste your text into your e-mail program and send it to the list address. Use a signature block to identify yourself, such as your name, e-mail address, job title, company name, and Web site URL.

Don't use the discussion group primarily to promote your business. Instead, become known as a resource person who contributes useful and valuable information to fellow members. If you have a business Web site, briefly mention the URL in your signature block.

Enhancing the Content in a Discussion Group

Whether you are responsible for running a discussion group or you are a member of the group, you can enhance the group's daily content by your own contributions. Stimulate or "seed" the discussion by introducing new topics that are related to the focus of the group. For example, in a freelance writer's discussion group, ask members for ideas on how they handle specific writing assignments and then tell them how you

handle your own assignments. Invite members to contribute URLs related to writing. Ask members what steps they take to find new free-lance writing business.

Developing an FAQ List for Your E-Mail Discussion Groups

If you're responsible for developing an FAQ list for your group, query the members to help you determine the type of information that would be helpful to new subscribers. Your FAQ list might include reference books, links to reputable sites that relate to the focus of the discussion group, industry definitions, information on online courses, and links to job boards. If you notice that a particular question keeps popping up every couple of months, prepare a concise response and post it to the FAQ list. Then when the question comes up again, refer the new member to the FAQ list instead of making the members rehash the issue on the discussion list.

OTHER ONLINE COMMUNITIES

Besides e-mail discussion groups, there are other types of online communities where people gather to discuss topics, share information, and network. These communities include newsgroups, forums, and live chats.

Newsgroups (Usenet news) are like huge electronic bulletin boards where users from all over the world can look for information or post a response or a request. While e-mail newsletters are more like a one-to-one communications vehicle, newsgroups are a many-to-many communications vehicle. The online traffic is usually heavy and the environment can be chaotic. Topic-specific forums can be found on many Web sites. Depending on the type of forum, you may have read-only access; after you register, you can then post messages. Other forums may require that you register before you can even read the messages. Writing or hobby sites usually sponsor topic-specific forums.

Real-time chat software lets people who are connected to the system correspond immediately with another person. People in different parts of the country or world can communicate with each other at the same time. If you're new to chat rooms, take an online tutorial to learn the rules and widely used acronyms. For example, users like to use shortcuts such as IMHO (in my humble opinion) or LOL (laughing out loud).

E-MAIL NEWSLETTER CHECKLIST

Use this checklist to make sure that you have included all of the important elements in an e-mail newsletter.

- Identify target audience (Do you have more than one target audience?)____
- Audience profile (gender, age, education, occupation, geographic location, Internet experience, Internet usage, number of hours spent online, type of things done online, Internet skill level, language, and personal interests)____
- Your newsletter's big idea____
- Newsletter's brand name____
- Newsletter personality____
- Analyze competition____
- Publication schedule____
- Writing style of e-mail newsletter____
- Newsletter masthead contents____
- Compelling content____
- Cultivate good content mix____
- "You-centered" stories____
- Write catchy subject line for e-mail newsletter____
- Editorial calendar____
- Nurture relationship with readers____
- Make it easy for subscribers to communicate with you____
- Survey subscribers____
- HTML or plain text format?____
- Make your newsletter and Web site work together____
- Maintain newsletter archives____
- Getting opt-in subscribers____
- Market your newsletter (swap ads, offer ad space, offer a premium [paid] edition)____
- Proofread your newsletter____

ENDNOTES

1. Funk, John. InfoBeat, in Pirillo, Chris. *Poor Richard's E-Mail Publishing: Creating Newsletters, Bulletins, Discussion Groups, and Other Powerful Communication Tools* (Lakewood, CO: Top Floor Publishing, 1999), pp. 30, 129, 173, 181–182.
2. Pirillo, Chris. *Poor Richard's E-Mail Publishing: Creating Newsletters, Bulletins, Discussion Groups, and Other Powerful Communication Tools* (Lakewood, CO: Top Floor Publishing, 1999), pp. 30, 129, 173, 181–182.
3. Cassingham, Randy. "This Is True" in Pirillo, Chris. *Poor Richard's E-Mail Publishing: Creating Newsletters, Bulletins, Discussion Groups, and Other Powerful Communication Tools* (Lakewood, CO: Top Floor Publishing, 1999), pp. 30, 129, 173, 181–182.
4. Pirillo, Chris. *Poor Richard's E-Mail Publishing.*
5. Chase, Larry. Author of the book, *Essential Business Tactics for the Net* (New York: John Wiley & Sons, 1998). Chase is publisher of *Web Digest for Marketers*, http://wdfm.com. Telephone interview, June 26, 2001.
6. Ibid.
7. Ibid.
8. Pirillo, Chris. *Poor Richard's E-Mail Publishing.*

Chapter 13

E-Zines

E-zines are electronic (online) magazines that are similar to print magazines. Because the printing and distribution costs that are associated with print publications are eliminated, e-zines cost much less to produce.

On the Web, e-zines cover just about any topic you can possibly think of. There are e-zines that focus on fiction, art, business, marketing, specific industries, or hobbies. There are also e-zines that are primarily promotional in nature. E-zines originally began as small publications usually run by one individual or a small group of people that catered to a specific niche (e.g., freelance writers). Many of these publications still exist today.

Some people consider larger online publications like the *Wall Street Journal* and Salon.com as e-zines but of a higher caliber. The home page of an e-zine usually contains the table of contents of the current issue. Past issues are stored in the archive section on the e-zine site.

PUBLISHING AN E-ZINE

Writing, editing, and publishing an e-zine will take more time, effort, and money than you'll originally anticipate. Compared to publishing an e-mail newsletter, it also takes more technical know-how to create an e-zine on a Web site. You can distribute the workload by lining up contributors to write columns, but you will have to pay contributors a fair price for their writing.

You will have to make many business and marketing decisions. That's why it's important to develop a marketing plan before you even begin to consider publishing your first issue. You should devote at least 50% of your time to marketing your e-zine. See Chapter 15, "Marketing Yourself," for some ideas to get you started.

Creating a Niche for Your E-Zine

The chapter on e-mail newsletters (Chapter 12) mentions the importance of establishing a niche for your publication. This same fact holds true for e-zines, too. E-zines are successful when they serve a niche audience. But first, you need to do extensive research.

Determine if other currently published e-zines are similar to your concept. Analyze the look and content of these similar e-zines. Try to figure out what makes them successful. Even though the idea for your e-zine publication may appear similar at first to other current e-zines, try breaking through your usual boundaries of thought. Decide how you can come up with a unique approach on the subject. Your goal is to differentiate yourself. Find the fresh angle and inject it with content that stands out from the crowd.

Imagine sitting in front of your readers' computer screen for a while. Ask yourself: What would my readers want? What do my readers need? What do they care about? Your e-zine has to answer these questions. By digging down deep for those informational and fascinating nuggets of gold, you'll provide a reading bonus to your readers.

Consistent Communication

After you publish your first e-zine, readers will expect you to consistently update your site. Regularly updating your e-zine will maintain credibility with your readers, but don't take the chance of allowing readers to forget about your site. Send out opt-in newsletters to remind readers of your presence and to bring them back to your site, where they can find out more about any updates and changes. Keep communication lines open by responding to your readers' e-mails. Find out what works in your e-zine through surveys and polls.

You're competing with millions of other online e-zines on the Web, from collections of amateurish pages cobbled together to well-designed presentations of valuable information. Project a professional image with quality content that is carefully edited.

E-Zine Content

Your e-zine needs to contain useful and valuable content to help you attract and retain subscribers. The contents of e-zines can include feature and service articles, and Q&A sections. E-zines often include reviews of books, software, Web sites, music, movies, and restaurants. Ongoing columns might focus on interviews with well-known people, analysis of new products and services, and opinion pieces. Contest announcements and polls may be posted on the site. Later, you could post the contest and poll results.

Promoting Your E-Zine

Promote your e-zine through discussion groups, newsgroups, forums, search engines, e-zine directories, chats, networking, and your signature block. Agree to participate in online interviews in chat rooms where you can talk about your e-zine. You could also agree to be interviewed by other online publications.

TAKING AN INSIDE LOOK AT SUCCESSFUL E-ZINES ON WRITING

Behind every successful e-zine, you'll find a hard-working, persistent, well-organized, and creative editor with high standards. Here's an inside look at a couple of the e-zines that regularly draw faithful readers with captivating content.

Behind the Scenes at *Inscriptions* E-Zine

Jade Walker, publisher and editor of the well-known *Inscriptions* e-zine (www.inscriptionsmagazine.com), believes that a successful e-zine should have intriguing topics, useful content, and a good amount of time devoted to it. An e-zine also needs to have a focus—something that will draw an audience in. The focus can be broad (such as movies or pop music) or more unique (such as single-parent homeschooling tips or quilting for children). Walker suggests that editors choose a topic they love because publishing an e-zine takes a lot of work. Once your publishing schedule is established, your audience will begin to look forward to future issues of your e-zine. That means you must make a commitment to publishing the e-zine on time and in a professional fashion.

Finally, Walker believes that every successful e-zine shines by disseminating useful and entertaining content. If you're an expert, she says to write your own articles. Or, hire experts to write the articles, and pay them for their work. The better your content, the larger your audience will grow, and the more successful your e-zine will become.

Project Management Tips for E-Zines

Inscriptions offers its readers more than 70 pages of solid content on the topic of writing each week. So how does Walker do it? In her words:

> I'm extremely organized. I receive about 1,000 e-mails a day, so I've learned how to filter through these messages in an efficient fashion. Once a week, I go through the filtered e-mails and spend several hours responding to queries and filing future articles. I devote three to four hours every night to the magazine and a full 30 hours (usually in two long shifts) on weekends to doing all the down-and-dirty work (writing, editing, proofreading, URL confirmation, graphic design, promotion, Web site coding, etc.).[1]

Editing Tips for E-Zines

Walker offers some useful tips for editing e-zines:

> The most important editing tip I can offer is to give yourself a fake deadline. Force yourself to complete the first edit of the e-zine by a specific time. Then walk away from the computer entirely. Cook a meal. Hang out with friends. Go to a movie. Read a book. Do anything but stare at the e-zine.
>
> After a bit of time has passed, then return to the file and proofread it carefully. You will see the copy in a fresh light and you'll be more likely to catch many of your mistakes. If you can hire a proofreader, that's even better. Spell check everything. Verify all of your URLs the day before you publish the e-zine. Finally, treat yourself to a job well done once the issue has been sent to your readers.[2]

Behind the Scenes at Writing-World.com E-Zine

To create a successful e-zine, Moira Allen, publisher and editor of Writing-World.com (www.writing-world.com), suggests that the key is to:

> Determine a niche that isn't already full of e-zines—or, be sure that you can really "be the best" in a niche that's already full. You also

have to decide whether you're going to invest real money in your e-zine. I decided that I would pay a halfway decent rate for articles, so that I'd be able to obtain high-quality material. Most of the writing e-zines don't pay as well as I do, and I don't pay that much. If you're not willing to pay for material, or you don't have the budget, you'll have to "take what you can get," and often that won't be great.[3]

Budget Your Time

Allen further states:

> You also have to budget your time. I track my hours, and estimate that I've put in over 500 hours on Writing-World.com during the first six and a half months—the bulk of that in the initial launch phase, in designing the site, etc. But an e-zine or e-mail newsletter often takes a lot more time than you ever expect, especially if you are conscientious about answering e-mails, keeping the site updated, etc. Be sure you can afford that time—especially if you need to focus on other, income-producing projects.[4]

Talent

Allen believes that:

> Another issue is "talent." Do you have the ability to design a site? If you don't, you may want to hire someone who can do it well. Do you have the ability to edit other people's work? If not, you may not want to buy material from others.[5]

Tone of Your E-Zine

One final thing Allen mentions is the issue of "overpersonalizing" an e-zine:

> I've received several e-mail newsletters that are (in my view), more like "me-zines." For example, a travel e-zine might say, "I really love to travel, and I love finding new travel Web sites. Today I was surfing the Web and came across a great site . . . I was delighted to see that it included sections on food, which is one of my favorite parts of travel. . . . "
>
> You could accomplish much more by simply saying, "The Such-and-Such site is one that any travel writer (or armchair traveler) will enjoy. It includes an excellent section on international foods that will whet any traveler's appetite." The point here is that you are a stranger to your readers—and your readers probably didn't sign up for your newsletter to hear about you. They signed

up for information that is valuable to them. Today, everyone is suffering from inbox clutter, and we don't have time to read through a lot of fluff to get to the point. If you want to start a successful e-zine, make sure that you focus on the benefit to the reader, not on the fun you're having doing it.[6]

FREELANCE WRITING FOR E-ZINES

E-zines can offer freelance writers an opportunity to break into online writing. Good writing skills that produce well-thought-out queries and ideas will get you noticed; however, e-zine pay is either low or sometimes there may be no compensation. Some writers offer their articles for free in exchange for a generous signature block placed at the end of the article. The signature block usually contains the e-mail address and URL of the writer's personal Web site. On their personal site, the writers may then promote their writing services, recently published books, or products and services. Taking yet another approach, other writers may write a limited number of articles for free for e-zines as a way of building up their online clips in their portfolio. Every writer has to weigh the pros and cons in their career and make the best decision that meets their current needs. Regardless, make sure you obtain a contract for every assignment before you begin writing, and read the fine print before you sign it.

E-ZINE CHECKLIST

Use this checklist to ensure that you produce a quality e-zine.

- Does your e-zine focus on an intriguing topic?____
- Will the focus of your e-zine pull in a big audience?____
- Have you analyzed your e-zine's competitors?____
- How can you differentiate your e-zine from the competition?____
- What will your readers want from your e-zine?____ What will they need?____ What will your readers care about?____
- Does your e-zine contain useful and valuable content? (feature and service articles; Q&A sections; and reviews of books, software, Web sites, music, movies, and restaurants. Ongoing columns that include interviews with well-known people, analysis of new products and services, and opinion pieces. Contest announcements and polls)____

- Did you develop a marketing plan for your e-zine?____
- Have you put procedures in place to effectively manage your e-zine?____
- Do you have the technical know-how to design an e-zine?____
- Will your e-zine be professionally edited?____ Or will you edit your e-zine?____
- Do you have enough time and money to devote to your e-zine?____
- Will you be able to devote at least 50% of your time to promoting your e-zine (through discussion groups, newsgroups, forums, search engines, e-zine directories, chats, networking, your signature block, participation in online interviews)?____
- Have you put a consistent publication schedule into place?____
- Do you promote your e-zine with an opt-in e-mail newsletter?____
- Do you respond to e-mail messages from your readers?____
- Do you use surveys and polls to determine what your readers want from your e-zine?____
- Do you have a network of potential contributors?____ Can you offer them fair compensation for their work?____

ENDNOTES

1. Walker, Jade. *Inscriptions* publisher and editor, www.inscriptionsmagazine. com. E-mail interview, June 21, 2001.
2. Ibid.
3. Allen, Moira Anderson. Writing-World.com publisher and editor, www. writing-world.com. E-Mail interview, July 10, 2001.
4. Ibid.
5. Ibid.
6. Ibid.

PART FOUR
Strategies for Online Success

Chapter 14

Finding Online Writing Jobs

Finding online writing jobs demands persistence, innovation, and flexibility. You need to continually be on the hunt—looking for new job boards, markets, writers' sites, writers' mailing lists, e-mail newsletters, and contacts. The sites and boards that you regularly depend on for leads may suddenly disappear from the Web. That's why it's important to bookmark both a variety and a long list of resources.

In the beginning of your online writing career, you need to make some important decisions. Do you want to be a freelance writer who juggles an assortment of projects at one time? Do you want a telecommuting job? Or do you want the security of a staff job on site?

Traditional job-hunting tactics don't always apply on the Web. You can't send out your resume and wait for the calls to come in. Sometimes you have to take bold approaches to find new leads. For example, you might contact companies who are not listing job openings and set up an informational interview. After the interview, keep in contact with the person who you spoke with in case job openings come up. Network with former colleagues, friends, and neighbors. Join professional organizations in your field. If you're a technical writer, you could join the Society for Technical Communication (STC) at www.stc.org.

If you want high-paying jobs, your best strategy is to go after the large companies. Visit company sites and contact recruiting agencies. You also have to keep up with technology to get the insider's edge. In the long run, employing a multitude of efforts will maximize your job leads. Following are more details to help you land an online writing job.

EVALUATING ONLINE WRITING JOBS

An online job opening may look good at first glance; however, it pays to take a little time to assess the job listing before you e-mail in your resume. This strategy holds true for job openings on Web sites and for online writing markets listed in e-zines. Later, use the same care if and when you begin negotiations to do the work. As an independent professional, it's your responsibility to defend your rights for fair compensation and copyright protection. Ask yourself the following questions when evaluating online writing jobs:

- *Check the site where the job is posted.* Does it appear to be a reputable, well-designed site? Or are there typos and poor use of grammar in the copy? Is there complete contact information on the site?
- *Look at the date that the ad was posted.* Is the ad still timely?
- *Check the submission guidelines.* What rights is the publication asking for? If the publication is requesting "all rights" to reproduce your work "in any media" or "in any form," later delete these clauses from your contract. Or, negotiate separate fees for each use of your article. If the editor won't negotiate fair terms, it may be better to turn down the job.
- *Read the payment terms.* Does the publication pay? Are the payment rates fair? Don't begin writing until you receive a signed contract.
- *If the job appears on a job board, is it a blind ad?* These blind ads usually provide only the job definition and a vague forwarding e-mail address, with no other information about the company. Ask yourself what the company is trying to hide. Sometimes, companies use blind ads to screen for writers who are willing to write for lower fees.

If you're unsure about a particular publication, here's where your networking comes in handy. By subscribing to writers' mailing lists, you can ask other writers what their experience has been with the publication, Web site, or company.

Even a signed contract doesn't automatically guarantee that you will receive payment. If you have submitted an article and it has been posted on the Web site, don't submit any more manuscripts until you have received payment for the first article.

SCHEDULING YOUR JOB SEARCHES

Put as much focus and discipline into finding new job openings as you do into your daily writing. Devise a job search schedule, note it on

your calendar, and stick to it. Either begin your day by quickly viewing the job boards and ads and immediately apply for the jobs or, if daily searches don't fit into your schedule or lifestyle, instead dedicate an entire day to searching for leads. Copy the leads into a file, print them out, and develop queries for one to two of the leads on each day of that week.

FINDING ONLINE MARKETS

Find online markets by reading e-zines, subscribing to e-mail newsletters, and searching writers' guidelines databases, job boards, and online classified ads. Check good old-fashioned newspaper ads, too.

E-Zines and E-Mail Newsletters

Many e-zines are devoted to online writing. These e-zines feature "how-to" articles on writing, market information, job opportunities, and writing tips. These writing sites provide a valuable service to writers. Unfortunately, because many of these sites are small operations, funding is a constant issue. Until viable business models are established on the Internet, some of these sites could suddenly disappear. Debbie Ridpath Ohi conceived the pioneering and well-liked writing site *Inkspots* and its companion e-mail newsletter *Inklings*. Unfortunately, the site ceased publication in 2001 because of funding issues.

Keep updated on writing and writing-related sites by checking the *Writer's Digest* site, where they list the *101 Best Web Sites for Writers*. To be included on their list, sites must be current and authoritative and offer value and free content.

Inscriptions *E-Zine*

Jade Walker is the publisher and editor of the excellent weekly *Inscriptions* e-zine (www.inscriptionsmagazine.com), which is available as an e-zine and through e-mail subscription. The e-zine is targeted to professional writers. Its mission is to help writers and editors hone their craft and find work in print and online venues. In the past three years, *Inscriptions* has grown to more than 70 pages a week. The e-zine has received dozens of awards in the press, being named one of the 101 best Web sites for writers and one of the top 50 online markets by *Writer's Digest*. Each jam-packed issue features writing and publishing-related articles; interviews with writers, editors, or publishers; writing news; job opportunities; writing contests; paying markets; book reviews;

and links. Subscription cost is US $5.00 (only 10 cents an issue), which is paid on the honor system via check, money order, or credit card.

Writing-World.com E-Zine

Moira Allen is the publisher and editor of Writing-World.com (www. writing-world.com). She is the former managing editor of *Inklings* and Inkspot. Allen's biweekly newsletter includes a feature article, Q&A column, market information, contests, links, and writing news. Allen is a strong advocate of fair payment and recognition for writers.

WritersWeekly.com E-Zine

Publisher and editor Angela Adair-Hoy produces the well-known freelance writing e-zine, WritersWeekly.com (www.writersweekly.com). The e-zine includes new job listings, new paying markets, a freelance writing Q&A column, feature articles, and freelance success stories. Adair-Hoy is also a strong advocate of fair treatment of writers.

Guidelines Databases

Several Web sites offer "premium" (fee-based) and free guidelines databases for writers. You can search the databases, looking for your writing specialty, specific publications, and genre.

WritersMarket.com Online Database from the Publishers of Writer's Digest

Readers can subscribe to the WritersMarket.com database, the online edition of the well-known print book *Writer's Market*. The one-year subscription costs $29.99, or writers can buy the Internet edition of *Writer's Market* for $49.99, which includes a hard copy of the book and a one-year subscription to the Web site. The searchable online database consists of approximately 4,000 publishers' listings and 400 literary agents that are continually updated.

The WritersMarket.com database features a Submission Tracker, which allows subscribers to keep records of all their manuscripts and which publishers they've submitted to. The Tracker will remind subscribers when they need to follow up on query letters or send in revisions to their manuscripts. Subscribers can also keep track of when payments are due.

The WritersMarket.com home page offers information to nonsubscribers through their Market Watch section, which gives updates on the latest news in the publishing industry. The Market Tip section

includes guidelines on writing query letters, formatting manuscripts, negotiating rights, and interviews with expert editors, authors, and agents about how writers can market their writing.

The Spotlight Market of the Day features a different publication, contest, or literary agency where writers can send their work. Writers can also sign up for a free biweekly e-mail newsletter that offers more publishing information, along with featured markets and other opportunities for writers. The web address of the site is www.WritersMarket. com. The Internet edition of *Writer's Market* is available in bookstores or by going to www.writersdigest.com.

Writer's Guideline Database

The Writer's Guideline Database (mav.net/guidelines/) offers both a free and a "premium" (fee-based) searchable database divided into categories.

The Writer's Place

The Writer's Place (www.awoc.com/Guidelines) has a searchable database with the following categories: market; subject; high, medium, or low payment; payment upon publication or acceptance; simultaneous submissions; and type of material (nonfiction, fiction, or columns).

Writer's Write®

Writers Write® The Write Resource™ Site (www.writerswrite.com/guidelines) offers information about books, writing, and publishing. The site includes a searchable directory. You can search by publication name, keywords, paying versus nonpaying markets, and genre (fiction, nonfiction, and poetry).

Job Boards

Try to make a regular habit of visiting the job boards to look for online writing assignments. Make the task easy by bookmarking these sites. Job boards are similar to classified ads in newspapers. A typical ad will list the type of position (e.g., content writer, editor, copywriter), e-mail address to contact, and payment rate. One drawback with job boards is that the competition is intense. You may be competing with writers from all over the globe.

On writers' mailing lists, I've heard editors complain that they received hundreds of queries for one assignment or job they posted. Therefore, it's easy to get lost in an editor's e-mail inbox. That's why

it's important to check the boards daily, craft a well-written query, and make sure that your ASCII resume and samples are ready to go. Don't forget to create an attention-grabbing subject line for your e-mail message. An enticing message in the subject line can mean the difference between the editor either reading your e-mail or hitting the delete button. One job board to check out is David Eide's *Sunoasis Jobs for Writers, Editors, and Copywriters* (www.sunoasis.com). On this site, under the Resources Section, you'll also find a useful tutorial on "How to Find Writing Jobs on the Net."

Many job boards also provide helpful articles on writing, the latest news about the online world, and an opportunity to talk with other writers via message boards.

Online Classified Job Ads on Sites

Although most of the online classified job ads consist of staff and on-site positions, freelance online writing positions can also be found here. Similar to job boards, competition is tight. You also have to wade through long listings of irrelevant and technical job openings before you find a writing job that suits your interest.

Check the online ads daily. To increase your chances of receiving a response, tailor your resume to the requirements of the specific position. In fact, it helps to have two to three customized resumes on file on your hard drive. This way when you find an interesting position, you can select the most appropriate resume, tweak it to suit the requirement of the position, and then promptly e-mail it to the prospective employer. Of course, you'll have proofread the hard copy of your resume to ensure that there are no spelling or grammatical errors.

On these job sites, look in the following categories: Internet/new media, journalism, writing/content, communications, creative arts, media, and other. Surprisingly, sometimes writing jobs are listed in the "other" category. Type in these keywords in the search box of the job site: writing, online writing, Web writing, and Internet writing. Get creative and try other word combinations that relate to writing and the Web. Here are some places to look:

- Monster (www.monster.com)
- Careerpath (www.careerpath.com)
- AJR Newslink JobLink for journalists (http://ajr.newslink.org/joblink. html)
- Headhunter.Net (www.headhunter.net)
- Silicon Alley (www.siliconalley.com)

You could also post your resumes on these types of sites. Make sure that you write your resumes so they are concise and highlight the work you are seeking.

WRITERS' MAILING LISTS

Writers' mailing lists offer many advantages that may help you in your job search. You can learn about new online publications, job leads, contracts and rights issues, or be warned about nonpaying publishers that you should stay away from. Writers may ask fellow list members for advice on how to handle an assignment or a specific client. List members usually respond back with a variety of ideas; however, the lists can just as easily turn into flame wars. Sometimes, certain individuals will persist in off-topic discussions.

Choose a writing list that meets your needs. If you're a new writer, you'll probably benefit from a list where writers critique each other's work. An experienced writer will benefit more from a list that offers job leads. Either way, when you first join, lurk for awhile until you get a sense of the list's culture before you post a message. Read the list's archives to make sure you don't post a question that has recently been discussed. Some experienced writers on lists won't tolerate amateur or redundant postings, and before you know it you could be involved in a flame war. Many mailing lists are very active. To avoid overloading your e-mail inbox, subscribe to the digest version of the lists. Here are two lists that are well known and that provide solid information:

Online Writing List

The Online Writing list is composed of professional writers, editors, and producers of online content. Members exchange ideas on how to create clear online writing, set fees, develop portfolios, handle clients, and write for different venues. Both new and experienced online writers can gain valuable information by subscribing. The list is a service of the Poynter Institute (http://poynter.org). To subscribe, visit http://talk.poynter.org/online-writing/.

Work for Writers List

Work for Writers is a moderated list for professional writers. Here writers can find job leads, share information, obtain writing contacts,

find out about contracts, and writer's organizations. To subscribe, visit workforwriters-subscribe@yahoogroups.com.

E-MAIL SUBSCRIPTIONS

As an online writer, your potential venues aren't limited to just articles and company Web sites. Words are our building blocks, and as writers we have the opportunity to virtually play with words in every corner of the Web. That's why it's important to subscribe to a variety of e-mail newsletters. These subscriptions can teach you how to improve your writing skills, which will help you get more online writing jobs. The subscriptions will also keep you up-to-date on Internet technology. You can find e-mail newsletters on a wide range of subjects by querying search engines. Type in the words "newsletter," "and," plus your subject choice.

E-Mail Subscriptions—Writing-Focused

Subscribe to a diverse number of e-mail newsletters that focus on writing. The newsletters will help you perfect and expand your online writing skills, and you may learn of new markets. There are online publications that cover copywriting, editing, grammar, "how to write" e-mail newsletters and press releases, and distance learning principles. One example of a free, writing-focused e-mail newsletter is The Grammar Lady (www.grammarlady.com). Readers can subscribe to the newsletter at the Grammar Lady Web site.

E-Mail Subscriptions—Generic

Subscribe to a wide variety of e-mail newsletters. The e-mail newsletters could cover the following areas: search engine news, new Web sites, technology news, and e-commerce. For example, the technology site ZDNet[sm] (www.zdnet.com/coinfo/filters/welcome) offers dozens of free e-mail newsletters on topics like tech news, business and technology, and Web development. By keeping up-to-date on a diverse range of topics related to the Web and its technology, you'll be better prepared for changes as the Internet evolves. By studying new subjects, you may even cultivate a new writing specialty that could land you additional assignments.

You should also subscribe to newsletters that focus on topics in your specific niche. If you write online learning courses, you might

subscribe to newsletters that report the latest findings in distance learning.

FINDING JOBS THROUGH SEARCH ENGINES

Search engines are good tools to use when you're doing research for a specific project; however, you can also use search engines to look for online writing assignments and jobs. You might first want to sharpen your search skills by taking an online tutorial, even if you believe you're a search engine expert. Because new search engines are always popping up and search engine parameters are constantly changing, there are always new tricks to learn online. Then visit a search engine site and read their advanced search tips. You might use search engines such as "Google" or "dogpile." Type in key words like "online writing jobs" or "Web writing jobs" and the name of your specific niche (e.g., "fitness"). Your search will bring up an enormous number of results, but you'll start to get an idea of potential markets—and you may just pluck out a new job. Your search will also bring up articles that have been published on your topic. Read the articles and explore the Web sites to get a good understanding of their focus. If you think your writing experience is a good fit, contact the editor with a well-written query.

LOOKING FOR POTENTIAL JOBS ON E-COMMERCE SITES

Take some time to search for e-commerce sites that sell products and services that relate to your specialty. Study the sites and their advertisements, and determine the different types of content services that you can offer. For example, let's say that a site sells office equipment to small businesses. If you have a marketing or business background, you could pitch a series of articles on how to effectively set up and run a small business office. You could also offer to write a monthly column, an e-mail newsletter, or do copywriting for their products.

SEEKING OUT NICHE SITES

Regularly look for new sites that specialize in your niche. Find these sites by hunting through search engines and typing in the keywords that relate to your niche. Visit the sites that come up in your search to get an idea of the type of material that is currently being published.

Study the material and then submit a query to the appropriate sites. Keep up-to-date on industry news and sites in your niche by subscribing to e-mail newsletters. Visit online syndicate sites such as *isyndicate* (www.isyndicate.com) and *screaming media* (www01.screamingme-dia.com/en/), as well as other syndicate sites that you find.

LOOKING FOR NEW COMPANY SITES

When you find out about new company sites through your research on the Web or from your business contacts, take some time to examine the site. Study how the writers handle titles, headings, subheadings, leads, topic sentences, content, and links. Look at the overall design of the site. Check the usability of the site by clicking on the hyperlinks and navigating the site. Visit the individual pages. Use the internal search box on the site. Determine if the site is easy to master.

Did your analysis give you any new ideas on changes that you could suggest to the decision maker that would (1) create a more reader-friendly Web site and (2) ultimately increase traffic to the site? If so, find out the name of the contact person or decision maker by looking on the site's "About Us" page. (If this information isn't listed, contact the Webmaster and ask for the decision maker's e-mail address.)

Send a brief e-mail message to the decision maker outlining a few of your ideas. Your e-mail message should be written to hook the company's interest. Remember you're selling both yourself and your services. If you receive a positive response from the company, set up a meeting with the decision maker. Here's your chance to tell the decision maker how your content services can improve the company's Web site. This meeting also gives you the opportunity to win the contract to do the work.

DEVELOPING A WINNING PROPOSAL FOR YOUR CONTENT WORK

Developing a solid proposal showcases your professionalism and gives you an edge over your competitors. How do you make sure that you develop a proposal that meets your client's needs? Merry Bruns, content consultant (www.sciencesites.com), explains:

> In writing proposals for my own work (in content strategy, and web writing, and editing and training), I make sure I understand precisely what the company I'm dealing with needs—what they perceive to be their biggest issues.

I often have the company poll their relevant employees, asking them what they would need from a course—or what areas of work they really feel they need help with from a consultant. Then I think through how I can help the company, and frame my proposal around nailing down as many of their concerns as I honestly feel I can help them with.[1]

ESTIMATING COSTS FOR YOUR CONTENT WORK

Estimating costs for content work can be a challenge for online writers. Bruns believes that:

All clients wish you could magically tell them in advance how much it's going to cost to totally read, and then analyze all of their Web site content. But you also have to look at competitors' sites, analyze their audience, develop an editorial style, and rewrite/edit it all. You need to work with the designer to develop an architectural system, create the navigation, and then re-edit everything once you've seen all of the millions of changes that are needed. In short, this is the single hardest part of working with content. You cannot second-guess how much time the work will take. But all clients want that. I have to build in a cushion for costs as we all do in this business.[2]

USING WRITERS' ORGANIZATIONS TO NETWORK

Writers' organizations can offer you networking opportunities and job leads. There are national organizations, state organizations, and regional independent writers' groups. Choose the organization that meets your specific needs and budget.

National Writers Union (NWU)

The National Writers Union (www.nwu.org) is a trade union for freelance writers of all genres who work for American publishers or employers. The group offers grievance resolution, contract advice, health and dental plans, member education, a job bank, and networking opportunities. Members are required to pay a finder's fee when they locate a position through the job hotline.

American Society of Journalists and Authors (ASJA)

The American Society of Journalists and Authors (www.asja.org) is an organization for freelance writers. The group offers members access to job and project leads through their writer referral service. The group also offers a free e-mail newsletter called *Contract Watch* that makes writers aware of unfair contracts.

NETWORKING THROUGH THE NET

Before the Internet, writers' networking options were limited to local writers' groups and writers' conferences. Now, writers can network globally and instantly through e-mail messages and online writing groups. Get in touch with fellow online writers to exchange and share ideas.

RECRUITMENT AGENCIES

Another way to find online writing jobs is to sign up with recruitment agencies for a position as a consultant. These agencies offer both permanent and temporary contract positions. Depending on the type of job and hiring company, the contract positions can last anywhere from a few months to a couple of years. The jobs might require you to work onsite or you may be able to work from home. Many of these recruitment agencies concentrate on technical writing jobs; however, you can also find online writing positions. Find these agencies through the Internet, classified ads in large city newspapers, and by networking with other writers. You could also call the human resources department of large companies and ask them for the names of the recruitment agencies they use for temporary employees. After you register with a few agencies, regularly check in with them through e-mail or by telephone to find out about recent job openings.

TRADITIONAL PRINT PUBLICATIONS

Although you may want to devote most of your job searching time to the Internet, don't forget to check the traditional print publications for jobs. Seek out online staff, freelance, or stringing positions. Look for online writing listings in these publications: *Writer's Digest*, *Publishers Weekly*, and *Editor & Publisher*. Check your local print newspaper ads,

especially the Sunday edition. The large city Sunday editions usually list higher-paying jobs.

COLD CALLING POTENTIAL MARKETS

Take an entirely different approach and look at the newspaper ads put out by graphic firms, advertising agencies, public relations agencies, and printers. The companies may not be seeking writers. In fact, they could be looking for salespeople or graphic artists; however, this could be the ideal time to make a cold call or send a query letter. It doesn't hurt to try. You could possibly land an online writing job in the future at the company. Or, your inquiry might encourage the employer to seriously think of adding a freelance or staff online writer to their organization. Use this same cold-calling approach to locate potential job leads by flipping through the yellow pages of your phone book.

FINDING LUCRATIVE JOBS

Amy Gahran (www.gahran.com) is a content consultant for online media. Gahran states that "corporate jobs do definitely pay better than writing article-style content for periodicals (online or otherwise)." She lists some important points to help online writers find lucrative jobs:

- *Make a name for yourself.* Either launch your own site or online publication, or make sure you get prominent credit for the work of which you are most proud. Prove that you can work in this medium. [Gahran definitely practices what she preaches. She is the founder and editor of the online newsletter CONTENTIOUS (www. contentious.com). She is also vice-president of Content Exchange (www.content-exchange.com), which produces the Content Spotlight newsletter].
- *Develop your network.* Do this through online discussion forums, conferences, and just plain networking. The best work will come to you through people who know you.
- *Develop a few specialties.* Online media is all about nichecasting, rather than broadcasting. If you develop a level of expertise in a lucrative topic area, or serve a popular or lucrative audience, you'll make better money than the "generalists."
- *Don't settle for low pay.* Lots of people will try to get you to work for free or way too cheap. Ninety-nine percent of the time, you can't

eat "exposure." Also, focus on the kind of work you *want* to do and go after it aggressively. Don't just settle for what floats your way.

- *Do more than just write.* Adding editorial, managing-editor, research, and project-management skills to your set of offerings will bring in far more work and money than if you only write.[3]

MOVING FROM PRINT WRITING TO ONLINE WRITING

What if you have written only for print publications? Moira Anderson Allen, publisher and editor of Writing-World.com (www.writing-world.com). believes that:

> The transition from "print" to "online" writing really isn't difficult. The majority of online publications use exactly the same type of material you see in print: Well-written articles with a beginning, middle, end, and a logical flow of information from one paragraph to the next paragraph.[4]

Browse Online Publications

Allen suggests that:

> The first step, therefore, would probably be to browse some online publications and get a feel for the type of writing that is found online. Again, you're going to find that quality online publications are looking for the same caliber of writing that print publications want. Those online publications that pay nothing get the same caliber of writing that nonpaying print publications get—i.e., pretty low.[5]

Provide Online References at the End of Article

According to Allen:

> The one difference is that online publications do tend to look for references to online resources. They're looking for hyperlinks, whether within the article or at the end. My preference (and that of many publishers) is to list links for "further information" at the

end of the article. Initially, you saw articles full of hyperlinks—individual words were hyperlinked so that you could click on them for more information on that topic. However, editors quickly discovered that this sort of internal hyperlinking had the effect of taking the reader out of the original article—and they might never click back. So most publications now prefer to run the links at the end, or have only a few links in the article itself, rather than risk losing the reader halfway through the text.

One point on hyperlinks: Generally, as a writer for the Web, you should provide the name of the site and the link, but you don't have to worry about formatting it. Let the editor/Webmaster do that. Do provide both, however; editors dislike having someone say, "You can find out more at http://such-and-such," without saying what the name of the site is, or "You can find out more at the Such-and-Such Web site," without providing the URL.[6]

LANDING JOBS IF YOU DON'T HAVE CLIPS

What if you're an aspiring writer who doesn't have any clips to show to editors? Publisher and editor Angela Adair-Hoy reports:

When WritersWeekly.com (www.writersweekly.com) interviews editors for market listings, we specifically ask if they work with new writers. The good news is...most of them do. Writers can find lots of paying markets for newbies starting here at www.writersweekly.com/payingmarkets.htm. At the end of each paying markets page at WritersWeekly.com, there is a link to more paying markets pages. They're all sorted by date. Writers can use the search function of their browser to look for the term "welcomes new writers." This will bring up all the markets that apply to new writers. And, they're all paying markets.[7]

GETTING CLIPS BY WRITING FOR
NONPROFIT ORGANIZATIONS

Still clipless? Approach nonprofit organizations and offer to write short pieces for their Web sites or e-mail newsletters. The pieces could include online articles, fundraising appeals, or online brochures. Ideally, you will get paid for your work. If you have to offer your work pro bono, at least you are building up your portfolio of online clips. Set a time limit to your pro bono work. After that time period has passed, begin to approach employers for paying jobs.

WRITING COLUMNISTS/GUIDES

On the Web, certain venues offer writers the chance to write ongoing columns on a specific topic of their own choosing. Some of these venues include:

- About (www.about.com)
- Suite 101 (www.suite101.com)
- Web Seed Publishing (www.webseed.com)

The writers may be experts in the topic or they may be hobbyists. Writers usually have to complete an application form in order to be considered for the position. The pay for writers/guides is generally low. Writers must devote a certain number of hours or submit a predetermined amount of articles to the site each month.

Some editors from other higher-paying sites may not consider clips from these type of sites as credibly published articles. If you are thinking of applying to one of these sites, consider the time and effort that is involved. Read the fine print in the contracts so you are not giving away valuable rights. Estimate your potential income. Maybe it would be more lucrative for you to go after higher-paying markets that require less of a time commitment.

EVALUATING WRITING SITES

Although many writing sites offer solid information, some sites exist primarily to sell print and e-books, writing courses, and editing services to writers. Spend time researching each new site. Does the site have a transparent "hard-sell" tone to it? Check the site to see who is sponsoring the courses. Does the site provide complete contact information? Are the courses and services guaranteed? Are testimonials provided and do they appear believable? Read the articles on these sites to determine their credibility factor before you invest any time and money. Subscribe to the site's mailing list to get a better idea of their total offerings and to determine if their courses will ultimately benefit your writing career. Ask other writers on mailing lists about their personal experiences with the specific site.

FINDING ONLINE WRITING JOBS CHECKLIST

If you want to be a successful online writer, make the pursuit of potential jobs a regular habit. Whether you look for jobs on a daily or

a weekly basis, use this list as a memory jogger. The more venues you pursue, the more jobs you will have to choose from.

- E-zines and e-mail newsletters (market/job listings for writers)___
- Writer's guidelines (databases)___
- Job boards___
- Online classified job ads___
- Recruiting agencies___
- Writers' mailing lists___
- E-mail subscriptions (generic)___
- Seek jobs through search engines___
- E-commerce sites___
- Niche sites___
- Company sites___
- Writing organizations___
- Network through the Net___
- Traditional print publications___
- Cold calling on potential markets___
- Do your best writing on every assignment (Your published article/document could land you your next job.)___

ENDNOTES

1. Bruns, Merry (E-mail: mbruns@nasw.org). Content consultant for online media and principal of ScienceSites Communications, www.sciencesitescom.com. E-mail interview, July 22, 2001.
2. Ibid.
3. Gahran, Amy (www.gahran.com). Content consultant for online media, founder and editor of the online newsletter CONTENTIOUS (www.contentious.com); vice-president of Content Exchange (www.content-exchange.com), which produces the *Content Spotlight* newsletter. E-mail interview, August 6, 2001.
4. Allen, Moira Anderson. Writing-World.com publisher and editor (www.writing-world.com). E-mail interview, July 10, 2001.
5. Ibid.
6. Ibid.
7. Adair-Hoy, Angela. WritersWeekly.com publisher and editor (www.writersweekly.com). E-mail interview, July 12, 2001.

Chapter 15
Marketing Yourself

To be successful, online writers need to cultivate a marketing mindset. Think about it. Every time you query an editor, submit a resume, publish an article, or complete a successful project, you are marketing yourself to the online world. You are selling both yourself and your work. You have a choice. You can continue to pursue jobs as they become available or you can sit down and develop a well-thought-out marketing plan. Take the latter step and you will achieve greater success.

DEVELOPING A PERSONAL MARKETING PLAN

In Chapter 6, "Getting Ready to Write," you had the opportunity to analyze Internet sites, determine your personal strengths, and identify your writing niches. Gathering this information will enhance your online writing skills. Now it's time to pull all of your ideas into a personal marketing plan. To make the plan a working document, it should include both short-term goals and long-term objectives. Your plan needs to be flexible to adjust to changing market conditions.

Personal Marketing Plan Definition

A marketing plan is a written document that describes your product's or service's marketing and financial objectives. The plan recommends programs and strategies for accomplishing those objectives. The

combination of marketing efforts that makes up your program is known as the *marketing mix*, or the four Ps:

- Product (writing services)
- Price (cost to customer)
- Promotion (advertising your services on your personal Web site)
- Place (channels of distribution—Internet)

The phrase *marketing plan* may be confused with the phrase *business plan*. In reality, a business plan is a larger and more comprehensive document that focuses on nonmarketing issues (e.g., manufacturing). A well-thought-out marketing plan can help you measure your accomplishments or quickly change your direction if you need to. Your market planning can bring you success, while a lack of planning can result in failure. Your marketing plan should cover the following points.

Goals

First, determine the goal of your online writing business. The goal should define what you want to accomplish in specific terms. Try to condense your goal into one sentence. For example: "My goal is to develop content for corporate intranet sites on a full-time basis within the first quarter of the year."

Current Situation

Here's where you take an honest look at your current situation as an online writer and the current situation on the Web.

Your Current Situation

What do you need to do to increase your sales or salary? Maybe you need to increase the number of queries or resumes that you e-mail out each day to help you land new projects. Maybe you need to contact more organizations and develop more proposals. Alternatively, you might have to focus on a different online writing venue. As a freelance writer, writing online articles may not be bringing in enough money to support you. It might make more sense to concentrate on finding jobs in small companies where you work on-site, even if you have to take technical courses to refresh your skills.

Follow new developments in your particular writing niche. Are the employers in your field demanding that writers be knowledgeable about specific software packages?

Current Situation on the Web

Look at the types of jobs that are presently being offered on the Web. This analysis will help you determine the current needs of your potential clients and how you can fulfill those needs.

Read regularly and read widely. Make sure that your marketing plan reflects the realities of the current online content world by keeping up-to-date on market conditions by reading the following publications: The online newsletter, Content Spotlight (http://content-exchange. com) is geared toward online content creators and publishers. Editor & Publisher Online and Stop the Presses, which are both at www.mediainfo. com, and USC Annenberg Online Journalism Review (http://ojr. usc. edu) are all good news sources. You can also sign up for E-Media Tidbits: A Group Weblog at the Poynter.org Web site. The Weblog is delivered to your inbox Monday through Friday. In the Weblog, you'll read news, analysis, and interesting updates from some of the sharpest minds in online journalism and content/publishing.

Stay abreast of changes and trends on the Internet. You'll be better prepared for the next big thing coming up on the Internet. If there is a downturn in one segment of the Internet, you'll know enough to devote your energies to those areas where there is a greater chance of return.

Type of Clients (Target Audience)

Identify a variety of potential clients for your business base, for example:

- Clients with both a brick-and-mortar presence and an online presence
- Clients who are primarily online
- Established clients
- Startup clients

Think beyond the development of online articles and small one-time jobs. Think in terms of business-to-business content and business-to-consumer content projects. Include print clients, too. Developing a good client mix will help you produce a regular revenue stream. The online market is in continual flux; therefore, it's wise not to rely heavily

on one or two clients or one category of work for your income. Part
of your working hours should also be devoted to finding new online
writing jobs.

Type of Content Work

Your marketing plan should include the type of content work that you
would like to specialize in, for example:

- Content provider for a company Internet site
- Online managing editor
- Copywriter
- Writer of e-mail newsletters
- Writer of online articles

Some writers like to take on a variety of freelance assignments for the
challenge and learning experiences. One way to begin developing
a client base and to gain work experience is to focus on those areas
where you have a good background. For example, if you once worked
on the public relations staff of a telecommunications company, try to
find online writing positions in this and related industries.

Your Unique Selling Proposition

Advertising agencies use the concept of "unique selling proposition"
(USP) to distinguish a product from other products on the market. Ask
yourself what makes you unique from other online writers. Determine
the value that you can offer to clients that differentiates you from the
competition. One example of a USP could be your knowledge of Web
design principles, which enhances your value as a writer to some
firms. Another example could be your expertise in a specific subject. If
you have a solid work background in investments, you could position
yourself as a writer who can develop online white papers, targeted
e-mail newsletters, and copy promoting products and services for the
financial industry.

Marketing Budget

An important part of your marketing plan is the budget. Determine
how much money you can afford to spend on promoting your online
writing business. Fortunately, with the Internet you do save postage,

paper, and printing costs whenever you send out queries and resumes; however, if you want to create an effective Web site, you may want to pay someone to design the site for you. You will also have to pay the Internet service provider (ISP) costs. There are also ISPs that give free Web "real estate." Carefully check the contract before you commit to a free ISP to make sure that you are not signing away the rights to your material.

You might also want to create a conventional print brochure detailing your services. You can use the brochure when you do direct snail-mail campaigns and meet face-to-face with clients; however, don't slap this same brochure on your personal Web site. Instead, rewrite it to make it easy to read on the computer screen.

Marketing Strategies

Now it's time to look at the strategies or marketing tools you will use to reach your target audience. Here's your chance to sell the benefits of your services. Ask yourself what are the best ways to achieve your objectives. You can take a variety of approaches. You could create a personal Web site. Later in this chapter, you'll read more about how to create a personal Web site.

Recruitment Agencies

Every week, you could register with a new recruitment agency that hires online writers. After a couple of months of this activity, you will be registered with at least eight different agencies.

Develop Customized Resumes

To give yourself an edge with recruitment agencies, develop a customized resume for each of your writing specialties. For example, I've created two customized resumes that focus on my two specialties: marketing/training, and nutrition and health. Although these specialties may appear unrelated, I've used my knowledge in each of these subject areas to enhance my career. If I receive a call from an agency who is looking for a writer to create documentation for a corporate intranet, I'll e-mail them my marketing/training resume along with a brief and catchy cover letter. I send my nutrition and health resume to agencies that place employees in the pharmaceutical and medical writing industry. By taking a different approach with each resume, I have created two targeted and focused resumes that will interest potential employers. Best of all, when I receive a call from an agency, I have a resume that is immediately ready to send out. In my own experience,

the agencies have requested that I e-mail them ASCII resumes instead of attachments. To save yourself time, format your targeted resumes in ASCII text so they are ready to go when you receive a call.

Customized Cover Letters

Whether you're applying to a recruitment agency or to a company, don't forget about the importance of including a catchy and customized cover letter with your resume. Your cover letter is a selling tool, too, but it serves a different purpose from your resume.

Do not use valuable space in the cover letter to simply repeat the details you outlined in your resume. Instead, use the cover letter to sell the company on what "You" can do for them. Hook your reader's attention by specifically explaining how you can help the company achieve success. Briefly sell those skills that you possess that will meet the company's needs. Explain how your experience and talents will benefit the company.

Finish off the letter with a call to action. Provide your telephone number and e-mail address. Let the employer know that you will follow up your letter with a telephone call to set up a face-to-face interview.

Write for the Trade Press or Online Magazines

You can try writing articles for the trade press or online magazines that are related to your online writing services. For example, you might write an article on "Ten Ways to Improve Your Online Writing." The published article will give you free publicity and show readers that you are an expert on the topic. Although you may receive little or no payment for the article, the benefits can outweigh the negatives. The article serves as a self-promotional tool, especially when your e-mail address and Web site URL appears at the bottom of the article. You can use the article reprints as a supplementary sales literature tool to send in or give to clients.

Participate in Writers' Mailing Lists

Become a regular participant in writers' mailing lists and share your writing experiences. You'll be learning, improving your craft, and getting name recognition, too.

Action Steps

After you identify your strategies, it's time to take action and follow your marketing roadmap. Independent online writers should spend about 10 to 25% or more of their time on marketing themselves to

potential clients. Look at your calendar for the current year and block out a specific time each week that you will devote to self-promotion. Make that time work harder for you by writing down the specific marketing action steps you will take during these hours each week.

For example, if you have a Web site, you can't sit back and wait for potential customers to find you and inquire about your services. You need to drive clients to visit the site by persistently submitting your resume and Web site URL to them.

If you're registered with recruitment agencies, check in regularly by e-mail or by telephone. When you update your resume, send the agencies copies, too. The agencies are more likely to remember your name when a hot job comes in—and you'll get called for the job.

If you decide to promote yourself by writing articles for the trade press, one article doesn't make for a promotion campaign. Write additional articles. You'll begin to develop a relationship with the editor. Before you know it, you will have a ready-made forum with that editor for getting your new ideas into publication. Regularly contact company sites that match your background, online writing goals, and writing experience with a well-developed query letter and resume.

Regular Review of Marketing Plan

After you have written your marketing plan, you're still not done. Planning is an ongoing process. The Internet is an ever-changing marketplace, and you must continually adapt and learn. You should always be thinking of the next steps you could take to enhance your career. Try to think in terms of what online writers will be doing in the future. Review your marketing plan at least once a month—weekly is even better. Weed out the tactics that aren't working. Refine your strategies. Make any changes that will help you meet your goals and increase your sales success.

CREATING A PERSONAL WEB SITE

You have writing talent. You're eager to see your byline published on the Web. But where do you start? Maybe you've only published print articles or maybe you have no published clips to your name. What you need is an online presence. After you have thoroughly studied what does and doesn't work on Web sites, including writers' sites, it's time to create your own personal site. Creating your personal site tells potential clients that you understand the dynamics of publishing online. Designing your personal site also gives you a hands-on learning

experience. A personal site is also a great sales tool that showcases your online writing to future clients. There are some basic rules to follow when creating a personal Web site:

- Keep your site simple.
- Revise, revise, and revise your content until it sparkles.
- Check your spelling and grammar by printing out hard copies of your Web pages and proofreading them carefully.
- Make it easy for potential clients to reach you by providing a "mailto" link on each page of your site.

For more information on creating a Web site, read Chapter 3, "Web Site Guidelines."

Posting Material on Your Personal Web Site

What kind of material should you post on your Web site? First, as an online writer, you should focus on one or two specialized niches. When clients visit your site, you'll increase your credibility by representing yourself as a specialist with extensive knowledge and background in your subject area rather than as a generalist who knows a smattering of information on a large range of unrelated subjects.

You could also specialize in closely related subjects that expand on your niche. For example, a nutritionist can offer articles on recipe development and international cooking. You'll still earn the trust of clients who will know that you are knowledgeable in your subject area.

If You Specialize in Unrelated Niches

If you do have professional expertise and writing experience in two unrelated niches (e.g., travel writing and financial investing), create two separate Web sites with unique URLs that each highlight your specific writing experience. In this way, you project a professional presence to potential clients. Don't make the error of creating one Web site with internal links to articles on distance learning, holistic health, and antique collecting.

Formatting Your Personal Web Site

After you have determined your specialty, post an online portfolio on your site that promotes your services. On your home page, create a hypertexted table of contents (menu) that links to your interior pages. The interior pages could contain your resume, examples of previous

projects, testimonials, detailed descriptions of the services you offer, a fee structure, a list of clients, writing samples and published articles, and links to reputable organizations.

Sell Your Strengths

Make sure you create a resume on your site that sells your strengths. Include supportable information, such as college degrees, training, and previous employment. You'll increase your response rate from potential employers if you provide an "easy-to-print" version of your resume on your site.

Post Past Columns

If you regularly write a column for another Web site, you might want to post these articles on your personal site. You never know when the other Web site will remove your articles from their archives. By posting the columns to your site, you can keep them there indefinitely. Of course, make sure that you retain the copyright to your work so you have the right to republish the articles. To avoid any legal issues, you should also notify the publisher that you will be posting these columns on your personal site.

Show Your Best Work

Your samples and published articles should be the best examples of your writing. Potential clients will be assessing your writing ability based on those samples. Update your site and online resume every time you publish a new piece or complete a new project.

Offer Value on Your Personal Web Site

To avoid the look of "brochureware," make sure that your site also gives readers informative news that will entertain, engage, educate, and enlighten them. Moira Anderson Allen, author of the book *Writing. com: Creative Internet Strategies to Advance Your Writing Career*, believes that: "The key to an effective Web site is that it must be a resource, not just an ad for you and your writing. You need to give people a reason to visit, to recommend the site to others, and to come back."[1] Allen further suggests:

> To give people a reason to visit, you need to provide information or entertainment. If you are a fiction author, you can provide entertainment in the form of excerpts from your books or short stories

that have been previously published, etc. If you are a nonfiction writer, you can provide information on the subject area in which you write.[2]

Allen continues her advice:

> What you don't want to do is have your Web page open on, say, a picture of your book, a collection of reviews, and ordering information. This comes across as simply an ad—and when was the last time you (1) bookmarked an ad, or (2) deliberately flipped through a magazine to find the ads? You don't. Neither do folks on the Web. Similarly, don't tease people, by saying, "Here's a problem that I have the answer to, and you can get the answer if you buy my book."[3]

According to Allen:

> The Web is a place where people "give it away," and the more you give, the more you'll find that people come back to you and buy your work. Fill your site with real information, make it a place of significant value, and you'll get hits.
>
> Be sure you have the rights to anything that you post online. If you've sold all rights, or all electronic rights, you're out of luck. Also, do not post unpublished works online. This often counts as a "first publication," even if only two people (including your mother) visit your site—and you'll have to sell the work as a reprint thereafter. In addition, and this is the primary issue from my perspective, it makes you look like an amateur, desperate for publication. Editors do not surf the Web looking for material; they have more than enough manuscripts in their slush pile.
>
> The best way to promote yourself by e-mail is to include information about your work (e.g., your book title and a link to your Web site or an ordering page) in your e-mail signature block. Never, ever send out "ads" by e-mail. That's considered spam, and is the ultimate anti-promotion.[4]

Promote Your Web Site to Potential Clients

When querying editors and clients, you can refer them to your personal Web site where you have assembled all of your published articles and sample projects.

Alternatively, you can refer editors to specific URLs on other Web sites where you have published articles for e-zines or clients; however, Web sites are often redesigned and the location of your articles are moved within the site. Editors could then encounter broken links when they try to access your articles on other sites.

Promote Your Web Site Offline and Online

Encourage potential clients to visit your Web site by including the URL on your business cards, letterhead, print brochures, hard-copy writing samples, or premiums (e.g., pens, pencils, keychains). Append the URL of your Web site to the signature block of every e-mail you send.

Create a Weblog or E-zine

Instead of a Web site, you could create a personal Weblog or e-zine. A Weblog is a regularly updated site that points to relevant links on other sites. The person who maintains the Weblog usually provides commentary about the links. You could create a Weblog that relates to your writing specialty and attract potential clients. For more information on Weblogs, go to www.weblogs.com. More information on Weblogs is also covered in Chapter 11, "Online News."

Or, you could create an e-zine to attract clients. The e-zine might contain feature articles, a Q&A column, and industry news. You could also offer potential clients an opt-in e-mail newsletter to let them know when the e-zine is updated; however, keeping an e-zine up-to-date is a big undertaking. Make sure you have the available time and the resources before you create the e-zine. A stale e-zine that is infrequently updated gives potential customers a poor image of your business.

MARKETING IT UP IN DOWN TIMES

The ups and downs and unexpected curveballs of the Web and the economy make it tempting to feel rejected and dejected when you're seeking online jobs. But not for Sacha Cohen (www.sachacohen.com), long-time business and technology journalist based in Washington, D.C. Cohen decided it was time to step up her marketing efforts during the economic turmoil. How did she do it? Here are some of her suggestions:

1. *Have a specialty/niche, but don't get pigeonholed.* Her lesson to writers is to be knowledgeable about a couple of subject areas and willing to write about lots of topics.
2. *Never stop selling yourself.* In order to succeed as a freelance writer, Cohen believes you must also be a self-marketing guru. At the heart of self-promotion is networking. Mingle with fellow writers and editors. Cohen recommends joining a club or association such as the National Press Club. It's also important to network outside of

your profession. If you're a travel writer, attend travel industry functions. No matter what subject you write about, there's usually an association that is related to it where you can build networks.

3. *Break boundaries.* Avoid restricting yourself to writing for a specific type of publication or medium. Get to know the "dos and don'ts" of each type of medium. Take courses to learn about mediums with which you are unfamiliar. Start out with smaller trade publications both online and off. Grow with these publications, and seek out larger publications as you gain more experience.

4. *Mix it up.* Make sure you nurture a good mix of print and online clients, as well as large and small clients. Cohen cautions that in these shaky economic times, you never know which one will succeed and which one will fail. It's good to have several clients at a time, including a few "bread and butter" projects that are long-term and stable.

5. *Build an online portfolio.* People can then find all of your clips in one place (or at least the URLs and descriptions). Cohen recommends that you pay someone with a strong Web design background to build you a simple but nice site rather than try to do the work yourself.

6. *Get an agent.* Consider signing up with a "talent" agency. Examples include Aquent or online at Guru.com or eWork.com. Aquent is a temporary and temp-to-perm agency for creative types.

7. *Always be searching.* This means searching for new gigs, new clients, new story ideas, and new venues to sell your work. Cohen tells writers to keep a copy of the *Writer's Market* closeby. Surf for new sites and visit media-specific job sites such as JournalismJobs.com and mediabistro.com. Read industry-specific magazines and send out a couple of queries every week.

8. *Sharpen your skills.* Perhaps your editing skills are a bit rusty or you've realized that your computer competency isn't up to snuff. It's important to constantly update and upgrade your skills so that you remain competitive in the marketplace. Look into continuing education classes at your local university, take an online class, or purchase a couple of books that will teach you something new and upgrade your skills.[5]

CREATING INVOICES

All of your communication with your editor or client should be handled in a professional and businesslike manner. Your invoice is a form of communication. A professional-looking invoice can also be thought of as a marketing tool. When you submit your article or complete your work in the case of a project, you should immediately include your

invoice. You can create an invoice with word processing software, specialized software, or purchase blank invoice forms from an office supply store. If you are creating an invoice with word processing software, you can develop a simple form that you can save as a template for future jobs. The form should contain the following information for an article.

Invoice

Your name

Complete address (street, city, state, zip code)

Telephone number and fax number

E-mail address

Web site URL

Social Security Number

Date:

Name of publication:

Article title:

Invoice amount:

Payment due date:

If you are submitting an invoice for a project that you've completed for a client, your invoice will look slightly different. On the invoice, you should include the client name, project name or number, the dates that the invoice covers (e.g., covers week of 01/21/02), total number of hours worked, amount per hour, and total amount of invoice.

If you don't receive payment within 30 days, contact the editor or your client. If that tactic doesn't work, ask to speak to the accounting department.

MARKETING PLAN FORM

Goals:_____

Current situation:

1. Your current work situation:

2. Current economic situation on the Web:

Types of clients to approach (clients with both a brick-and-mortar and online presence; clients who are primarily online; established clients; start-up clients; print-only clients):

_____ _____

_____ _____

Type of content work (freelance online articles, content provider for corporate Web site, copywriter, e-mail newsletter writer):

_____ _____

_____ _____

Your unique selling proposition (USP) as an online writer:

Your marketing budget:

Marketing strategies:

_____ _____

_____ _____

Action steps:

_____ _____

_____ _____

Review marketing plan:

Dates: _____ _____

Dates: _____ _____

ENDNOTES

1. Allen, Moira Anderson. Writing-World.com publisher and editor, www. writing-world.com. E-mail interview, July 10, 2001.
2. Ibid.
3. Ibid.
4. Ibid.
5. Cohen, Sacha (www.sachacohen.com). "Surviving the Slowing Economy: 10 Tips for Freelance Writers," www.sachacohen.com/survive.htm. Accessed August 8, 2001.

Chapter 16

Copyright in the Web World

The tight deadlines on the Web demand that writers push out material faster than they ever did in the print world of newspapers, articles, or books. In this hectic environment, it may be tempting to be more liberal in our use of quoted material, but when it comes to intellectual property laws, writers can best safeguard their interests by taking the proper precautions on the Web. Gaining permission to use published material is as important in online writing as it is in print writing.

COPYRIGHT CONSIDERATIONS

Some people think that because much of the information on the Internet is free, then the material is also free for them to redistribute, reprint, or copy on their own sites. These facts are untrue, even in the case of usenet postings. Writers need to be aware that copyright laws apply to documents that are posted on the Internet.

Although you may not see a copyright notice on an online document, this does not mean that you are at liberty to use the written work. As soon as a document is created in tangible form, the work is copyrighted. The same copyright rule applies to the graphics, logos, and animations that you see on other Web sites. If you do create your own graphics or logo for your site, post a copyright notice next to the images to protect them.

Although facts and ideas can't be copyrighted, copyright laws protects an author's original expression in a work. Therefore, paraphrasing quoted material can cause you problems, too. Your best option is to gather your facts from a variety of reputable sources. Then write your documents using your own words. Draw on your originality and unique way of expressing your ideas in words, and you'll create an innovative final product.

Giving credit to an author does not automatically grant you the right to use that person's work either. The author may not want a portion of his or her work quoted. Ask for the author's permission first and request a signed permission form.

If you are writing an online article, electronic book (e-book), or book, and you are quoting your own previously published, copyrighted work, you also need to obtain permission from the publisher of the previously published work.

Don't assume that the U.S. copyright laws apply to other countries. There are international variations to copyright law. The Fair Use doctrine varies from country to country, too. If you need to obtain publishing permission from an international publisher, locate the publisher by looking up its contact information on the Web. Use one of the major search engines like Google (www.google.com) or All the Web (www.alltheweb.com).

PROTECTING COPYRIGHTED MATERIAL ON YOUR SITE

"Copyright laws are very important in cyberspace, as a number of high-profile cases—including Napster—have shown," reports Doug Isenberg, Altanta attorney and publisher of GigaLaw.com, a Web site that provides legal information for Internet professionals.[1]

Isenberg further states:

> But copyrights are infringed every day on the Internet in many ways that receive little or no attention. If you are a copyright owner of online content (that is, someone who has created and published text, images, photographs, music or software on the Internet), you need to be very vigilant about protecting your rights, because others can easily violate them simply with the click of a mouse.[2]

OBTAINING COPYRIGHT PERMISSION

Isenberg also offers important information for users of the Web:

If you are an online copyright consumer (that is, someone who uses another's content on the Internet), you should be very careful not to reproduce or distribute that content without the owner's permission. Because U.S. copyright law carries penalties of up to $100,000 per infringement, failing to obtain that permission can be quite costly.[3]

INTERPRETING THE FAIR USE DOCTRINE

Regarding the Fair Use Doctrine, Isenberg explains:

Not every instance of copying requires permission, thanks in part to the "fair use" doctrine. In general, this doctrine says that certain limited uses of a copyrighted work for purposes such as criticism, comment, news reporting, teaching, scholarship, and research do not constitute copyright infringement; however, determining whether a particular use qualifies as fair is often not an easy task. The U.S. Copyright Act says that at least four factors must be considered in determining whether fair use applies:

1. the purpose and character of the use, including whether such use is of a commercial nature or is for nonprofit educational purposes
2. the nature of the copyrighted work
3. the amount and substantiality of the portion used in relation to the copyrighted work as a whole
4. the effect of the use on the potential market for or value of the copyrighted work.

Weighing these factors is no easy task and should rarely be done without the advice of a copyright lawyer.[4]

REFERENCE SOURCES

Writers can consult many online reference sources to learn more about copyright rules.

U.S. Library of Congress Home Page

Check the "copyright office" section located on the home page of the U.S. Library of Congress (www.loc.gov) Web site. This detailed section answers any questions you might have about the use of copyright in the United States.

GigaLaw.com Review

Visit Doug Isenberg's GigaLaw.com Review (www.gigalaw.com) Web site. The site provides legal information for Internet and technology professionals, Internet entrepreneurs, and the lawyers who serve them. Doug M. Isenberg, an Atlanta attorney, is the founder, editor, and publisher of GigaLaw.com.

WHEN IN DOUBT, GET PERMISSION

If you have any doubts about whether to use any passages in a publication, get permission from the publisher. It's simpler to request permission than to find yourself involved in court proceedings. If you neglect to obtain written permission, you could be legally liable.

How to Obtain Permissions

When you want to cite passages from online or print articles or books, you must obtain written permission from the copyright owner. Who is the copyright owner? The copyright owner could be the author or the publisher. To determine who owns the copyright, look at the end of the online article, the masthead in the print magazine, or the copyright page of the book. Many book publishers list their specific permission instructions and contact information online. Send an e-mail to the appropriate person asking for permission to use the specific passage in your manuscript. Depending on the publisher, you may have to send a copy of the page from the book/article that you want to quote or the copy as it will appear in your manuscript. It's also important to send a permission form with your request so you will have a written and signed record of your agreement for your own publisher. Keep a copy of the signed permission form in your own files, too.

Some publishers choose to use their company permission form instead of your publisher's form or your personally developed form. These publishers may also stipulate different rights (e.g., first edition only) than the rights you are requesting. You will then have to negotiate rights with the publisher and your publisher. Finally, some publishers may charge you a fee for use of the requested passage(s) and ask for a copy of your final article or book.

Some publishers prefer to handle the entire permission process by e-mail and fax transactions. If you are sending the quoted passage by e-mail, paste the passage into the body of your e-mail message. The

permission form can be sent through e-mail (pasted into the body of the e-mail message or as an attachment—the latter will look more professional because the formatting will not change; however, some publishers will not accept attachments). Alternately, the permission form can be sent via fax transmission to the publisher.

Ask the permissions editor to either fax or snail-mail the permission form back to you. In the latter case, provide a self-addressed, stamped envelope (SASE) to the editor.

CITATION CONSIDERATIONS

Citation guidelines for the references that appear at the end of online documents continue to change on the Web. There appears to be an abundance of contradictory information about how to properly cite references. As technology advances and the Web grows, citation guidelines will continue to change. Writers will need to keep up-to-date on how to correctly cite references guidelines by following developments on the Web.

Proper online citation style should make it easy for users to access the reference material listed at the end of a published work if they want more information. At first, hypertext citations may seem like a simple way to cite and get references. But today, the nature of the Web means that documents can quickly disappear or be moved to a different place on the Web in a matter of weeks or months. If the cited references cannot be found, readers can look for the information using search engines or by contacting the author or the author's organization. If those tactics don't work, readers may lose access to the valuable source material.

Because people read documents both online and offline when they print documents out, citations need to be presented in a format that can be read on the Web as well as easily read on paper.

Citation Guidelines

Whenever possible, the following information should be included in a citation: author, document title, publication title, section or page number, date of document (if applicable), location of the document (URL), and the date when the document was accessed. Following is an example of an online citation:

Smith, Mary. "Online Documents," ABC Publication, page 2, January 20, 2002, www.newsletter.com. Accessed February 5, 2002.

For more information on citation specifics, consult the print edition of *The Columbia Guide to Online Style*. Book updates can be found at www.columbia.edu/cu/cup/cgos.

COPYRIGHT FORMAT

If you are posting an article on your own site, the accepted copyright format is:
Copyright © 2002 by Mary Smith

DEEP LINKING

Can deep linking get you in trouble? A few years ago, deep linking caused some controversy in the online world. Deep linking is linking to an interior page within another Web site instead of linking to that site's home page or front door. This practice gives a reader entry into a site's resources without going through the home page. Why do sites dislike this practice? Many site's home pages function as a front door. Here, visitors find out what articles and offerings are available on the site. The home page usually posts promotional ads. Deep linking could cut into a site's profits.

If you do link to other sites, either link directly to the site's home page or ask the owner at the other site for permission to deep link. If you have any doubts about linking, obtain legal advice. Don't take any chances. Some people believe strongly that the Web gives everyone the right to link to other pages because the Web is built on links; however, this issue is not yet completely resolved.

PERMISSION REQUEST FORM

Author Name
Author Street Address
Author City, State, Zipcode
Author E-Mail Address
Author Telephone & Fax Number

Date of Letter
Publisher Name
Publisher Street Address
City, State, Zipcode

ABC Publisher is planning to publish my online article/E-book entitled:

Name of Your Online Article/E-Book:

I request permission to quote material from the following:

Title of Online Article/Book:
(online article/book title; newspaper, journal title or book publisher;
include city, if book source; date of publication; page number[s]; URL;
and date accessed)

Author's name:

Material to be used:
(include photocopies of the page(s) on which the original material
appears)

I request permission to reprint the specified material in this book and
in future reprints, editions, and revisions thereof, for possible
licensing and distribution throughout the world in all languages. If you
do not control these rights in their entirety, please advise as to whom I
should contact. Proper acknowledgement of title, author, publisher,
and copyright date (for journals: author, article title, journal name,
volume, first page of article, and year) will be given. If the permission
of the author is also required, please supply a current address.

Thank you. I enclose a stamped, self-addressed envelope for your
convenience.
Sincerely,

Your Signature

Permission Granted:

Date: _____ Name:_____

Title:_____

ENDNOTES

1. Isenberg, Doug. Atlanta lawyer, publisher of Gigalaw.com. E-mail interview,
 August 30, 2001.
2. Ibid.
3. Ibid.
4. Ibid.

Chapter 17

Contracts

Technology is rapidly creating new forms of media. As we grapple with the development of databases and online archives, new clauses are popping up in writers' contracts. More futuristic media forms are on the horizon. Publishers are creating contracts that demand more rights from writers, but these contracts do not offer additional compensation for those rights. Because the Internet offers users easy access to the works of writers through publications and databases, writers should be better compensated for their work. The more that writers negotiate for improved working conditions, which includes better contracts and fair pay, the more that all writers will benefit now and in the future.

KNOWING YOUR RIGHTS

According to Doug Isenberg, an attorney in Atlanta and the publisher of Gigalaw.com, a Web site that provides legal information for Internet professionals:

> Negotiating a contract in the online world is not very different from negotiating a contract in the offline world; however, depending on the type of contract involved, some issues are especially important. For example, if the contract is for the creation of content that is to be published on the Internet, then specific permission needs to be granted for that use. A number of recent cases have illustrated this point very clearly.

In one case decided by the U.S. Supreme Court, a number of publishers, including the *New York Times*, failed to obtain permission from freelancer writers to publish their articles in CD-ROM format and in online databases; as a result, the freelancers sued for copyright infringement and won.

In another case, *National Geographic* published a photographer's work that originally appeared in the print magazine in a CD-ROM compilation without specific permission from the photographer, who later sued for copyright infringement. A federal appeals has ruled in his favor.[1]

CONTRACT CAUTIONS

After a freelance article assignment is offered to a writer, many publishers will send contracts that contain confusing legalese. These types of publishers offer "boilerplate contracts" that grab all rights. Some writers who want to get experience in online writing are eager to sign these contracts. Later, these writers bear the consequences as their valuable writing efforts are resold to database companies or compiled on CD-ROMs. Writers need to read contracts carefully and negotiate clauses that protect their rights and provide fair compensation. Writers should retain the rights to resell their works. Sometimes a contract is so restrictive that the best alternative is to turn down the work.

Work-Made-for-Hire Contracts

Work-made-for-hire (WMFH) contracts deprive freelance writers of fair compensation and treatment. These contracts are more appropriate for writers of corporate, advertising, or technical writing. These latter writers are usually paid by the hour or per project, and receive a high salary as compared to freelance writers who are paid per word for articles at a much lower fee. Some periodical publishers ask freelance writers to sign WMFH contracts as part of their writing assignments. The National Writers Union (NWU) and the American Society of Journalists and Authors (ASJA) recommend that writers not accept a WMFH agreement for magazine and newspaper work.[2,3] The ASJA takes the position that professional writers do not "sell" their articles; instead they license specific uses of the articles (e.g., licensing the use of an article to be posted on a Web site for a specific time).[4]

A WMFH contract situation gives the author the status of employee but without any employee benefits, such as Social Security contributions, health insurance, retirement plans, and paid vacation. Because employers (publishers) are generally entitled to the copyright on works

produced by their employees, a publisher owns the copyright under a "work-made-for-hire" arrangement.[5] The contracts usually contain language that strongly emphasizes that the writer is an "independent contractor."

If you do sign a WMFH contract, you lose the right to sell reprints to other publications, to foreign publications, or to reuse the material in a book you may write. You also may not be able to use your article on your personal Web site.[6] You should give strong thought to all the rights you are losing with a WMFH contract. The publisher considers you an employee but does not give you any benefits beyond payment for your article. The publisher is also free to take your written work and offer it to other groups or include it in a book for additional monies.

"All Rights" Contracts

An "all rights" contract is somewhat similar to the WMFH contract. In both cases, authors are the losers on the revenue end. Authors are asked to sign a contract that gives up their electronic, second serial, syndication, and other rights to the publisher. These contracts may be labeled as "First North American Serial Rights" (FNASR), and writers may think they retain some rights; however, the contract usually also includes a listing of additional rights known as *subsidiary rights*.[7] In these contracts, look for clauses that give publishers the rights to reproduce your work in "all media, whether existing now or invented in the future," or "in any media," or "in any form." Delete these clauses from your contract or negotiate separate fees for each use of your article.

BEWARE OF THESE CONTRACT CLAUSES

The clauses in writing contracts will continue to become more complex as technology advances and new forms of media become available to the public. Each contract offers you the chance to assert your rights as a writer and to gain fair payment.

Indemnification (Liability) Clauses

The indemnification clause basically means that "You," not the publisher, will be liable for any legal costs if any of your published material results in legal court proceedings. The wording may state that the

"Author shall indemnify and hold publisher harmless for any and all damage, and/or expenses based on a breach or alleged breach of any of the warranties made by the author."[8]

As an ethical and professional writer, you definitely want to guarantee that your work has not been previously published by someone else or plagiarized from another person's work; however, as the wording usually states, you cannot guarantee that no portion of your work violates any provision of law in any of the 50 states or any of the countries on the World Wide Web. The indemnification clause is a big financial risk that should be assumed by the publisher instead of the author.[9]

The ASJA recommends that you ask the publisher to delete this clause from your contract. The ASJA organization suggests that another alternative is to add the following phrase to the contract clause: "to the best of writer's knowledge" to decrease your liability. As an additional safeguard, you could also purchase professional liability insurance.[10] The National Writers Union offers its members affordable coverage.

Clauses in Periodical Publications

Contracts in periodical (print) publications may include phrases such as the right to publish, distribute, and license others to publish and distribute the work in all forms or in any media. By signing this type of contract, you give up your right to receive additional payment for electronic rights if the publisher decides to post your article on their Web site.[11] In fact, you give up your right to gain any further compensation from additional revenues that the publisher might make from your article.

Educational or Research Purpose Clauses

Depending on the type of writing you do, publishers may insert a clause in your contract that allows them to use your work for educational or research purposes.[12] That clause means that someone may be paying money to access your work in the future. Your publisher may be reaping the financial gain long after your article is written. Because you created the work, you should be sharing in the revenue, too.

Revise, Edit, and Alter Clauses

Watch out for contracts that allow publications to revise, edit, or alter your work.[13] Request to see a final copy of the edited work before it is

posted online. This step allows you to correct any errors. Your byline will be on the final document; your writing reputation and expertise is at stake.

Database Clauses

Contracts with database clauses usually give publishers the right to distribute the author's article in a database such as Lexis-Nexis. The catch is that these databases generally collect a per-article fee from people who access the database.[14] The moneymakers are the database producers and publishers who collect royalty payments on the archives of these articles. The writer does not make any money unless the author-publisher contract includes a clause for revenue sharing. Last June, 2001, the Supreme Court ruled that in the *New York Times* vs. Tasini case, freelance writers do have online rights to their work. (Jonathan Tasini is the president of the National Writers Union.) The court stated that writers can control whether the articles they sold for print publication to a magazine or newspaper may be reproduced in electronic form. Because the court claimed that compilation in an electronic database is different from other types of storage (like microfilm), publishers must obtain the author's permission before placing the work online. Although this ruling is a positive win for freelance writers, you still need to be careful when you sign print publication contracts to make sure they do not contain clauses that give up your electronic rights. You should also keep up-to-date on writers' contract and copyright rulings and changes by joining a writers' organization, subscribing to writers' publications, and joining writers' mailing lists.

Look Before You Sign Revised Contracts

If you have been writing for a publication for awhile and you are asked to sign a new contract, read the text in your revised contract carefully. Look for any new clauses, such as retroactive rights, which gives the publisher rights to your previously published work without giving you additional compensation.[15] If you sign this revised contract without removing the clause, the publisher can reprint your work in other forms, but you will not receive any monies for the republication of your writing.

GETTING THE CONTRACT FIRST

The editor likes your query and asks you to write an article for their Web site. Before you do any writing, insist on receiving a contract from the publisher—verbal and e-mail agreements don't count.

Your receipt of the contract starts the negotiation process and hopefully leads to the final signing of a fair contract. Although obtaining written contracts aren't an absolute guarantee that you will be paid, reputable publishers usually stand by their agreements.

Writers who work with startup publications that have only an online presence are especially vulnerable to lost revenue when these publications suddenly disappear from the Web. Before you sign any contract with these firms, research their sites carefully to make sure they have a real (street, city, and state) address, and not a post office box address. Look for telephone and fax numbers. Check these publications out with other writers through writers' mailing lists.

Negotiate Fair Contracts

Some publications keep a couple of versions of their contracts on file. They may first send new writers an "all-rights" contract. When the writers then request a contract that contains more writer-friendly clauses, these publications will send another version of a contract out to the writers. This contract is usually less restrictive.

Firmly but professionally stand your ground with publications. Do not simply accept the first contract that is offered to you. You could be signing away possible future revenue that is rightly yours. Read the contracts carefully. Ask questions on any clauses that sound confusing. Obtain opinions on the contract from other more experienced writers, writers' organizations, or lawyers.

National Writers Union Recommendations

Because the Web is still a new medium, it's a challenge for individual writers to determine proper fees and to negotiate the length of time that an article can be posted on a publication's Web site. Fortunately, the National Writers Union (NWU) continues to make progress in advocating for the rights of writers. In regard to online articles: "The Journalism Division of the National Writers Union recommends that writers be paid a fee commensurate with the original print fee (e.g., First North American Print Rights) for use of a writer's work on the World Wide Web for a period of up to one year."[16]

Request "Duration Clauses" for Online Work

On the Web, writing terms that are used for print publications quickly lose their meaning. In a print publication, a monthly magazine is outdated after one month. Then most magazines are discarded by the public. But when do an online publisher's first rights expire?

After a week, an article may no longer appear on the front page of a publication's Web site, but the article probably appears in the archives forever. That's why the NWU suggests including a "duration clause" in a contract for online rights (e.g., 30 days, 60 days, one year).[17] After that period, the publisher and the author can agree on an extension period or the publisher removes the article from the site. A "duration clause" protects the rights of writers, provides more fair compensation, and recognizes the value of a writer's work.

Reuse of Your Writing—Publication Practices

When querying a print publication (magazine) about a potential assignment, ask about their contract practices. If the publication claims that their contracts allow for reuse of printed articles, ask them to specify their definition of "reuse." As mentioned earlier, print publications often include clauses in their contracts that give them the right to post print articles on their Web sites without offering any additional payment to authors. Reuse could also involve inclusion in a CD-ROM developed by the publication, sales to online databases, or compilation of your article in a book issued by the publication.

Ask for First North American Serial Rights (FNASR) contract terms for your print articles. Let the publisher know that the major writers' organizations do not support "all rights" contracts.[18] Ask the publication to add a clause in the contract that defines the additional fees to which you will be entitled for each reuse of your material.

If the publisher asks for more rights, such as including your article in a future CD-ROM, ask for a separate payment for that use. If the publisher wants to post your article, which appeared in their print publication, on their Web site, request an additional fee for the posting and a duration clause. If the publisher wants to resell your article to online databases, you can (1) negotiate separate compensation and a "duration clause" for that use; (2) request that the clause be deleted; (3) decline the assignment; or (4) seek legal advice on the matter. Unfortunately, legal fees are costly, and writers usually do not have the resources to contact a lawyer about their rights on article assignments.

Get Paid Royalties for Articles in Online Archives

After articles appear on a Web site for a certain number of weeks, publishers usually put the articles into the site's archives. Do you collect royalties on these articles? You should. These archives represent valuable content for publishers, especially if advertisements are displayed alongside the archived articles. Users can access any of these archived articles, at any time, from anywhere in the world. These users will see the advertisements, click on the ad, and may purchase the products. The publishers will then get a cut of the revenue from the companies who advertise. You should be benefiting from this ad revenue, too.

Publishers can gain even more advertisement exposure by placing internal links in new articles that lead to your old content consisting of important background information. This old content can be surrounded by revenue-generating ads. For the publisher, the cost of maintaining old content is small, but if publishers use their old content wisely with inventive ad placement, the value is big. They make more money with old content.

Negotiating Payment for Your Archived Articles and Documents

Check your new contracts for online archiving clauses. Many publishers believe they can post these articles forever. If the article that you wrote will be quickly outdated, you may not be concerned about online archiving, but more likely your article will have value to future readers. Tell the editor that you expect to be paid a separate "annual subscription fee" for archiving your article on the publisher's site. Be specific about the dollar amount that you expect and the period that the subscription will cover. In fact, get these specifics in writing as part of your contract. If the editor declines the subscription fee, try to negotiate a higher rate for your article. Remind the editor that the publication will benefit from your archived content because it will bring in increased revenue. Research has shown that old content adds value to a site. Do some research on the Internet to come up with statistics that back up your argument, and take them to the editor. Another alternative is to ask the editor for a live byline that links to your own Web site. Your live byline may generate visits to your Web site and subsequent writing assignments. By understanding, following, and analyzing the marketing tactics of online publishers, you'll be in a better position to negotiate for more fair compensation for your potential archived articles.

E-BOOKS CONTRACTS

The evolution of electronic books (e-books) is happening at an accelerated pace. Devices that researchers are tinkering with in their laboratories today will soon replace the e-books that we are currently reading. These changes will only complicate the contract process for writers. Writers need to negotiate e-book contracts that protect their interests. Because this area of publishing is so new, writers will benefit by seeking professional advice. Basically, the copyright of the text should belong to the author, not to the publisher.

Authors should give online book publishers the right to distribute the book only in an electronic format. In this way, writers can make separate agreements with print publishers to produce a hard-copy version of the book.[19]

The granting of electronic rights should be limited to a specific period. After that time has elapsed, writers can then renegotiate an extension of time with the online publisher. Because publishers reap many benefits from online publishing in the form of lower production costs and less inventory expenses, writers should also receive a much higher royalty fee than they do with print publishers.[20] These factors are only some of the points that should be reflected in an e-book contract.

After your electronic book is published, how will readers find it? Will the online publisher list the book on its Web site? Or, do you have to create a personal Web site to let readers know about your book? (Even if your online publisher lists your book on its Web site, a personal site describing your book is still a good idea. Just make sure that you offer readers some useful information on the site in addition to your book description.)

There are other promotional considerations. Contracts should detail how e-books will be promoted (e.g., online promotion and print promotion). Will the online publisher actively promote your book on other Web sites? In e-mail press releases? Contracts should also stipulate how readers will order the books. The details regarding royalty payments and statements should also be a part of the e-book contract.

CONTRACTS FOR COMPANY ONLINE COURSES

Initially, developing online courses for companies may seem like a lucrative way for freelance writers to make a living. But you first need to read the fine print in the company's contract. A few years ago, I had the opportunity to write an online course for a financial institution. The work sounded challenging and paid well. I was eager to begin work until I received the contract and read the fine print.

The contract was many pages long, cloaked in legalese, and contained the following clauses. On nearly every page, the document reinforced the point that I was an independent contractor. Course ownership—whether on the World Wide Web, CD-ROM, or other computer-based format—belonged to the company in a "work-made-for-hire" (WMFH) contract arrangement. Of course, there were no employee benefits. Indemnification clauses were rather detailed. There was also a covenant not to compete clause. The contract stated that upon my completion of the project, the company was under no obligation to post the course if it did not meet the company's standards. After serious consideration, I did not sign the contract because I decided that the restrictions and risks were not worth the effort or the money. Every writer has to make a decision that meets his or her best interests.

CONTRACTS FOR COLLEGE DISTANCE LEARNING COURSES

The proliferation of distance learning courses at colleges has raised the question of who owns the content of these courses—the faculty or the college. Instructors put a lot of time into developing distance learning courses. If they move on to another college, they may want to take their courses with them. Administrators may believe that the courses should belong to the colleges because instructors created the material on an institution's time, using college equipment and library resources.

If you teach distance learning courses, you should request or negotiate a contract if your college does not have one. There are many issues to resolve, especially if Web designers from other departments are involved. Do the Web designers own the design of the course? Do the instructors own the content they wrote? What if two instructors co-wrote the course? Do they co-own the content? The issues can quickly become complex. If you write content for a distance learning course, be proactive and negotiate a contract with the college to protect your interests.

PROTECTING YOUR RIGHTS

One of the best ways to protect yourself is to treat your writing as a professional business. This chapter only briefly touches on the many complexities of contracts; it definitely is not a substitute for legal advice. Seek out the well-known organizations listed as follows. If you have specific contract questions, consult with an attorney that specializes in writer's issues.

National Writers Union

The National Writers Union (NWU), www.nwu.org, offers a wide variety of benefits to its members. For example, members can call on a network of trained contract advisors and grievance officers who can help them get fair contracts and payment.

Media Special Perils Insurance

The NWU also offers "Media Special Perils Insurance" to its members. This coverage is the first group insurance program to protect freelance writers and authors against the costs of libel and other lawsuits, which are often used to intimidate investigative reporters and other writers. The policy, with an annual premium of $215, provides up to $1 million a year in coverage for each enrollee and applies to writing in all media anywhere in the world.[21]

Publication Rights Clearinghouse

The NWU has set up the only author-controlled, transaction-based licensing system, the Publication Rights Clearinghouse (PRC). Writers give the PRC permission to act as their agent in licensing secondary rights to their previously published articles. These articles then become part of the PRC's "inventory." When the PRC signs an agreement with a secondary user, it collects the copyright fees from that publisher or database and distributes the royalties to its enrollees (writers). Writers do not have to be members of the NWU to enroll in the PRC.[22]

American Society of Journalists and Authors

The American Society of Journalists and Authors (ASJA), www. asja.org, offers many benefits to its members. The organization also offers a free e-mail newsletter, *ASJA Contracts Watch*, that is provided by the ASJA Contracts Committee. The latter serves as Contract Information Central, keeping thousands of freelance writers informed about the latest terms and negotiations in the world of periodicals, print, and electronic publishing.

The Authors Registry

The Authors Registry (www.authorsregistry.org) is a nonprofit organization that was created to help issue the payment of royalty fees and small "reuse" fees to authors, especially for new media uses. According

to their Web site: "Virtually every important writers' organization and more than 100 literary agencies cooperate with the Registry." The Registry acts as a payment clearinghouse for specific categories of royalties and fees by working with publishers to deliver checks to freelancers. Major publications work with the Registry to share database royalties from third parties or pay fees for articles reused on the Web. For more information, writers can visit the Web site.[23]

Attorneys

Attorneys who specialize in intellectual property law can answer your specific questions and guide you in making the best decisions regarding article and book contracts.

DEALING WITH PUBLISHERS WHO DON'T PAY

If you encounter publishers who do not pay, you can try to take them to small claims court. You can turn the matter over to a collections agency, which will take a percentage from the amount they recover for you. If you're a member of the National Writers Union, you can contact them for support. In any case, it's important to warn your fellow writers via mailing lists about the publication's nonpayment practices.

CONTRACT RIGHTS CHECKLIST

Before you negotiate your next online contract, review this checklist. Steer clear of unfair contracts and obtain support from the major professional writers organizations.

Contract Don't's	Contract Do's
• Work-made-for-hire (WMFH) contract	• Separate payment for each reuse of your work
• "All rights" contract	• Limited duration of work online
• Indemnification clause	• Subscription fee for online archives
• Use your writing for educational or research purposes	• National Writers Union (NWU) -Media Special Perils Insurance -Publication Rights Clearinghouse (PRC)

Contract Don't's	Contract Do's
• Right to publish work in all forms, in any media	• The American Society of Journalists and Authors (ASJA)
• Publisher reserves right to revise, edit, or alter your work	• The Authors Registry
• Retroactive rights	
• Database clause	

NATIONAL WRITERS UNION
STANDARD JOURNALISM CONTRACT

Contract between (Writer)_____
and (Publisher)_____ :

1. The Writer agrees to prepare an Article of ____words on the subject of _____ : for delivery on or before

_____ (date). The Writer also agrees to provide one revision of the Article.

2. The Publisher agrees to pay the Writer a fee of $ ____within thirty (30) days of initial receipt of the Article as assigned above. (In other words, an original and coherent manuscript of approximately the above word count on the subject assigned, and for which appropriate research was completed.)

3. The Publisher agrees that the above fee licenses one-time World Wide Web rights only. This use is time-limited to the webzine's publishing cycle. (A new publishing cycle commences when the home page is completely refreshed.) All other rights, including but not limited to hard copy, CD-ROM, database, archive, proprietary services and other electronic rights are fully reserved by the Writer and must be negotiated separately.

4. The Publisher agrees to reimburse the Writer for all previously agreed-upon and documented expenses within fifteen (15) days of submission of receipts.

5. The Publisher agrees to make every reasonable effort to make available to the Writer, the final, edited version of the Article while there is still time to make changes. In the event of a disagreement over the final form of the Article, the Writer reserves the right to withdraw his/her name from the Article without prejudicing the agreed-upon fee.

6. The Writer guarantees that the Article will not contain material that is consciously libelous or defamatory. In return, the Publisher agrees to provide and pay for counsel to defend the Writer in any litigation arising as a result of the Article.

7. In the event of a dispute between the Writer and the Publisher that cannot be resolved through the National Writers Union (NWU) grievance process, the Writer will have the option of seeking to resolve the matter by arbitration, or in court. If arbitration is chosen, the Writer may be represented by the NWU in any procedures before the arbitrator. The arbitrator's fees shall be shared fifty percent (50%) by the Publisher and fifty percent (50%) by the Writer. Any decision reached by the arbitrator may be appealed pursuant to applicable law.

_____ _____
Writer or Publisher's Representative
Writer's Representative

_____ _____
Date: Date:

ENDNOTES

1. Isenberg, Doug. Atlanta lawyer, publisher of Gigalaw.com. E-mail interview, August 30, 2001.
2. National Writers Union. "Journalist Electronic Rights Negotiation Strategies," March 25, 1999, www.nwu.org/journ/jstrat.htm. Accessed May 28, 2001.
3. The American Society of Journalists and Authors. "Electronic Rights in Newspaper and Magazine Contracts," www.asja.org/pubtips/asjatips.php. Accessed January 8, 2001.
4. Ibid.
5. The American Society of Journalists and Authors. "Work-Made-for-Hire and 'All Rights' Contracts," www.asja.org/pubtips/wmfh01.php. Accessed January 8, 2001.
6. Ibid.
7. National Writers Union, "Journalist Electronic Rights Negotiation Strategies."
8. The American Society of Journalists and Authors. "How to Deal with Indemnification Clauses," www.asja.org/pubtips/indem01.php. Accessed January 8, 2001.

9. Ibid.

10. Ibid.

11. The American Society of Journalists and Authors. "Watch Out for These Clauses," www.asja.org/pubtips/clauses.php. Accessed May 17, 2001.

12. Ibid.

13. Ibid.

14. National Writers Union. "Recommended Electronic Rights Policy," July 30, 1998, www.nwu.org/journ/j15pct.htm. Accessed May 28, 2001.

15. The American Society of Journalists and Authors, "Work-Made-for-Hire and 'All Rights' Contracts."

16. National Writers Union, "Recommended Electronic Rights Policy."

17. National Writers Union, "Journalist Electronic Rights Negotiation Strategies."

18. The American Society of Journalists and Authors, "Work-Made-for-Hire and 'All Rights' Contracts."

19. National Writers Union. "Contract Issues Books Published Online," April 16, 1997, www.nwu.org/book/online-p.htm. Accessed May 29, 2001.

20. Ibid.

21. National Writers Union. "Media Special Perils Insurance Annual Premium $215," May 21, 2001, www.nwu.org/ben/mpi.htm. Accessed May 27, 2001.

22. National Writers Union. "About the Publication Rights Clearinghouse," February 24, 2001, www.nwu.org/prc/prcabout.htm. Accessed May 27, 2001.

23. The Authors Registry. "Helping Writers Get Theirs: Royalties and Fees for E-Rights." www.authorsregistry.org. Accessed May 28, 2001.

Chapter 18
Electronic Books and Online Learning

Today many of us are downloading electronic books (e-books) from the Web. If we don't want to print out an e-book, we can use the Web to place an order for a print-on-demand (POD) book, and the book will be shipped to our home that day. After dinner, we might decide to log on to the Web and sign up for a marketing or biology distance learning course.

E-books and distance learning are developing at a rapid speed. The processes that appear to bring us information quickly today will look slow and obsolete by tomorrow's standards. As writers, we need to monitor the advances of technology, adapt, and continue to learn. Those traits will bring us tomorrow's writing opportunities.

E-BOOKS AND E-BOOK PUBLISHING COMPANIES

Currently, writers who want to get their books published can choose an alternative route to the traditional print publishing book houses. Instead, they can sign a contract with an electronic-publishing (e-publishing) book company to produce an e-book.

Readers pay a predetermined fee for the e-books on the e-book publishers' site. The readers may then download the e-books as PDF files, HTML files, ASCII text, or through a PDA platform. E-books can also be sent through the mail to readers' homes on a CD-ROM or diskette.

Some e-book publishing companies also offer a print-on-demand (POD) option as part of their contracts to writers. A POD version of a book will satisfy those readers who don't want to print out a 250-page book on their printer at home. In addition, some readers may not have a reading device for e-books.

A POD book publisher can create a computer file of your complete book. As orders are received from readers for copies of your book, the POD publisher prints as many copies as needed. This process saves thousands of dollars that are usually spent on large print runs of traditionally published books; however, authors usually do have to pay a setup fee to the POD book company. The amount of the setup fee depends on the e-book publisher. The authors then receive a percentage of each sales transaction later.[1] Sometimes, depending on the e-book publisher, authors may also have to sign restrictive contracts. If you don't understand the POD book contract, seek legal advice from a lawyer.

The Differences in E-Books

Generally, e-book publishers pay little to no advance money to authors. E-book publishers also vary in the royalties they pay to authors; however, the royalties are usually higher than traditional print book publishers, ranging anywhere from 30 to 70%. The amount of editorial guidance and promotional support received from these e-book publishers depends on the company's policies.

Study E-Book Sites

Take an in-depth look at a variety of e-book publishing sites on the Web. Look at their home pages and interior pages. Do the sites look professional? Read their FAQ sections. Compare the costs that authors must pay, book formats offered, types of books that have been published, contracts, royalties paid, and editorial and promotional support provided to authors. If you have specific questions, write an e-mail message to the e-book publisher. Ask other writers on mailing lists if they have any information about the e-publisher's reputation. E-book categories can include how-to, romance, science fiction, general fiction, business books, and books whose rights have reverted back to the author. The average cost of consumer nonfiction e-books ranges from $10 to $20, with consumer fiction e-books usually costing less.[2] Some sites offer free sample chapters taken from a book, or an entire free e-book, to readers. Take advantage of this offer and download the book.

You can also purchase an e-book. This will give you a better idea of how e-books are made.

Promote Your E-Book

M.J. Rose and Angela Adair-Hoy are authors of the successful print book, *How to Publish and Promote Online*. From her own experience, Adair-Hoy finds that the best marketing method for promoting e-books, by far, is by publishing an e-zine or e-mail newsletter. Adair-Hoy encourages writers to copy her e-zine/e-mail newsletter format. Readers can subscribe at writersweekly.com (www.writersweekly.com).[3] Adair-Hoy is also the e-book publisher of Booklocker.com, which helps authors publish their own works through an e-book program or POD program. Authors receive royalties of 50 to 70%, and the authors own all rights to their work.

Vanity Publishers

Be aware that some of the electronic publishing companies you see on the Web are "vanity" publishers, which means you are responsible for all of the costs to print your book. Other companies charge for editorial services with no guarantee of publication. Before you sign a contract with any e-publisher, it pays to do your homework and research the many types of companies you'll find online. Read the fine print in the contract and check the publisher's credentials; ask other writers about their experiences with the company via writers' mailing lists or bulletin boards.

The Future of E-Books

E-books are still in the early stages of growth. Transformations in how we publish and read information will continue to occur in the coming years. The form and shape of e-books will look entirely different from the e-books we use today. Already, we are hearing of such futuristic-sounding ideas as electronic paper, software that enables consumers to create their own multimedia books, and dynamic annotation.

Some experts in the technology field believe that e-book readers and POD books are merely passing technologies. They claim that the future will bring a variety of entirely new media where users read at many different levels, and content and form reaches new levels of enrichment.

Self-Publishing on the Web

If you prefer not to sign a contract with an e-book publisher, you can publish your own e-book and sell it on your personal Web site. If you do decide to self-publish an e-book, you are totally responsible for the costs, liability, and promotion of your book.

Before you self-publish your e-book on your Web site, make sure you register your copyright with the U.S. Copyright Office at the Library of Congress site (http://lcweb.loc.gov/copyright). Going through the process of establishing a formal copyright for your e-book will give you more rights than merely placing a copyright symbol on your work. Your formally copyrighted work may be eligible for statutory damages and attorney's fees in a successful litigation case.

WRITING OPPORTUNITIES IN ONLINE LEARNING COURSES

Besides writing and developing online learning courses for a corporation's Internet, Extranet, and intranet, there are other job opportunities for writers. A writer can create online learning courses for colleges, distance learning vendors, adult learning sites, primary and middle schools, high schools, and writers' sites. As mentioned in the chapter on contracts, make sure you obtain a signed and fair contract before you begin writing the course.

Many colleges have developed for-profit companies to create, deliver, and promote online learning courses. One example is NYUonline, which was formed by New York University. The online learning company was developed to serve the corporate sector.

Defining Online Learning Courses

Online learning courses, or Web-based training (WBT), refers to courses available on the Internet, Extranet, or intranet. Well-constructed online learning courses offer students the opportunity to do things, try things, and make discoveries by interacting with the material. This type of training often works in concert with other learning resources outside of the course, such as e-mail messages exchanged with the instructor and fellow students, reference material, online class discussion groups moderated by the instructor, and videoconferences. Training material can be presented as text, audio clips, video clips, or graphics.

Online learning courses are different from computer-based training, which is presented on a computer and does not provide links to learning resources outside of the course. Another term often mentioned is *distance learning* to refer to online learning. In fact, online learning is just one form of distance learning. Think of distance learning as any educational situation where the teacher and students are separated by location, time, or both.[4]

Developing Online Learning Courses: Basic Considerations

When you write online learning courses for the Web, you cannot merely take standard, print training manuals and put them onto Web pages. You have to take advantage of the uniqueness, versatility, and interactive nature of Web media. Following are some basic considerations to keep in mind as you create online learning courses.

Create a Plan for Your Online Learning Course

Start with the basics. Your project manager should form a team that includes writers, designers, programmers, and usability experts. In a one-paragraph summary, define the goals of your online learning course. Your goals should be specific and measurable. For example, your goal might state: "The online course's goal is to teach telephone sales representatives how to close a sale for US $50 worth of office supplies during the first call to a small business customer."

Next, define your learning objectives for the course. When the course is over, what do you expect the students to do, know, and understand? Your project manager should create and manage the project timeline during the development of the course. The timeline should list all the crucial due dates (e.g., design template, first draft, final draft, beta test, course kickoff date).

Who Is Your Target Audience?

Define your target audience and their location(s) and environment. How will they access the training? (e.g., from their desktop PC or on the road from their laptop). What is the learning level of your audience. For novice Internet users, you might want to offer an online orientation that explains what the Internet and online learning is all about. You should develop online pre- and post-tests to measure students' progress. You might also consider developing an online student evaluation form to help you improve future courses.

Define Online Learning Course Standards

Define standards for the course that includes style guidelines so that each team member is working toward the same common goal. For example, here is where you might determine the tone of your training. Start by creating a design template to help you standardize the look of the online course. Sharing the template with each member of the team will keep you all on the same page. To create a quality end product, you should develop an Editorial Checklist somewhat similar to the one that was mentioned in Chapter 8, "Editing Web Writing."

Content of Online Learning Course

An online learning course should use sound educational principles. In the introduction (or Welcome section) of the online course, the students should know what is expected of them and how they will be evaluated. Online learning is self-directed learning. Building in a non-linear structure into your course allows students to move through the material in any order as long as they complete the course. For example, in a fiction writing course, some students may want to study character development before they move onto plot development or setting. A simple, clear, and intuitive navigation system in a nonlinear course will motivate students and decrease frustration. Providing a good user experience will decrease the student dropout rate. Conversely, a linear structure in a course requires students to complete the material in a sequential manner. This type of structure may bore some students; however, certain online courses necessarily have to be presented in a linear structure, such as a course on how to learn to operate a software program. In this case, online writers have a greater challenge to engage students and keep them motivated throughout the course. Here's a situation where plenty of interactive exercises are required.

Build in Interaction. A "virtual instructor" (possibly an animated character or cartoon, if appropriate) should provide immediate feedback to students throughout the course. One example of immediate feedback is placing short quizzes at the end of each section of the course. After students answer the quiz questions, they are given the correct answers. To enhance the effectiveness of these quizzes, the correct answer could be followed with brief, additional facts on the topic. (Limit the facts from one to two sentences in length.) Immediate feedback and providing students with additional facts, will help you reinforce the key information you want students to learn. Different learning modalities (e.g., video clips, audio clips) can enhance students' experience. Pop-ups on the screen can provide additional, related course information to

students. A glossary button placed on each screen can help students easily look up terms that are unfamiliar to them. Unusual terms in the text should be hypertext linked to this same glossary of definitions. Once students have read the definition of the term, they should be able to easily get back to the place where they left off in the course. Offer students the ability to print text material because they may want to use it as a reference source later on.

Other challenging interactive activities, which provide immediate feedback, should be woven into the course to engage students' attention. For example, student nurses can participate in a simulated and interactive physician/patient virtual case study. After completing the case study, the student nurses can check their answers against the physician's responses, which are played back via videotape or audio tape.

There should be opportunities for positive reinforcement of students' efforts through e-mail messages or discussion groups. Instructors can use e-mail messages and discussion groups to mentor and encourage students. Offer opportunities for students to interact with each other and share information via the Web through collaborative Weblogs or on an intranet. Students can share the insights and ideas they have gained from the course material by posting notes to a class Weblog. They can also post questions or requests for help from their fellow students. Students should be given the opportunity to again review and assess the course material before taking the final online exam.

Content Guidelines. Course content should follow the guidelines of good online writing principles. Content should be written in a clear, concise, and direct manner. Think in terms of compact writing. Writers should break information into short paragraphs. Make scanning easy by using meaningful headings and subheadings. Because your goal is to draw students into the material and get them to finish the course, your content should have a friendly tone. Your writing style has to be easy for students to understand to help them forget "screen stress" (i.e., the difficulty of reading on a screen).

Research the subject matter of the course through search engines and databases before you begin writing to make sure you have gathered the latest research and that you thoroughly understand the topic. If necessary, hold interviews with subject matter experts (SMEs) on the topic.

Explore different ways to reinforce the content of the course. Repeat key ideas in diverse ways by using headings, subheadings, sidebars, captions, graphs, graphics, tables, and illustrations that extend, reinforce, and summarize the content you want your students to learn.

Copyrighting Online Learning Courses

If you see an online learning course on the Web, that course belongs to either an individual or an organization. Therefore, you need permission to use the course or parts of the course. There are situations where material is in the public domain. It's important to do your research and determine the status of the educational material you see on the Web.

If you write an online learning course, you should formally register it. You can register your work by filling out the appropriate form, which can be found at the U.S. Copyright Office at the Library of Congress Web site (http://lcweb.loc.gov/copyright). Send the form along with a copy of the course and appropriate fee to the copyright registration office.

It's important to place the phrase "Copyright © 2002 by ABC Business" on all of the training materials you develop. In fact, if you develop online learning courses, create a copyright ownership statement on a separate page on your site. On every page of your training, provide a link to this copyright ownership statement. Your statement page should outline your permission policy and include a live "mail-to" link for people who want to request permission to copy all or parts of your course material.

For example, the copyright ownership statement might read:

> Copyright © 2002 by ABC Business. All editorial content and graphics on this site are protected by U.S. copyright and may not be copied without the express permission of ABC Business which reserves all rights. Do not reproduce or redistribute any material from this course in whole or in part without written permission from ABC Business.

You should also add a live "mail-to" link to ABC Business, as well as your own e-mail address, and the complete business snail-mail address, telephone, and fax number.

Resources for Writers of Online Learning Courses

A variety of resources is available on the Web for writers who want to learn more about online learning or how to develop online learning courses. A few of these sites follow.

Distance Learning Resource Network (DLRN)

The Distance Learning Resource Network (DLRN), www.dlrn.org, is a federally funded, nonprofit, distance education program. Some of the

services that DLRN provides include information about distance education, and instructional methods and strategies. The site contains online course design tools to help instructors design courses for Web-based instruction. If instructors have specific requests, they can call a toll-free helpline number or e-mail their request to dlrn@wested. org. Online forums on this site provide educators with networking opportunities.

United States Distance Learning Association

The United States Distance Learning Association (www.usdla.org) promotes the development and application of distance learning for education and training.

Training SuperSite.com

The Training SuperSite.com site (www.trainingsupersite.com) offers educators information on learning, training/staffing resources, business tools, and networking opportunities. Bill Communications (a VNU Business Media Company) produces a variety of magazines and newsletters, including *Training* magazine and *Online Learning* magazine. There are also archives of articles on the site.

American Society for Training and Development (ASTD)

The American Society for Training and Development (ASTD) (www. astd.org) is a professional association that focuses on workplace learning and performance issues. The organization hosts conferences, expositions, and seminars. The ASTD also offers many publications, including *Training and Development* magazine. The ASTD site includes articles, a job bank, a learning community, and an online store.

World Campus 101

Penn State University's distance education department created World Campus 101 (www.worldcampus.psu.edu/wc101). The free, self-paced tutorial teaches students how to be effective online learners. This site could be a helpful resource to writers who are preparing students for online learning.

Workers.gov

Check out the learning category on the Workers.gov site (www.workers.gov) to find a rich source of information on distance education and online learning.

Capella University

Capella University (www.capellauniversity.edu/aspscripts/home/index.asp) offers certificates in online training programs. The university also offers a master's and doctorate in this field.

ONLINE LEARNING COURSE CHECKLIST

To create a successful online learning course, make sure that you have included the following key points.

- Course development team (includes project managers, writers, designers, programmers, and usability experts)____
- Project timeline (list all the crucial due dates—design template, first draft, final draft, beta test, course kick-off date. etc.)____
- Goals (specific and measurable)____
- Learning objectives (When the course is over, what do you expect the students to do, know and understand?)____
- Target audience (their location(s) and environment. How will they access the training? From their desktop PC or on the road from their laptop? What is the learning level of your audience? Novice Internet users? Then offer an online orientation that explains what the Internet and online learning is all about.)____
- Course navigation (nonlinear versus linear)____
- Research topic (through search engines and databases; interview subject matter experts [SMEs])____
- Course content (follow good online writing principles. Use a clear, concise, and direct approach. Think in terms of compact writing. Break information into short paragraphs. Make scanning easy with meaningful headings and subheadings. Use a friendly tone. Writing style has to be easy for students to understand to help them forget "screen stress.")____
- Different learning modalities (text, video clips, audio clips, videoconferencing, pop-ups, glossary, ability to print text material)____
- Interactive elements (short quizzes with immediate and additional factual feedback; simulated and interactive case studies with immediate feedback; students interact with the instructor and with each other through collaborative Weblog and/or intranet)____
- Reinforce course content (Repeat key ideas in diverse ways through use of headings, subheadings, sidebars, captions, graphs, graphics,

tables, and illustrations. These tactics will extend, reinforce, and summarize the content that you want your students to learn.)___

- Other related online learning resources and motivators (e-mail messages with instructor and fellow students; online class discussion groups moderated by instructor; class Weblog; additional reference materials)___

- Design template (if necessary, revise as project progresses)___

- Editorial Checklist (revise as project progresses)___

- Copyright online course (formally register course with the U.S. Copyright Office at the Library of Congress Web site)___

- Copyright ownership statement (On every page of your training, provide a link to the course's copyright ownership statement page.)___

ENDNOTES

1. Rose, M.J., and Angela Adair-Hoy. *How to Publish and Promote Online* (New York: St. Martin's Press, 2001), pp. 9, 48.
2. Ibid.
3. Adair-Hoy, Angela. E-mail interview, July 12, 2001.
4. Carliner, Saul. "What Is Online Learning?" An Overview of Online Learning, www.lakewoodconferences.com/wp/what.htm. Accessed June 6, 2001.

Glossary

acronym Condenses an often-used collection of words. Acronyms are used in the business world, such as LAN (local area network). Acronyms are also used in discussion groups, newsgroups, forums, and chat rooms, such as BTW (by the way).

address book Personal directory of e-mail addresses stored in one's e-mail program.

archives Documents stored in online archives on Web sites. These documents may be past issues of online newsletters or a series of messages saved from an electronic discussion group.

ASCII (American Standard Code for Information Interchange) Most common format for text files in computers and on the Internet.

autoresponders Automated programs that are set up to send out a prewritten response upon receipt of an e-mail message.

banner ad Advertisement on a Web site that hyperlinks to the advertiser's Web site. It's called a "banner ad" because the original online advertisements were always in the shape of a banner and were usually positioned at the top of a Web page.

benefits Turns prospects into buyers. The benefits of a product, not the features, answer the prospect's question "What's in it for me?" (WIIFM). You must answer the customer's question by explaining how the features are useful to the customer. The answers then turn the features into benefits.

bookmark A function in a Web browser that allows users to save frequently visited Web sites. Users can then easily access the bookmarked sites (URLs) through a dropdown menu. Many users use the bookmark function to organize their favorite Web sites into specific categories so they can find their favorite sites faster.

Boolean operators Boolean operators can help users further refine their search for specific information. Users can combine two or more sets

of data with any one of the following boolean operators: "AND," "OR," "NOT," or "NEAR." Boolean operators work with most search engines.

bot A program used on the Internet that performs a repetitive function such as searching for information.

bounced message The return of an e-mail message because the message could not be delivered to the recipient.

brand A name that distinguishes a company's product or service from its competitors.

broken link A link that no longer works (e.g., no longer takes the user to the destination page) when the user clicks on it. This situation could occur if the Web site has moved to a new server or the file or files have been moved or deleted.

browser A software program that allows you to view documents on the World Wide Web. The most popular browsers are Microsoft Internet Explorer and Netscape Navigator.

cache A cache temporarily stores Web pages you have visited in your computer. Web browsers use caches to remember recently viewed Web pages and images, thereby speeding their display when a user returns to them.

chat A form of interactive communication that enables users to have real-time conversations with other people who are also online on their computers. Chatting on the Internet can take place through Web pages in chat rooms or on IRC (Internet relay chat) channels.

chat room A site on the World Wide Web where several users can type in messages to each other and chat in real-time online conversations from their individual computers. Inside the chat room, there is usually a list of people currently online. The users are alerted when another person enters the chat room. To participate in the chat session, users type a message into a text box. The users' message usually appears immediately on a section of the screen next to their nickname or handle. Other users respond to the message. There are chat rooms devoted to a variety of interests and hobbies.

chunk Brief blocks of text that are easy to read and scan on the computer screen. The text should be composed of 100 words or less. Each chunk of text should begin with a topic sentence and focus on a specific idea.

click rate When used in Web advertising, it refers to the percentage of ad views, i.e., the number of times users click (e.g., banner ad).

community Online communities are groups of people who share a common interest (e.g., writers). Discussion groups, chats, and other interactive forums help build online communities.

content gardener A term coined by Jakob Nielsen. Because old content continues to get hits over a long period, it's in a site's best interest to employ a "content gardener" to maintain the content. This person's

job is to edit, update, and remove outdated content so that the older material still offers valuable information to users.

content provider An organization that provides regularly updated information on the Internet. "Content" includes various forms of information, from news to stock quotes to gossip to worldwide weather forecasts. A writer who develops content for the Web, such as a weekly column for a Web site, is also considered a content provider.

contextual clues Cues that help users locate their position on a Web site. These cues may include a logo, site name, headings, menus, color-coding, navigational buttons, and contact information.

cookies Small text files stored on the hard drive of your personal computer (PC). When you visit a Web site, the site's server may check to determine if you have a cookie on your PC's hard drive from a previous visit that you made to the site. If you do have a cookie, the server retrieves it and reads it. If you don't have a cookie on your PC, the server may place one on your PC's hard drive. Cookies enable you to personalize a Web site, store your user ID and password, and make online shopping easier by storing your billing and shipping address. Cookies can track your movements on a site via the code that is assigned to your computer.

cross post To post the same message simultaneously to several different discussion groups or newsgroups. This practice is considered poor Netiquette.

cyberspace Metaphor for describing the digital (nonphysical) world created by computer systems, specifically the Internet. These online systems produce a cyberspace within which people can communicate by e-mail, do research, take online courses, or purchase products. The term was coined by the author William Gibson in his science fiction novel *Neuromancer.*

database Collection of data that can be accessed electronically on the Web.

deep linking The practice of linking from your site to another Web site's interior pages instead of linking to the Web site's home page (front door). Deep linking is frowned on because businesses say that advertising revenue that might be generated by "hits" on the home page are lost and that prospects are not exposed to the full offerings of the Web's home page. At this time, deep linking is still a controversial issue.

delivery receipt Optional e-mail feature that tells you when a recipient has opened the e-mail message that you sent to that person.

delurk To come out of online lurking mode after reading the postings on a mailing list for a period.

demographics Segment of your market analysis that tells you the characteristics of your customers, such as gender, age, income, employment status, or personal interests.

digital watermark Used on the Internet to prevent unauthorized usage of content by an individual or group. A marker that is encoded in a graphics file to indicate ownership.

disclaimer A statement that disowns responsibility and liability for contents on a site. For example, a disclaimer on a health site may warn readers who visit the site that the information is provided in summary form only. Readers are told that the information should not be considered complete and should not be used in place of a visit, call, consultation, or advice of their physician or other health care provider. Readers are encouraged to contact their physician or other health care provider with any health-related questions. Disclaimers can be more lengthy than this example to protect the rights of the site owners.

discussion group Online conversation among users with a shared interest, occupation, or hobby who post e-mail messages to the group through software such as Listserv or Yahoogroups.com. These discussion groups are also called discussion forums, lists, or listservs.

domain name The unique registered name for an organization connected to the Internet (e.g., http://www.poynter.org).

domain suffix The last part of a domain name. In the United States, the suffix generally describes the type of organization, such as ".com" for commercial sites, ".net" for network, ".gov" for government sites, ".mil" for military sites, ".edu" for educational sites, and ".org" for nonprofit sites. In other countries, the suffix identifies the country of origin (e.g., ".fr" translates to France and ".uk" to United Kingdom).

download To transfer electronic documents or data from the Internet to your own local computer.

e-commerce Also known as electronic commerce. The concept involves buying and selling products or services on the Internet. When you buy a book over the Web, you are engaged in e-commerce.

e-journal Also known as electronic journal. A regularly published journal that is usually academic in nature.

e-mail (electronic mail) A basic Internet service that allows users to exchange messages electronically.

e-mail press release Brief e-mail document sent to the press that announces a new product or service offering or significant company announcement.

emoticons Also known as smileys. Emoticons are ASCII symbols originally designed to show various emotions and expressions in plain text messages and e-mail messages. Through the years, they have turned into an art form. Generally, emoticons are created to be viewed by tilting your head left so the right side of the emoticon is at the bottom of the "picture"—:0).

encryption A process that converts a file from its original form to one that can only be read by the intended recipient.

Extranet When a company allows part of its intranet contents to be made available to its customers, suppliers, partners, or other groups outside of the company, this access is called the Extranet.

eye candy Term used for visual elements that are displayed on computer monitors that are attention getting or visually appealing.

eyeballs A term used in online advertising, such as measuring the eyeballs or visitors to a Web site.

e-zine Also known as electronic magazines that can be accessed through the Web. E-zines cover a wide variety of subjects from Inscriptions, which targets writers, to HotWired, which is technology-focused, to Newsweek, which focuses on current events and news.

FAQ (frequently asked questions) Collection of frequent questions and answers about a Web site, product/service specific discussion group, or other subject. The questions and accompanying answers are posted at the site for newcomers to read. The FAQ list eliminates the need for newcomers to ask questions via e-mail messages to the site or to ask questions of more experienced discussion group members. Asking a question without first reading the FAQs and/or archives is considered poor Netiquette. On a discussion group list, you may get flamed if your question covers material contained in the FAQs.

feature A descriptive fact about a product or service. Features define your product or service. For example, one feature of a cellular phone is clear reception.

flame An insulting or rude e-mail message, often posted as a response on a mailing list, newsgroup, or sent to an individual via e-mail.

flame war A series of public posts in which people flame one another rather than contribute useful information in a discussion group.

focus group Market research in which a small group of people are brought together to discuss a product, service, or business.

frame Section of a Web page that is displayed separately from other portions of the page. The frame could include a scroll bar that allows the user to scroll the section of that page while the other frame on the page remains constant.

handle A pseudonym used by a person in a chat room or on a message forum.

hierarchical structure Can refer to the structural levels of a Web site. For example, there can be many different levels to a corporate site that sells PC equipment and services. The top level is the corporate home page. The second level could include these categories: desktops, notebooks, servers and storage, and software and peripherals. The notebooks category could be broken down into a third level of different types of notebooks, and so on with the other categories. The ultimate goal is to create a Web site that is reasonably shallow. Users should not have to "drill down" through too many levels to find the information they need.

history list In a Web browser, the history list displays the Web sites that the computer has visited. The browser's toolbar can be configured to determine the total number of days that the computer retains its history list.

hits The number of times that a Web site has been visited. The word *hits* can also refer to the results that come up when a key word search is done in a search engine.

home page Front (first) page of a Web site. The front page should offer users an easy-to-use navigational structure in the form of an index, menu, or table of contents.

hyperlink A highlighted (or underlined) word within a hypertext document that, when clicked on, takes users to another area within the document or to a different document on the World Wide Web. A image may also function as a hyperlink so that when users click on the image, they are taken to the destination page. Hyperlinks are also called *links*, *hypertext links*, and *hot links*.

hypertext Writing and displaying text so that the text can be linked in many different ways, at several different levels, and including links to related documents.

hypertext markup language (HTML) Tag-based ASCII language that is used to create Web pages.

hypertext transfer protocol (HTTP) Protocol used by Web browsers and Web servers to transfer files, such as text, graphic images, video, sound, and other multimedia files, on the World Wide Web.

image map Users can click on different areas of the image map (graphic image) and be linked to different destinations on the Web.

interactivity Interaction that occurs when a user participates in an online message board, game, chat session, e-mail–based discussion group, or survey.

International Standard Serial Number (ISSN) "The same criteria for determining if a serial is eligible for an ISSN apply to electronic and print publications: an intention to continue publishing indefinitely and being issued in designated parts. In the case of electronic serials—especially those available online, such as on the Internet—the most significant criterion is that the publication must be divided into parts or issues which carry unique, numerical designations by which the individual issues may be identified, checked in, etc." Source: http://lcweb.loc.gov/issn/e-serials.html.

Internet Worldwide system of computer networks. The World Wide Web (often called the Web) is part of the Internet.

Internet Corporation for Assigned Names and Numbers (ICANN) Nonprofit corporation that was formed to assume responsibility for the IP address space allocation, protocol parameter assignment, domain name system management, and root server system management functions

previously performed under U.S. Government contract by Internet Assigned Numbers Authority (IANA) and other entities.

Internet Network Information Center (InterNIC) Established by the National Science Foundation (NSFNet) in 1993 to handle domain name registration, information services, and directory services. InterNIC now handles domain name registration only (www. internic.net).

Internet service provider (ISP) A company that provides connection to the Internet, usually for a monthly fee.

intranet A private network developed for a specific group of people (e.g., the employees in a company). The company may post company news, human resources information, white papers, or training.

keyword(s) Word(s) typed into a search box to find information on the Web.

lead The introduction to your document. A lead should contain an intriguing or interesting statement(s) to grab your readers' attention and pull them into your copy.

linkrot Term used to describe the situation when a user clicks on a link and an error message is returned or a message tells users the site has moved to a new URL.

lurker A person who reads messages in an online discussion group or mailing list but does not respond or actively participate in the discussion by posting messages. New members should lurk before they post messages to a group so they can get a feel for the culture and views of the group.

mail bot Program that automatically responds to incoming e-mail messages. The mailbot receives the e-mail message and sends a prewritten, automated reply.

mailing list See *discussion group*.

masthead The printed matter displayed at the top of an e-mail newsletter that gives the title of the publication, publisher, date of issue, volume number, issue number, Web site URL, copyright statement, and International Standard Serial Number (ISSN). Other details could include contact information, "subscribe" and "unsubscribe" instructions, advertising rates, and subscription rates.

meta search engine Allows you to search several search engines at the same time and compiles the results for you.

moderator A person who manages the postings of messages in a moderated mailing list to make sure subscribers stay on topic and adhere to list policies. The moderator also screens the messages to make sure they are appropriate to the list.

micropayments Small payments for brief pieces of content.

Netiquette Adhering to the rules of appropriate conduct on the Internet. These acceptable practices apply to e-mail messages, conduct on

mailing lists, and discussion in chat rooms. For example, using caps in an e-mail message is discouraged because it appears as if the writer is shouting at the other person.

net lingo Slang that is used on the Internet.

newbie A newcomer to the Internet.

new media General term for a product or service that combines elements of computing technology, telecommunications, and content to permit interactive use by consumers and business users. Some examples of new media can include online communities, streaming video, and virtual reality environments. New media includes multimedia and hypermedia.

newsgroup Online forum that allows the public to post and read messages on a specific topic.

niche A group of people with a specific set of interests (e.g., educators who are interested in distance learning). An online writer can specialize in writing for a specific niche (e.g., a writer can create articles on distance learning for educators). Alternately, an online writer can specialize in writing niche articles for the health market.

nonlinear Information that can be read or viewed in any order on the Web.

opt-in e-mails Good business practice means sending e-mails to people who have asked to be on your list.

opt-out e-mails Sending e-mails to people who never signed up for your e-mail list. Spamming is sending out information to a huge list of people who did not request the information.

personal digital assistant (PDA) A handheld portable device that can be used as a personal organizer, take notes, write memos, keep track of appointments, send or receive e-mail (some models), and get information from the Internet (some models). One example of a PDA is the Palm TM Handheld. PDAs are also called *handheld computers* and *palmtops.*

personal home page Web page created by an individual to display personal or professional information (e.g., resume, portfolio).

plug-in Add-on software that adds new features to a commercial application.

portable document format (PDF) File format developed by Adobe Systems that produces a document with its original formatting, fonts, and graphics intact when it is opened with the Adobe Acrobat reader. Some of the documents that are usually put into a PDF format include white papers, academic articles, business reports, and research reports.

post To send a message to a public area (e.g., newsgroup), where it can be read by other people on the Internet.

pro bono Doing work that is donated for the public good (e.g., writing an online press release for the local branch of a nonprofit organization, such as The American Institute for Cancer Research).

protocols A set of rules or procedures for exchanging information between networks or computer systems.

repurposing Taking content from one form of media (e.g., print newspapers) and rewriting it to fit the specific requirements of another media (e.g., online news).

scroll To move up or down within a document that is longer than the height of your computer screen. On some sites, you can also scroll to the left or right of the document.

search box A field box in which users type in keywords or phrases to find information on a Web site or through a search engine.

search engines Allow you to type in keywords, phrases, and concepts to search the World Wide Web for specific information. Some search engines allow you to type in questions instead of a few search terms.

shovelware Taking content from different sources (e.g., newspaper articles or magazine articles) and putting it on the Web with disregard to its usability and appearance. Content for the Web needs to be repurposed (revised) to meet the unique needs of online media.

sidebar A short piece of text that is presented outside the chronological flow of the main online document. Sidebars can entice readers to read more of a specific article. Sidebars can be used to present interesting information that is related to the main document.

sig Short for signature line.

signal-to-noise ratio A term borrowed from electronics. In discussion groups, this term often refers to the amount of useful information (i.e., signal) versus meaningless, off-topic, conversation (i.e., noise).

signature line A block of four to six lines of text placed at the end of an e-mail message. Depending on the author's objective, a signature line can provide readers with the author's contact information, occupation, company name, Web site URL, favorite quote, recent book or article, or special promotions.

smiley See *emoticons*.

spam To e-mail mass mailings of unsolicited advertisements to discussion groups or newsgroups or people. Spam is considered the junk mail of the Internet.

splash screen (splash page) An initial Web page that is suppose to capture the user's attention (e.g., welcome message or company logo) as a lead-in to the home page. Splash screens are often slow and annoy users.

sticky Capacity of a Web site to keep users on the site and to explore it, as well as the ability of the site to attract repeat visitors. Sticky can also apply to the content of an article or document. A sticky article interests people and keeps them reading.

stop words Small words such as "and," "in," "the," "a," "or," "of" that are often ignored by search engines.

thread A posting on a specific topic to a newsgroup or e-mail discussion list that is followed by replies from list members. These interactive replies develop into a continuing conversation on the topic.

uniform resource locator (URL) The unique address of a Web site or document. The components of a URL include file type, such as "http"; host or server name, such as "www"; domain name, such as "bookstore"; and an extension to identify the type of site, such as "com" for a commercial site.

unique selling proposition (USP) A product or service difference that a company or Web site offers that is not available in other products or services and is important to the customer. An online writer can advertise a USP such as a specialty in medical writing for pharmaceutical companies.

Weblog A regularly updated site that points to links on other sites. The person who maintains the Weblog usually provides commentary about the links. Writers can create Weblogs that relate to their writing specialty and attract potential clients. For more information on Weblogs, go to www.weblogs.com.

Web site Collection of pages on the World Wide Web.

World Wide Web (WWW) Large network of Internet servers providing hypertext and other services to terminals running client applications such as a browser.

Bibliography

Allen, Moira Anderson. *Writing.com: Creative Internet Strategies to Advance Your Writing Career* (New York: Allworth Press, 1999).

Allen, Moira Anderson. *The Writer's Guide to Queries, Pitches & Proposals* (New York: Allworth Press, 2001).

Anderson, Daniel. *Connections: A Guide to On-Line Writing* (Needham Heights, MA: Allyn & Bacon, 1998).

Bayan, Richard. *Words that Sell: A Thesaurus to Help Promote Your Products, Services, and Ideas* (Westbury, NY: Caddylak Publishing, 1984).

Bonime, Andrew, and Ken C. Pohlmann. *Writing for New Media: The Essential Guide to Writing for Interactive Media, CD-ROMs, and the Web* (New York: John Wiley & Sons, 1998).

Brusaw, Charles T., Gerald J. Alred, and Walter E. Oliu. *Handbook of Technical Writing*, 5th ed. (New York: St. Martin's Press, 1997).

Chase, Larry. *Essential Business Tactics for the Net* (New York: John Wiley & Sons, 1998).

Editors of EEI Press. *E-What? A Guide to the Quirks of New Media Style and Usage* (Alexandria, VA: EEI Press, 2000).

Flanders, Vincent, and Michael Willis. *Web Pages that Suck: Learn Good Design by Looking at Bad Design* (Alameda, CA: Sybex, 1998).

Holtz, Shel, with contributions by Neville Hobson. *Writing for the Wired World: The Communicator's Guide to Effective Online Content* (San Francisco: International Association of Business Communicators, 1999).

Horton, William. *Designing and Writing Online Documentation*, 2nd ed. (New York: John Wiley & Sons, 1994).

Kent, Peter. *Poor Richard's Web Site: Geek-Free, Commonsense Advice on Building a Low-Cost Web Site* (Lakewood, CO: Top Floor Publishing, 1998).

Kilian, Crawford. *Writing for the Web* (Bellingham, WA: Self-Counsel Press, 1999).

Kim, Amy Jo. *Community Building on the Web: Secret Strategies for Successful Online Communities* (Berkeley, CA: Peachpit Press, 2000).

Levinson, Jay Conrad, and Charles Rubin. *Guerrilla Marketing Online: The Entrepreneur's Guide to Earning Profits on the Internet* (New York: Houghton Mifflin, 1997).

Lewis, Herschell Gordon. *On the Art of Writing Copy: The Best of Print, Broadcast, Internet, & Direct Mail*, 2nd ed. (New York: Amacom Books, 2000).

Locke, Christopher, Rick Levine, Doc Searls, and David Weinberger. *The Cluetrain Manifesto: The End of Business As Usual* (Cambridge, MA: Perseus Publishing, 2000).

Lynch, Patrick, and Sarah Horton. *Web Style Guide: Basic Design Principles for Creating Web Sites* (New Haven, CT: Yale University Center for Advanced Instructional Media, 1999).

Maciuba-Koppel, Darlene. *Telemarketer's Handbook: Professional Tactics & Strategies for Instant Results* (New York: Sterling Publishing, 1992).

Nielsen, Jakob. *Designing Web Usability: The Practice of Simplicity* (Indianapolis, IN: New Riders Publishing, 2000).

Pirillo, Chris. *Poor Richard's E-Mail Publishing: Creating Newsletters, Bulletins, Discussion Groups, and Other Powerful Communication Tools* (Lakewood, CO: Top Floor Publishing, 1999).

Rich, Carole. *Creating Online Media: A Guide to Research, Writing and Design on the Internet* (New York: McGraw-Hill College, 1998).

Ridpath Ohi, Debbie. *Writer's Online Marketplace: How & Where to Get Published Online* (Cincinnati, OH: Writer's Digest Books, 2001).

Rose, M.J., and Angela Adair-Hoy. *How to Publish and Promote Online* (New York: St. Martin's Press, 2001).

Sammons, Martha C. *The Internet Writer's Handbook* (Needham Heights, MA: Allyn & Bacon, 1999).

Samsel, Jon, and Darryl Wimberley. *Writing for Interactive Media: The Complete Guide* (New York: Allworth Press, 1998).

Sherman, Chris, and Gary Price. *The Invisible Web: Uncovering Information Sources Search Engines Can't See* (Medford, NJ: CyberAge Books, 2001).

The UCLA Internet Report, "Surveying the Digital Future." (Los Angeles: UCLA Center for Communication Policy, November 2000), www.ccp.ucla.edu. Accessed November 30, 2000.

Usborne, Nick. *Net Words: Creating High-Impact Online Copy* (New York: McGraw-Hill, 2001).

Vitanza, Victor J. *Writing for the World Wide Web* (Needham Heights, MA: Allyn & Bacon, 1998).

Walker, Janice R., and Todd Taylor. *The Columbia Guide to Online Style* (New York: Columbia University Press, 1998).

Wycoff, Joyce. *Mindmapping: Your Personal Guide to Exploring Creativity and Problem-Solving* (New York: Berkley Books, 1991).

Zinsser, William. *On Writing Well: An Informal Guide to Writing Nonfiction*, 6th ed. (New York: HarperCollins, 1998).

Index